AGITATE! EDUCATE! ORGANIZE!

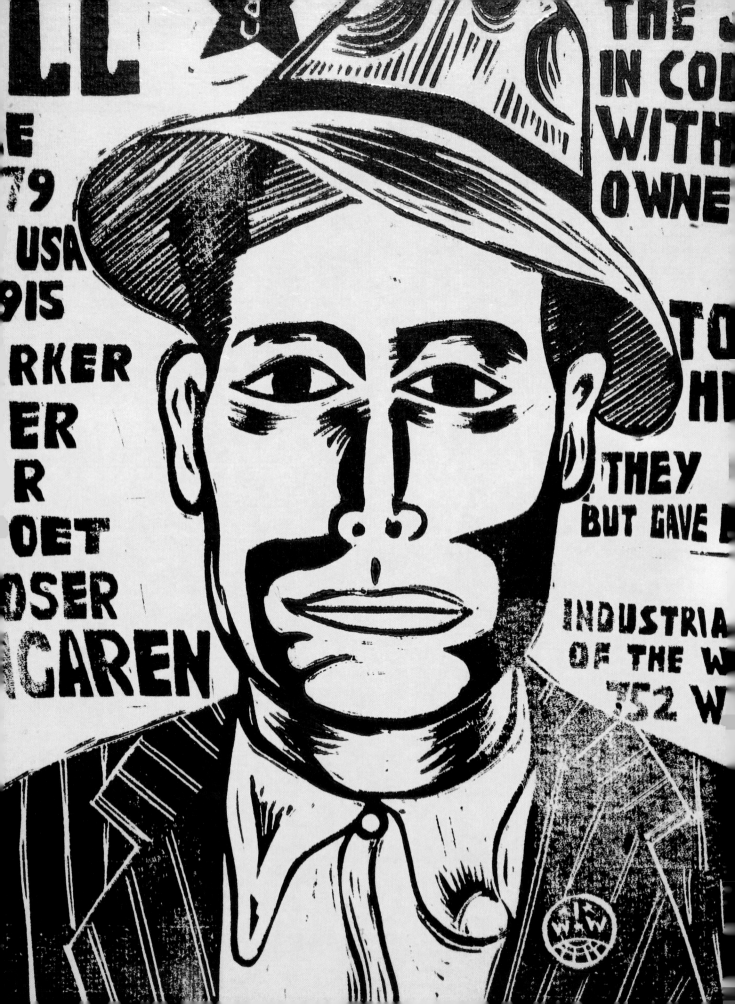

AGITATE!
EDUCATE!
ORGANIZE!

AMERICAN LABOR POSTERS

LINCOLN CUSHING AND TIMOTHY W. DRESCHER

ILR PRESS
AN IMPRINT OF CORNELL UNIVERSITY PRESS
ITHACA AND LONDON

First published 2009 by Cornell University Press

First printing, Cornell Paperbacks, 2009

Library of Congress Cataloging-in-Publication Data

Cushing, Lincoln, 1953-
 Agitate! educate! organize! : American labor posters / Lincoln Cushing and Timothy W. Drescher.
 p. cm.
 Includes bibliographical references and index.
 ISBN 978-0-8014-7427-9 (pbk. : alk. paper)
 1. Labor movement—United States—Posters. 2. Posters, American. 3. Political posters, American. 4. Labor movement in art. I. Drescher, Tim. II. Title.
NC1849.L3C874 2009
741.6'740973--dc22

 2008044165

Cornell University Press strives to use environmentally responsible suppliers and materials to the fullest extent possible in the publishing of its books. Such materials include vegetable-based, low-VOC inks and acid-free papers that are recycled, totally chlorine-free, or partly composed of nonwood fibers. For further information, visit our website at www.cornellpress.cornell.edu.

Paperback printing 10 9 8 7 6 5 4 3 2

Printed in Canada

To the artists who created these posters,

The working people and unions whose struggles they illustrate, and

The poster archives and collections that preserve them.

NO BUY OFFS, SELL OUTS, OR TRADE OFFS.
**ALL OF US OR NONE
ALL OF US OR NONE
ALL OF US OR NONE
ALL OF US OR NONE**
© 1983 D. Minkler

"All of us or none." DOUG MINKLER,
self-published, 1983. Screenprint, 81.5 x 51 cm.

CONTENTS

AGITATE! EDUCATE! ORGANIZE!

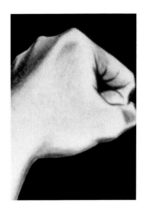

INTRODUCTION

Labor posters reflect the grand sweep of the pageant of humans working on this earth for their daily bread. A public medium known for dramatic visual impact, they provide a graphic insight into important aspects of our culture and contribute greatly to the fabric of our society. The strongest images are visually fresh and offer a compelling message. These images of men and women of all races and ethnicities working in a wide variety of jobs serve as a valuable lens through which one can look at the history of millions of people as they struggled to improve their lives and their work experiences. Yet, despite their significance, they have received little critical or scholarly attention.

It is our intention in this book to present the rich graphic tradition of labor posters and its contribution to our national culture. We seek to inform as well as to celebrate. The best posters about American workers and the jobs at which they labor make up a visually fascinating body of work that rewards our attention. When originally produced, the posters' purpose was to be both entertaining and informative. They were also vehicles for working people to present themselves visually, which is rarely as straightforward as it might seem because the labor force itself is not monolithic. Nor are the posters about just paid or wage labor. They repeatedly demonstrate that labor issues include both the workplace and the outside community, which is why they often portray families and neighbors, not just fellow workers. Even within unions, tensions pull members different ways: Is fighting for higher wages more important than increasing safe working conditions? Should we "work to rule" or continue trying to negotiate with management? Should we strike or not? These posters reveal nuanced and sometimes contradictory expressions of strategies, priorities, tactics, and analysis. The posters and placards produced during strikes are often the most forceful and have an immediacy that other media lack.

If we don't act quickly the legacy of labor posters will be lost. In *British Trade Union Posters: An Illustrated History* (1999), author Rodney Mace remarked that "When the research for this book began . . . John Gorman and I expected to find great stores of posters in union offices up and down the country. However, with one or two exceptions, we were to be gravely disappointed." Unfortunately, this has also been the case with our research on American and Canadian posters.

The magnitude of this lack became quickly apparent. In 2003, while a librarian at University of California Berkeley's Institute of Industrial Relations, Lincoln Cushing, one of the authors of this book, received a grant to build a database of American labor graphics. This project surveyed archives, libraries, unions, and other institutions and assembled a preliminary collection-level description of U.S. holdings in the areas of labor posters and graphics. The research revealed that the material had simply not been seriously examined. This book is the manifes-

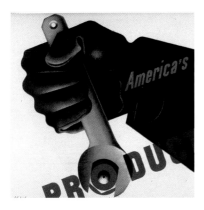

tation of subsequent research by both authors, examining labor posters in both private and public collections. These documents are scattered, usually existing as portions of special collections or larger libraries or archives. Rarely are they digitized or fully catalogued. Consistent and thorough subject headings and naming authorities remain to be developed. The formal collections that do exist represent enormous dedication on the part of archival and library staffs. Each collection, in its own way, contains vital elements of an eventual whole.

The database behind this book consists of nearly 1,000 digitized and catalogued images that allows for multiple methods of organizing, sorting, and analyzing these documents. As a result, we can make an informed assessment of the overall contours of U.S. labor posters. We know that there are many more "out there" than we have identified. Major gaps exist in dates and subjects covered, and in regions represented. Some gaps are explainable—few political posters were produced in this country during the McCarthyist 1950s, for example—but others, such as the relative lack of posters from the southern states, are not.

Posters are a pragmatic art, and generally rely on an interactive relationship among client, designer, artist, copywriter, printer, and distributor. In many cases these roles become compressed into one or two people, but the need for these functions remains the same. The posters in this book can be roughly split into two main types—those formally produced with institutional support, and those informally produced by individuals or small groups. The institutional clients that have been significant in the creation of these images include unions (among the most prominent being the Industrial Workers of the World [IWW], the United Auto Workers [UAW], and the United Farm Workers [UFW]), coalitions of labor unions (the Congress of Industrial Organizations [CIO]), special programs within unions (the Bread and Roses Project of SEIU 1199), labor support organizations (Coalition of Labor Union Women [CLUW], University of California Berkeley's Labor Occupational Health Program, and the Labor Institute), and community-based cultural organizations, most notably the Northland Poster Collective and the JustSeeds Artists' Cooperative.

The artistic contributors include established or famous artists commissioned to design occasional posters on this subject (Ben Shahn, Milton Glaser, Jacob Lawrence) and labor movement artists in other media whose work fits well in a poster context (such as muralist Mike Alewitz, painter Ralph Fasanella, and photographers Earl Dotter and David Bacon). But most labor posters were created by graphic artists specifically for this purpose. Most of these people also make their own linoleum or silk screen prints, some of which are subsequently reproduced in larger editions. Some are prolific and are well known within the labor art community. These

include Ricardo Levins-Morales who founded the Northland Poster Collective, Chicago's Carlos Cortez, and Berkeley's Doug Minkler and Jos Sances. A new generation of artists has been making substantial contributions in the field as well, including Favianna Rodriguez, Nicole Schulman, and Josh MacPhee, to name just a few. The baton has been passed, and labor art continues into the twenty-first century.

Not to be forgotten in this creative cauldron are the movement union print shops that actually put ink on paper (such as Inkworks Press in Berkeley or Salsedo Press in Chicago), the progressive design firms (Public Media Center in San Francisco), and the projects that help market and distribute these works, most notably the Northland Poster Collective, the Bread and Roses Project, Labor Heritage Foundation, and the Syracuse Cultural Workers.

The posters presented here are only a portion of the several thousand we have examined in the course of researching this book. These images drive the text. In many cases, the poster itself is all that exists—with no indication of who designed or produced it; no date, no location, just the poster. We have provided some explanatory historical background, but this is only an initial survey—neither definitive nor comprehensive—that offers a point of departure for further research. Much more remains to be done. Part of our purpose is to indicate the potential for further investigations, not only a more complete survey of the posters, but deeper, more detailed study of specific trends and events and the visual responses to them than we have space for here. For further information about the labor history which gave birth to these posters see the selected bibliography.

The scholarship on labor posters is as uneven as their collecting. Despite the existence of labor images going back to some of the earliest examples of representational art, very little scholarship in this country acknowledges the contribution labor posters have made to our national culture. Other countries, including Germany, the United Kingdom, the Netherlands, and Australia, take this genre more seriously. Foreign scholars have done some of the best writing about our culture, including labor posters. These documents represent the joined periphery of two marginalized communities—the labor movement and the political poster movement—neither of which have enjoyed much institutional support over the years.

We hope the material presented in this book, and the broader catalog of material available through the book's website, www.docspopuli.org, will encourage respect for these posters including the need for further resources in preserving them and making them accessible to scholars.

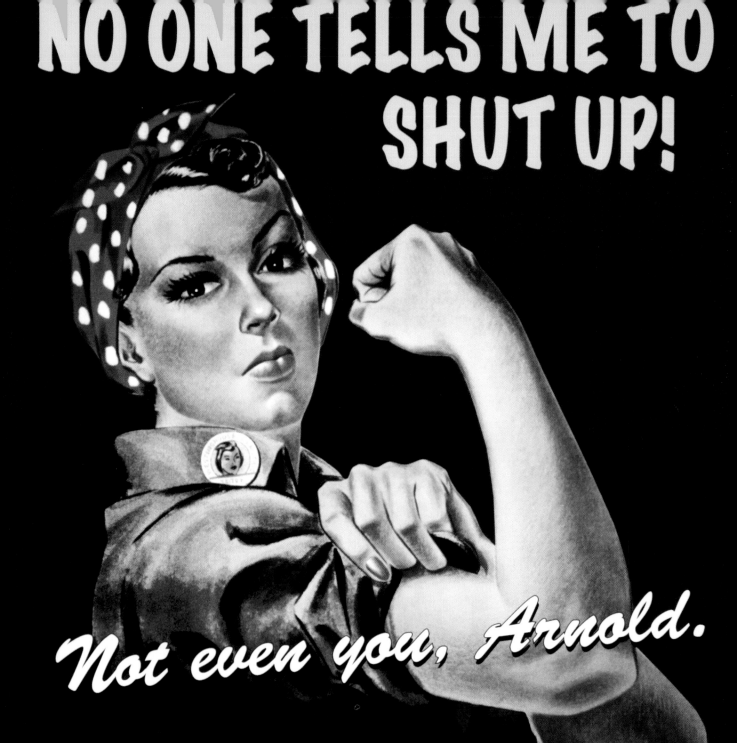

NO ONE TELLS ME TO SHUT UP!

Not even you, Arnold.

NO ON 75 & 76:

They give the Governor the power

A BRIEF HISTORY OF
ACTIVIST GRAPHIC MEDIA

A brief history of activist graphic media provides a useful framework for understanding the posters in this book. Posters are duplicated public documents that usually join powerful images with punchy text. As such, they have enjoyed a special place in the arsenal of those challenging the status quo for over two hundred years. British abolitionist Thomas Clarkson interviewed sailors who had worked on slave ships, and had a diagrammatic image prepared of the *Brookes* with a typical "cargo" of 482 human beings stacked like cordwood (see 5.21 for a later usage of this drawing). It was produced as a poster in 1789 and, when widely distributed to a shocked public, it challenged the pro-slavery propaganda that the transatlantic voyage was comfortable for slaves. The horrible truth was that slaves, as well as common sailors, were brutally mistreated as basic laborers in this industry of extracting human capital to build the new countries in the western hemisphere. Posters are a very democratic medium and have been readily embraced by those concerned with organizing and supporting working people.

The earliest posters were mainly text, because the technology for easily reproducing images had not been developed. However, as technology advanced, designers had more options for imagery and color. The late 1800s saw the transition from illustrations (woodcuts or engravings) to photographs, a shift that dramatically affected coverage of major news events such as the Pullman strike (1894)[1] and the Spanish-American War (1898). No longer could an editor request a certain dramatic (and biased) artistic depiction of an event—now the public had a thirst for the ostensible truth of photography. Newspapers in this period frantically competed to expand circulation, and vibrant full-color images served as an enticement.

Another milestone in poster making came during the Great Depression when the Federal Arts Project of the Works Progress Administration (WPA, 1935–43) hired fine artists to teach the public. These artists discovered that silk screen printing was an inexpensive and accessible form of public expression. The chilling effect of McCarthyism and the cold war severely dampened agitational public poster art, reducing such creativity to limited-edition prints for gallery settings or sharing in private spaces. During the "long 1960s" screen printing was resurrected to become a staple for many activist artists. Emboldened by the rich florescence of rock and counterculture posters, as well as the broader militancy of the civil rights, women's, and antiwar movements, a new generation of labor artists arose.

Labor movements, like many agents of social change, have relied on graphic imagery to "agitate, educate, and organize." Trade union logos display the tools of their trade or symbolic hands clasped in unity. The IWW created the concept of "silent agitators," tiny stickers with images and slogans that could be slapped on time clocks and shop-floor walls to spread the message. Many union halls feature murals that bring history to life and honor labor. And worker-oriented

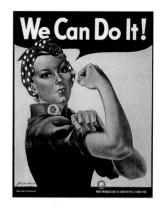

1.01 "We can do it!"
J. Howard Miller,
Westinghouse Corporation,
1942. Offset, 56 x 43.

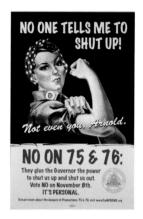

Facing page 1.02 "No one
tells me to shut up!"
artist unknown (after
J. Howard Miller), AFSCME,
2005. Offset, 89 x 58.5.

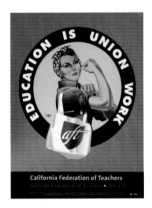
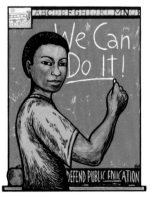

1.03 "Education is union work." John Mattos (after J. Howard Miller), California Federation of Teachers (CFT), 2002. Offset, 41 x 30.5.

1.04 "We can do it! Defend public education." Ricardo Levins-Morales (after J. Howard Miller), Northland Poster Collective, 2004. Offset, 43 x 28 cm.

Below 1.07 Detail of 6.22.

publications have a long tradition of cartoon art, replete with clueless bosses and clever workers. One of the best examples of artistic and political synthesis is the poster.

Late twentieth-century technology such as desktop publishing, digital imaging, the Internet, and inexpensive color duplication have all transformed the methods graphic artists use to express their ideas. But big sheets of paper with a printed message still have a place in this world. A cool YouTube snip will have its moment, but won't replace a poster in a coffee shop window about how employer X is unfair because of Y reasons.

The best graphic images have an immediate impact on the viewer and stay in his or her mind long after the poster itself is no longer visible. The very best of these, such as Rosie the Riveter, "We Can Do It!", a wrench on a giant gear, or a woman at a sewing machine, pass into a special realm of images that achieve symbolic status and come to represent trades, industries, and even entire groups of people. A few examples of these labor images that have been appropriated for other, usually commercial, ends ("repurposed"), will help set the stage for the posters that follow. Probably the most iconic images are "We can do it!"[2] and Rosie the Riveter (1.01–1.05, and see chapter 4 for more recent uses of the Rosie image). Other images too have become iconic in the graphic labor lexicon. Depictions of the tools and dress of specific occupations and broader job classifications ("blue collar," "white collar," etc.) are essential clues regarding a poster's message. Hard hats, lunch pails, tool belts, hammers, and computer keyboards all provide unambiguous clues that these posters are about *working people.* This extends to images of the workplace itself, such as smokestacks, cranes, and "saw-tooth" factory roofs. In some cases, the simple presence of hands honors the key component of

manual labor. Labor rolls up its sleeves and gets to work. In figure 1.06 the person holds a pipe wrench, symbolic of blue collar work but also of militant sabotage. In the second image we see the wearers of a straw hat, longshore cap, and hard hat all marching together (1.07). This iconography has become more difficult to create for the burgeoning service trades sector.

Iconic images symbolize more than just the craft. They also represent the role of working people in our society's smooth functioning, the human beings, often humbly behind the scenes, who deserve more recognition (1.08–1.09). Note that the second set of gears is only symbolic (the teeth do not mesh and they do not represent actual machinery), but typify illustrations by well-meaning graphic artists unfamiliar with the trades. The various incarnations of the upraised fist[3] either by itself in militant salute or combined with tool in hand, symbolize the mili-

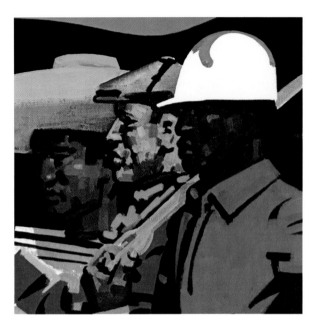

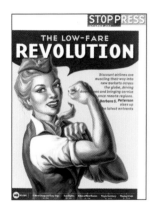

1.05 "The low fare revolution." Artist unknown (after J. Howard Miller), Southwest Airlines, 2004. Offset (magazine), 28 x 21.5.

1.06 "We can do it!" Artist unknown (after J. Howard Miller), unspecified New Zealand anarchist group, 2001. Electronic (website).

Below 1.08 Detail of 6.13

tancy of the labor movement while the image of clasped hands is used again and again to represent mobilization and unity (1.10–1.13).

Modern labor graphics make retro references by incorporating design elements borrowed from earlier labor posters. Such changes of older designs build on historical memory to effectively drive the point home. The classic IWW image of a militant worker from the 1913 Paterson, New Jersey, strike, rendered for a program cover at Carnegie Hall, is one example (1.14). It has been recycled into contemporary murals and posters (see 3.10), and made into a 2001 web graphic for the United Electrical, Radio & Machine Workers of America union (UE) (1.15).

In 2002 the Coalition of Immokalee Workers (CIW) used an old IWW graphic (the example here was published in 1960, but originally created much earlier) to support its own call to boycott Taco Bell (1.16–1.17). The spirit of the two campaigns was similar and the alterations made to the original graphic were few. The IWW demands were removed merely by cutting off the right hand portion of the original image. Where the original figure hammered a nail into a poster, in the 2002 version he hammered/rang a brightly colored reproduction of the Taco Bell logo. The lettering on his shirt has been altered, almost indistinguishably, from "I.W.W." to "C.I.W." Interestingly, perhaps in the spirit of labor solidarity, the recent version has kept the artist's signature, "ManX," as if he were still at work and supporting the Immokalee workers, as he once used his art to support the IWW.

Sometimes this approach of reusing earlier imagery betrays a lack of new ideas. On one level, such imagistic references are saying it would be better to go back to the era where the worker *was* bold and took action. Modern labor might want to make that claim but it is hard to do

when using a dated image. Presenting labor as antique also presents labor as antiquated, so efforts have recently been made to develop more contemporary imagery. In 2007, a joint project of JustSeeds, the Service Employees International Union (SEIU) 1199's Bread and Roses Project, and the Workforce Development Institute put out a call for new poster art—"Graphic Work: Imaging Today's Labor Movement"—that resulted in forty fresh images of the contemporary labor movement (see 6.16 and 7.05). Sometimes, well-known images or phrases are invoked, but "turned" to produce a new meaning—a "detournment." Using the original provides familiarity, and changing its meaning gives the new use punch. In addition to examples cited in this book (for example, 3.20, "Sun Mad Raisins;" 2.14, Campbell's Soup; and 6.11, Lipton Tea), billboard corrections are among the leading examples of this technique—they depend on subverting the advertise-

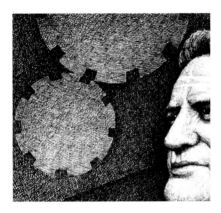 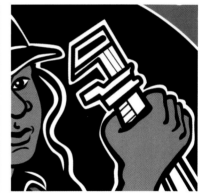

ments' original meanings so that the ads shoot themselves in the foot. The Canadian magazine *Adbusters* regularly publishes examples from the world of advertising and its radicalized offspring, known as "subvertisements."

In some cases, image appropriation does not show the faintest remnant of the continuity of labor's struggle, but rather offers a stark reversal of the original intent. This is most obvious when a labor-related image, such as Rosie the Riveter, is twisted into promoting a commercial product. In the mid 1980s, the corporate clothing chain Gap stapled an ad tag to a line of blue jeans (1.18). Jean Carlu's 1942 war production poster—from which the later Gap ad was taken—claims that labor, represented by the gloved hand of the worker turning a nut with a wrench, is "America's answer!" (1.19) In contrast, the Gap ad tag replaced the patriotic slogan with "Gap Traditional," a clever, iconic illustration of how domestic production after World War II shifted the country's priorities from nationalism toward consumerism. Because it is reminiscent of the Carlu image, this claim invokes a tradition of which Gap was not a part, and furthermore substitutes a private company in place of the United States. In addition, a 1962 Cuban example uses the Carlu image to promote production (1.20).

Similarly, the characteristics that make Rockwell Kent's mid-1930s illustration of machinists effective are what attracted the artist stuck with trying to make a mid-1980s pizza restaurant attractive (1.21–1.22). Both subjects apparently demanded association with the dynamic strength captured in the stances of the two workers. The differences, however, are telling. Kent's workers are set against a background of gears and industrial windows. One man overlooks machinery, the other has his hands on a valve wheel. In the restaurant advertisement, the only thing in the black and white background is a part of a sun

in the upper left hand corner. The two cooks are standing on what looks like a patio deck, and everything is enclosed within a vertical ellipse with decorations on each side, something like a Chrysler logo. The advertisement is also a further mishmash in that the product is "New" and "Sunshine" but the restaurant is quaintly labeled as a *"ristorante."* The advertisement does not pretend to do anything but inject as many details favorably associated with pizza as possible.

Of course, the hand/wrench/nut and human figure/gears images also remind us of earlier photographic images associated with photographer Lewis Hine and film star Charlie Chaplin. One can't think of gears without those icons springing to mind. Hine's version was a bent-over worker wrenching a massive nut. Chaplin literalized the metaphorical gobbling up of workers by machines in depicting a worker being chewed up by massive gear wheels in the film *Modern Times*. Chaplin the worker rides through the machine, rotating through a series of human-scale gears with huge teeth.

Designers of community murals and labor posters share similar motivations, at least where the murals deal with labor, because they work from similar political stances. Posters derived from murals have taken two forms. During the 1970s some posters were produced from mural details. By the 1980s another approach emerged and has continued to dominate since that time; posters used a photograph of the entire mural, basically celebrating the mural rather than specific details of it, and repurposing the imagery. Muralists came to believe that such posters gave their work publicity, established their reputations, and helped secure financial support for future projects.

A major exception here is the work of Mike Alewitz, who works in both media, primarily on labor-related

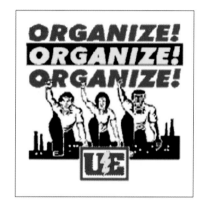

themes. He has designed murals so that they will function effectively as posters, as well as larger, wall-sized works. In addition, he has designed posters, several examples of which are in this book.

Studies of labor history and those about oppositional visual culture have followed different paths in the United States, often completely divorced, but they do shed light on each other. Obviously, labor posters draw on the same events and issues that labor history does, and comprise an important part of labor history. With this book we try to bring these two aspects of U.S. history together.

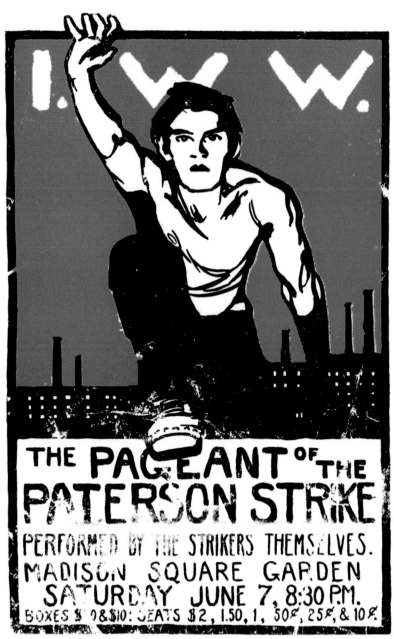

Facing page 1.09 Detail from "In our hands is placed a power . . ." (poster series). International Association of Machinists (IAM), 1980s; 1.10 Detail of 4.12; 1.11 Detail of 7.05.

Above 1.12 Image from *Report of Proceedings of the Eighteenth Annual Convention of the American Federation of Labor*, 1898; 1.13 Detail of 7.07; 1.15 "Organize! Organize! Organize!" Artist unknown (after Robert Edmond Jones), UE, 2002. Electronic (website).

Right 1.14 "I.W.W.: The Pageant of the Paterson Strike." ROBERT EDMOND JONES (Paterson Pageant committee), 1913. Lithograph, 18.5 x 14 cm.

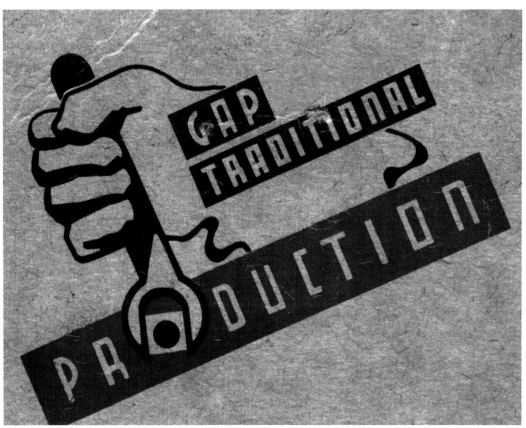

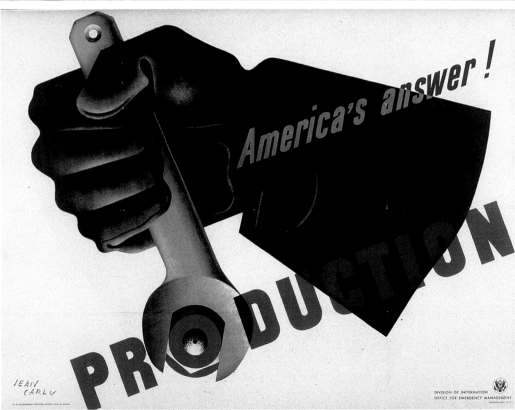

1.18 "Gap Traditional" (jeans tag). Jean Carlu derivative, designer unknown, Gap Incorporated, circa 1985. Offset, 4.5 x 6 cm.

1.19 "America's answer! Production!" JEAN CARLU, Office for Emergency Management, Information Division, 1942. Lithograph, 76 x 101 cm.

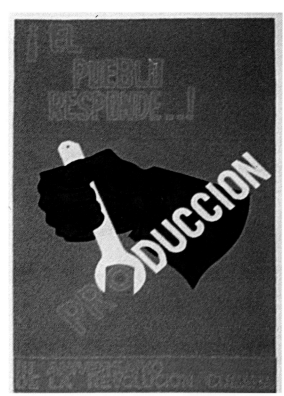

1.20 *"¡El pueblo responde . . . !
Produccion."* Jean Carlu derivative,
designer unknown, Editora Politica
(Havana, Cuba), 1962. Screenprint.

1.21 "Industry's wheels . . ." (*Fortune*
magazine advertisement), Rockwell
Kent, Commercial Bank and Trust
Company of New York, 1934. Offset
(magazine), approx. 14 x 20 cm.

1.22 "New Sunshine Pizza" Rockwell
Kent derivative, designer unknown,
New Sunshine Pizza Company, 1984.
Offset (newspaper), 10 x 8 cm.

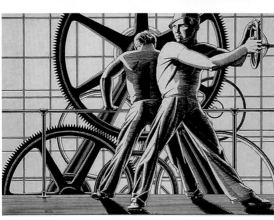

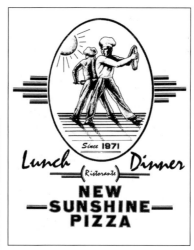

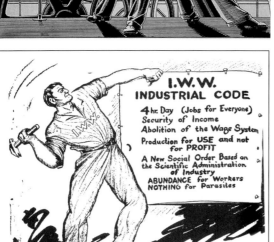

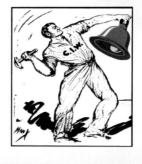

1.16 "I.W.W. Industrial
Code" ManX, IWW, circa
1920–1930. Offset.

1.17 "Let freedom ring . . .
Boycott the Bell!" (Taco
Bell). Art by ManX, de-
signer unknown, Coalition
of Immokalee Workers,
circa 2001. Offset, 43 x
28 cm.

IF YOU LIKED SCHOOL...

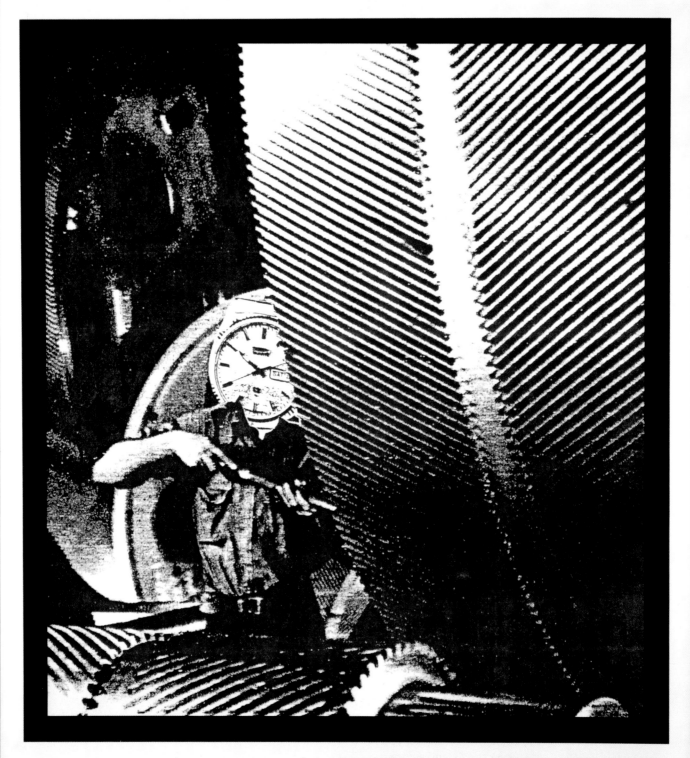

...YOU'LL LOVE WORK

WORK: A PRISON OF MEASURED TIME

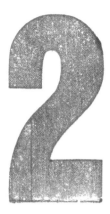

DIGNITY AND EXPLOITATION

More posters have been produced about employees not being given their fair share and suffering loss of dignity than any other category except the theme of strikes and other labor actions. All of us want to be "whole" human beings, treated with respect and in charge of our lives and work. We want to produce for the mutual benefit of ourselves and others. But too often workers give that up when they walk through the shop gate or the office door. When working people feel the loss of control over what they produce, how they produce, the materials they use, how they may relate to fellow workers, and even how they view themselves, they feel alienated—they want to be treated decently.

From the employers' point of view, such issues are often irrelevant. The primary goals of a corporation are financial solvency, market survival, and cost efficiency. Basic profitability goals require that they make more in sales from a worker's efforts than they pay that worker (a relationship referred to by some economists as exploitation). When workers don't get their fair share or aren't treated decently, they sometimes "suck it up" and remain isolated, suffering the hidden injuries of class—but that response doesn't produce stunning graphics. When they join together, a collective voice is recognized. They form unions and turn from blaming themselves to blaming first bosses, and then, sometimes, capitalism itself. The motivations for joining a union are psychological (alienation and lack of respect), physical (dangerous work conditions), and financial (pay and benefits), among others. Over time, understanding that we as workers are all in this together can lead to a growing awareness of socio-political class. The posters in this chapter represent this by moving from individual psychological concern for lack of decent treatment at work, through stages involving increasing numbers of co-workers, to a projected realization that collectively, we have enormous power.

This progression from individual experiences to larger social categories (including issues in surrounding communities as well as at the workplace) has been recognized by poster makers at every level, from individual and independent, to unions, to the government itself. Many posters discuss nonmaterial aspects of labor, including one created during the Great Depression, when the WPA issued "Work promotes confidence," featuring a strong, dignified workingman (2.01).[1] Understanding how people lost confidence during the 1930s is easy, but the poster is ambiguous about whether the confidence was in oneself, in the country, or the government— probably all three. While confidence is not necessarily the same thing as dignity, the illustration is certainly of a dignified worker. Forty years later, the UFW issued a linoleum-print poster by San Diego–area artist Domingo Ulloa of farm workers performing stoop labor, watched over by a foreman, with a prayer asking not for commodities, but simply for food and shelter and a decent life (2.02):

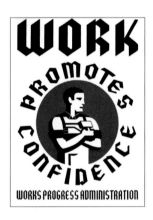

Above 2.01 "Work promotes confidence." Artist unknown, New York: Federal Art Project, circa 1937. Screenprint.

Facing page 2.05 "If you liked school…You'll love work." Artist unknown, client unknown, circa 1972 [?] Offset, 48 x 35.5 cm.

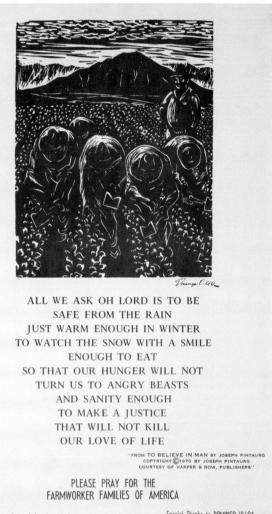

ALL WE ASK OH LORD IS TO BE
SAFE FROM THE RAIN
JUST WARM ENOUGH IN WINTER
TO WATCH THE SNOW WITH A SMILE
ENOUGH TO EAT
SO THAT OUR HUNGER WILL NOT
TURN US TO ANGRY BEASTS
AND SANITY ENOUGH
TO MAKE A JUSTICE
THAT WILL NOT KILL
OUR LOVE OF LIFE

"FROM TO BELIEVE IN MAN BY JOSEPH PINTAURO
COPYRIGHT Ⓒ 1970 BY JOSEPH PINTAURO
COURTESY OF HARPER & ROW, PUBLISHERS"

PLEASE PRAY FOR THE
FARMWORKER FAMILIES OF AMERICA

United Farmworkers of America
P.O. Box 62, Keene, CA 93531

Special Thanks to DOMINGO ULLOA
and JOSEPH PINTAURO

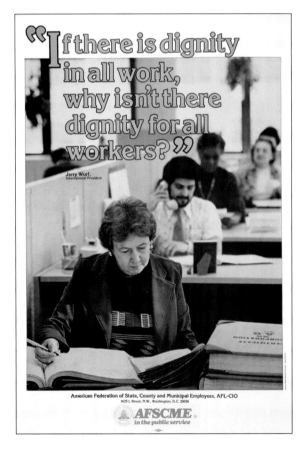

2.02 "Please pray for the farmworker families
of America." DOMINGO ULLOA, UFWA, circa 1976.
Offset, 57.5 x 36 cm.

2.03 "If there is dignity in all work, why isn't
there dignity for all workers?" Photograph by
MIKE MITCHELL, designed by SABINA PARKS;
AFSCME, circa 1980s. Offset, 51 x 35.5 cm.

2.04 "UC employees deserve respect!" Designer
unknown, University Professional and Techni-
cal Employees Communications Workers of
America (UPTE/CWA) Local 9119, circa 2001.
Offset, 61 x 46 cm.

All we ask oh lord is to be
Safe from the rain
Just warm enough in winter
To watch the snow with a smile
Enough to eat
So that our hunger will not
Turn us to angry beasts
And sanity enough
To make a justice
That will not kill
Our love of life

The UFW, perhaps more than any other poster-producing union besides the IWW, has always sought to integrate work and quality of life.

A few posters seek to articulate workers' need for dignity directly, which can only be achieved if the nature of their work is worthy of respect. An American Federation of State, County, and Municipal Employees (AFSCME) poster asks the simple question, "If there is dignity in all work, why isn't there dignity for all workers?" (2.03). A strike placard from the University Professional and Technical Employees Communications Workers of America local 9199 AFL-CIO (UPTE) at the University of California declares: "UC employees deserve respect!" (2.04)

Another subject featured in many posters is alienation. An unattributed poster literalizes the analysis of alienation at work by pointing out the similarities with the school day: "If you liked school . . . you'll love work. Work: A prison of measured time" (2.05, p. 12). San Francisco Bay Area teacher, union activist, and artist Bruce Kaiper produced several posters focusing on the alienation of an employee losing control over his or her time during production. In a 1974 poster of "Our dreams and realities," he

shows a young woman office worker at her desk dreaming of a happy childhood, adolescence, a college education, motherhood, and finally, at the end of the day as she stares exhausted at a growing pile of work in front of her, fighting with her husband (2.06). Her life struggles are mirrored in her work day. Kaiper followed this with a poster showing a young office worker transforming into a rubber stamp that says, "I object" (2.07). This can be read two ways, one as her objecting to how she is treated at work, but also as her seeing herself as an object. The text reads in part, "The more I work, the more boring and repetitious the job becomes. I can't make any decisions concerning the work I do . . . My superior . . . treats me like a THING!" The visual transformation reflects the psychological transformation, and Kaiper helpfully adds a definition of "alienation" at the bottom: "Work is viewed as an item to be bought and sold—A commodity. Our work becomes inhuman; a thing to be manipulated by our employer." His poster on surplus value illustrates the same idea, a large clock face within which is a multi-armed worker whose output is constantly measured against the clock (2.08). Workers are alienated because they usually lack control over the most basic features of their working lives—what they do, how they do it, and how long they do it for. But employers do not alienate workers out of sheer malice. It is simply a byproduct of the profits derived from exploitation. Other posters cite different ways of alienating working people, such as electronic eavesdropping, urine tests, and computers counting keystrokes.

A few posters move beyond specific abuses to a higher level of economic analysis such as the "Guess who pockets the difference?" poster by the Los Angeles collective project Common Threads (2.09). (By using the word "guess," but not the brand name "Guess Jeans," this clev-

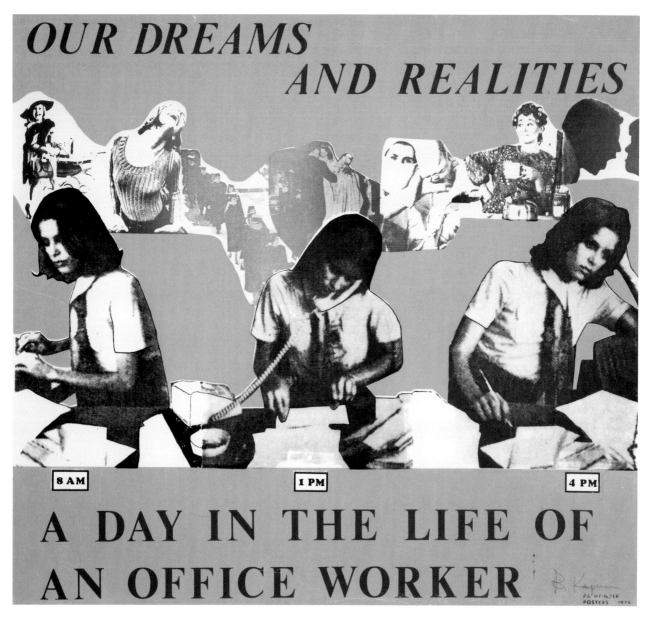

OUR DREAMS AND REALITIES

A DAY IN THE LIFE OF AN OFFICE WORKER

er title does not necessarily allude to a specific manufacturer directly, but the poster gains impact from the verbal connection at the same time that it indicts all sweatshop labor.) It juxtaposes the image of a blue jeans seamstress labeled "$3.50 an hour" with a topless, sexy, blue jeans–wearing man, fly half undone, labeled "$75 a pair." The poster's power derives from its horizontal design creating a left-to-right movement from worker's salary to product price, the starkness of the black and white format emphasizing the vast financial divide between the seamstress's pay and the retail jean's price. Another poster about Guess jeans (not shown) states "Nobody should be a slave to fashion," while an obviously suspicious modern

seamstress looks up from her sewing machine. This photograph inverts the metaphorical title of the poster into a literal reality for exploited "wage slaves." (For a similar example, see 4.11.)

Sometimes, exploitation and loss of dignity are most apparent at the beginning and end of the employment spectrum, concerning child labor, retirement, or looming unemployment. Bay Area printmaker Jos Sances's 1990 poster for the Fremont Unified School District Teachers Association points out the disparity between a teacher's three decades of service and a retirement without "Social Security, Medicare, employer pension . . ." just "a monthly state pension [that] could not cover the cost of even one

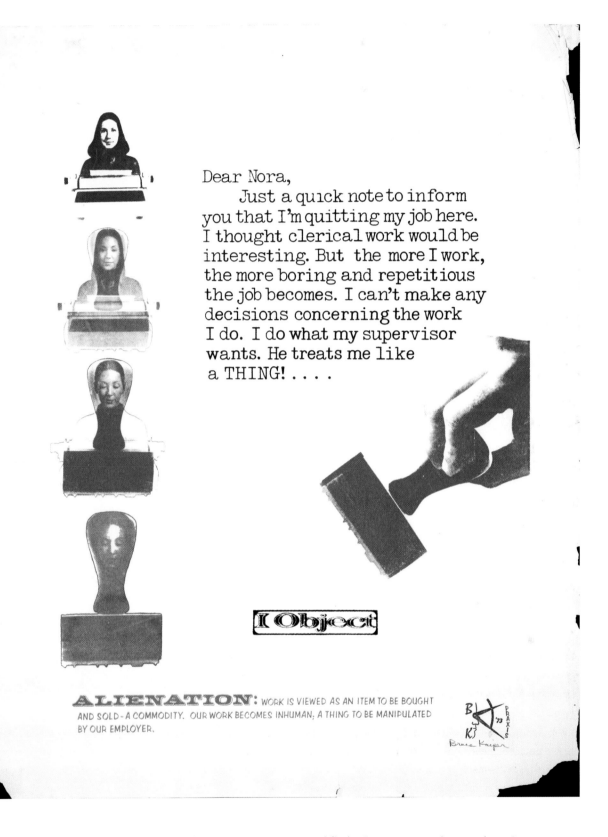

Dear Nora,

Just a quick note to inform you that I'm quitting my job here. I thought clerical work would be interesting. But the more I work, the more boring and repetitious the job becomes. I can't make any decisions concerning the work I do. I do what my supervisor wants. He treats me like a THING!

I Object

ALIENATION: WORK IS VIEWED AS AN ITEM TO BE BOUGHT AND SOLD - A COMMODITY. OUR WORK BECOMES INHUMAN; A THING TO BE MANIPULATED BY OUR EMPLOYER.

Facing page 2.06 "Our dreams and realities." BRUCE KAIPER, Pathfinder Posters, 1974. Screenprint, 58.5 x 51 cm.

Above 2.07 "I object." BRUCE KAIPER, Praxis Posters, 1973. Screenprint, 76 x 58.5 cm.

day in the hospital" (2.10). The formal juxtaposition between the black border, the content of the text, and the brilliantly executed (twenty-four silk screen passes) pastel illustration of the teacher sitting at her table with a cup of coffee is striking. She has been exploited, and now can be discarded. Figure 2.11, "32 years seniority at Wagram," from the important J. P. Stevens campaign, makes the same point. A huge southern textile manufacturer, J. P. Stevens has been periodically targeted by union organizers since the 1930s, charged with poor treatment of workers and anti-union tactics.[2] In the 1960s, J. P. Stevens was part of the three great boycott efforts led by the New Left (grapes and Coors beer were the others), and an example of how labor and social justice issues were brought together.

A CIO poster from the 1940s or 1950s, "Too old to work. Too young to die," calls for pensions, a topic that is also on the early twenty-first century agenda as employers try to escape funding them (2.12). At the other end of the age spectrum, a UFW poster seeks to "Stop child labor," making exploited underage workers visible to the public in order to gain support for the union's efforts (2.13).

In the same spirit, "Boycott Campbell's in support of midwestern farm workers" is a detournment of Andy Warhol's screen print of a Campbell's Soup can (2.14). Warhol simply reproduced the label design and then offered to sell his art object (another consumer product) to art collectors—reiterating the goal of the original product to sell soup to consumers. The artist here, however, made strategic alterations to drive his point home: "Condensed" is changed to "Condemned," and "Cream of Mushroom" is changed to "Cream of Exploitation," calling attention to the exploited workers behind the world-famous label. An advertising scrap on the upper left adds: "Good idea" to further reinforce the point. The poster's impact increases

from its identification with both Warhol's art and the ubiquitous soup label.

Adding a touch of humor to the physically harmful rigors of rote work, the IWW produced "Speedups cause breakdowns . . ." which could easily been placed in chapter 3 on health and safety (2.15). It is used here to make the point that speedups cause not only physical health problems, but on another level exemplify alienation brought about by exploitative working conditions, that is, the hidden injuries of class sometimes become visible. The poster is deliberately ambiguous. The IWW black cat adds a comment to the title, subtly suggesting that instead of a worker breakdown, the speedup could be the cause of a worker-initiated production breakdown, which would give the worker a real break from the alienating, monotonous assembly line. She wants to work at her own pace, one that will not cause her to break down, and worker-initiated sabotage might be a way, if not to work at her own pace, then at least not to have to work at the alienating pace determined by the company.

Automation raises similar issues. A UAW poster draws a larger lesson from the often undignified effects of mechanization on human employees (2.16). People want respect and dignity. Machines don't care. Automation (the introduction of supposedly labor-saving machinery into production) has been a focal point of class struggle since the dawn of the Industrial Revolution. The Luddites of early nineteenth-century England defended their skilled craft livelihood against a systematic attack by commercial interests that had no long-term concern for the workers or their community. Figure 2.17, "Fight automation fallout with fewer hours of work and no loss in pay," probably from the late 1950s, shows a robot pushing workers over the edge, a literal depiction of the psychological metaphor. In

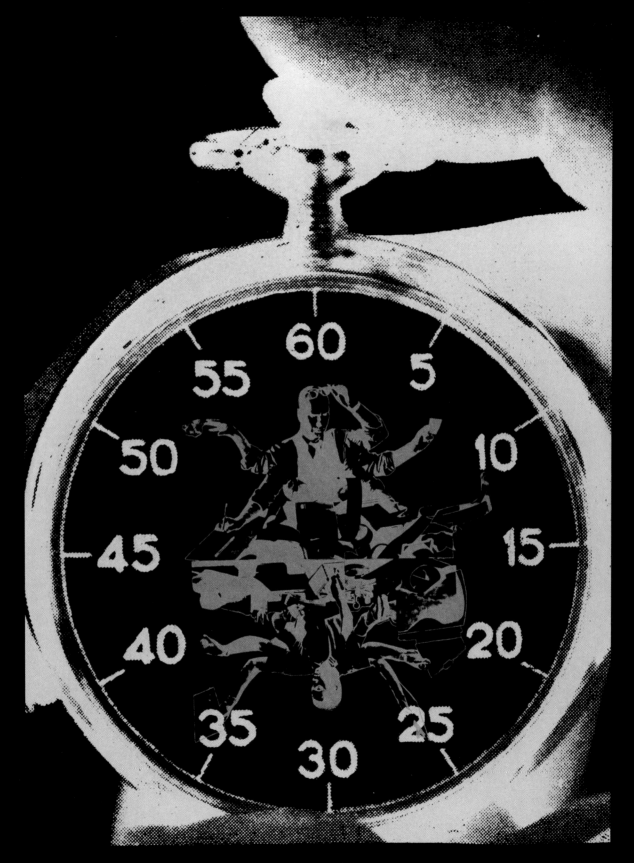

SURPLUS VALUE: IN SPEEDING UP OUR WORK WHILE PAYING US THE SAME HOURLY WAGE, OUR EMPLOYER GETS ADDITIONAL OUTPUT AND MONEY TO USE AT OUR EXPENSE.

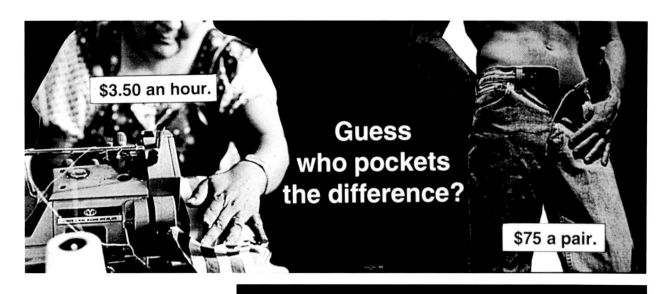

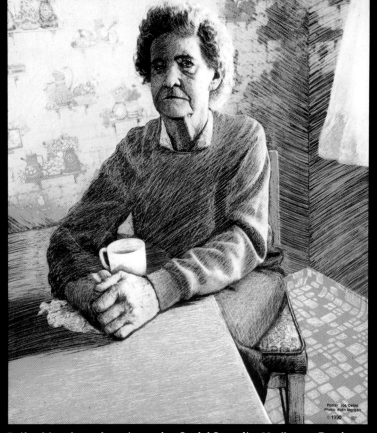

2.09 "Guess who pockets the difference?" Common Threads Artist Group (Los Angeles), 1995. Offset, 28 x 71 cm.

2.10 "After 30 years of teaching, is this her reward?" Jos SANCES, from a photograph by Ruth Morgan; California Teachers Association (CTA), 1990. Offset, 57 x 43 cm.

another version of the same poster, the second part of the slogan was replaced by "With a shorter work week," and in yet another, by "With reduced work time." Workers wanted to realize the promises of increasingly sophisticated machines with less stress and more free time. Bosses wanted to increase productivity. The bosses won.

The "us" and "them" analysis is as old as struggle itself. Sometimes that struggle is expressed as Democrats versus Republicans. An 1896 engraving shows "The Republican Party protecting the workingman" by squashing him flatter than a pancake (2.18). In a 1970s poster, Chicago-area Chicano IWW artist Carlos Cortez similarly observed, "There's so few of him and so many of us!" in his depiction of the employer-employee relationship (2.19). The (literal) fat cat boss here has all the milk. These images connect exploitation with class interests, and imply the need for collective representation. Ricardo Levins Morales, a silk screen artist and illustrator who founded the Northland Poster Collective, is more direct about the threat that unions pose to bosses with his "Bosses beware" poster (2.20).

Unions frequently invoke the ideas seen in the posters in this chapter, but since early unions were not as demographically representative as they were later to become, their subtexts are sometimes shocking to us today. A 1901 example shows a worker rolling up his shirtsleeves with the caption "Union labor: The bone and sinew of America" (2.21). The figure is a union member, dignified and poised. This poster, however, goes on to identify it as produced by "makers of 'Union Label' clothing," which at that time meant that no Chinese were allowed to work on these products, and it was rare that anyone other than whites was allowed to join any union. On the whole, unions have learned from the past, and sought to reform their racism

and sexism (although these battles continue to be fought today in union halls and beyond).

The UFW has been so strong in its cultural effort to inform its constituents and organize their support for the union that its symbol, an angular black eagle on a red background, has become a cultural symbol for Chicanos (Mexican Americans) in general. For Chicanos, joining or supporting the union was a natural part of community membership. Almost everyone in the Chicano community old enough to remember the grape boycott and formation of the union in the mid-1960s and 1970s, or who has worked in the fields, identifies with the union's efforts as a symbol of community struggles for dignity, respect, and decent labor conditions. The UFW eagle icon may remind union members of Mexican descent of the eagle on the national flag, but this icon has the broader function of inspiring workers with roots in many different countries. One such significant constituency is Filipino-Americans, whose Agricultural Workers Organizing Committee merged with Cesar Chavez's National Farm Workers Association in 1966. Richard Correll's elegant woodcuts and linoleum prints make this point with exquisite deftness. His 1970 work, "Vineyard march," depicts a line of UFW marchers beneath the multiple banners of the Virgin of Guadalupe (a Catholic saint, and effectively the patron saint of activism), the United States, and the UFW (2.22). In the foreground are grape vines, which Correll draws to mimic the shape of the marchers, giving the vines a dynamic aspect and the marchers a relationship to the land and its strength. It is a brilliant piece. Another UFW poster, figure 2.23, shows a single farm worker, with recently picked fruit in hand and a bag emblazoned with UFW by his side. As in Correll's design, the formal elegance expresses the worker's dignity. The text reads: "I am somebody. Together

TOO OLD TO WORK

TOO YOUNG TO DIE

PENSIONS NOW

CIO DEPT. OF EDUCATION AND RESEARCH

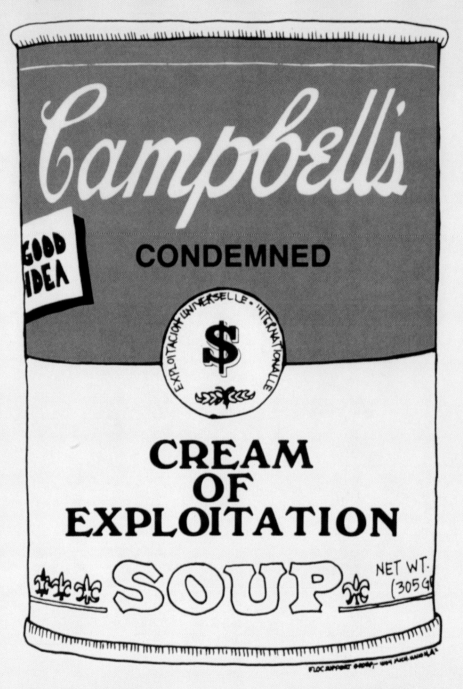

FLOC, 714½ South St. Clair Street, Toledo, OH 43609; (419) 243-3456.

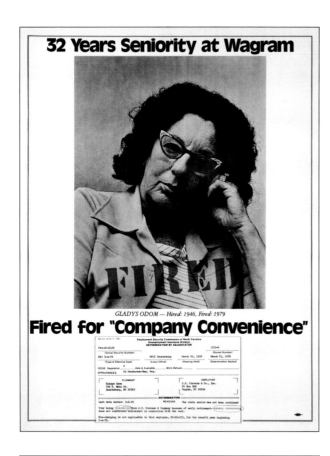

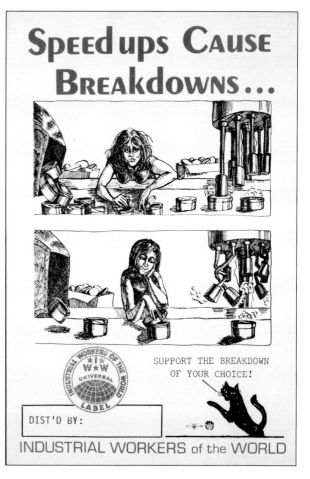

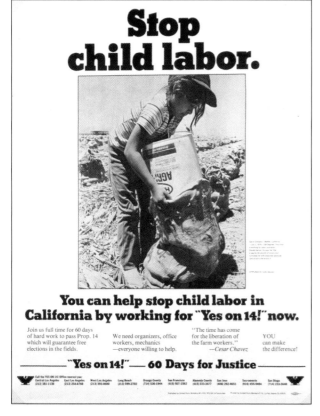

2.11 "Fired: 32 years seniority at Wagram." Artist unknown, Amalgamated Clothing and Textile Workers Union (ACTWU), 1979. Offset, 57 x 44 cm.

2.13 "Stop child labor: You can help stop child labor in California by working for 'Yes on 14' now." Artist unknown, UFW, 1976. Offset, 57 x 44.5 cm.

2.15 "Speedups cause breakdowns . . . Support the breakdown of your choice!" LESLIE FISH, IWW, circa 1975. Offset, 43 x 28 cm.

Facing page 2.17 "Fight automation fallout with fewer hours of work and no loss in pay." Artist unknown, UAW Education Department [?], circa 1950s. Screenprint, 70 x 56 cm.

Previous spread 2.12 "Pensions now: Too old to work, too young to die." Artist unknown, CIO Department of Education and Research, circa 1950s. Screenprint, 96.5 x 63.5 cm.

2.14 "Boycott Campbell's Condemned Cream of Exploitation Soup." Artist unknown, FLOC Support Group, 1984. Screenprint, 40.5 x 29.5 cm.

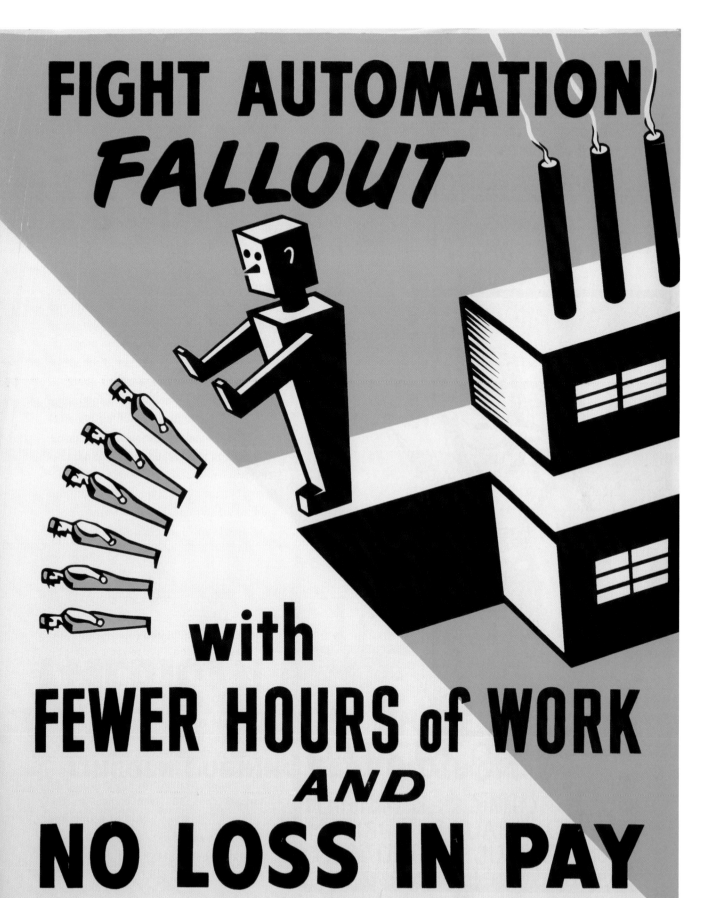

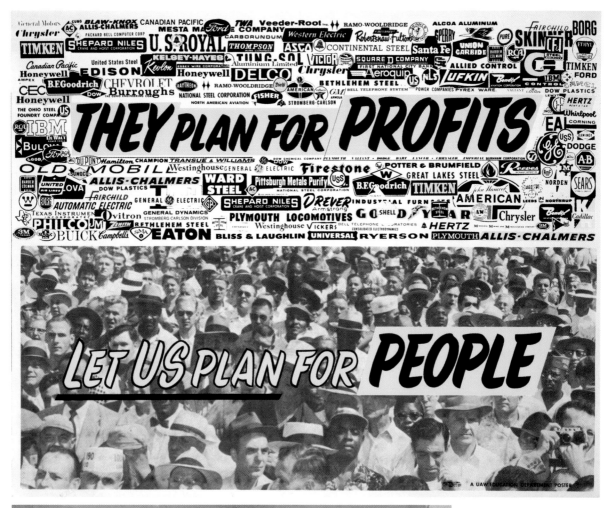

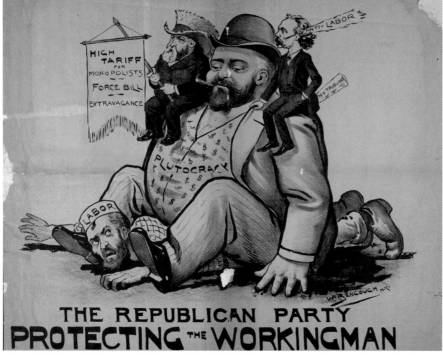

2.16 "They plan for profits:
Let us plan for people."
Artist unknown, UAW Edu-
cation Department, circa
1950s [?]. Screenprint,
56.5 x 69 cm.

2.18 "The Republican Par-
ty protecting the working-
man." WILLIAM BENGOUGH
[?], client unknown, 1896
[?]. Lithograph, 61 x 76 cm.

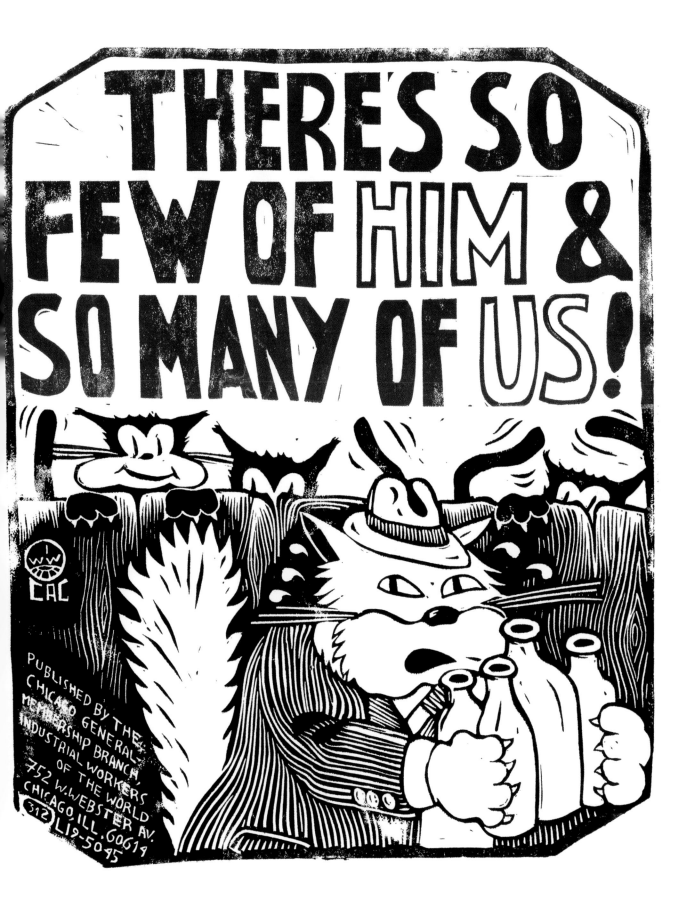

2.19 "There's so few of him and so many of us!" Carlos Cortez, IWW, circa 1985. Linocut, 57 x 44.5 cm.

© 1994 Ricardo Levins Morales Northland Poster Collective Minneapolis, MN (800) 627-3082 www.northlandposter.com P667

2.20 "Bosses beware." RICARDO LEVINS-MORALES, Northland Poster Collective, 1994. Offset, 43 x 23 cm.

Facing page 2.21 "Union labor: The bone and sinew of America." URQUHART WILCOX, Harry J. Buck and Co. (Buffalo, NY), 1901. Lithograph, 94 x 61 cm.

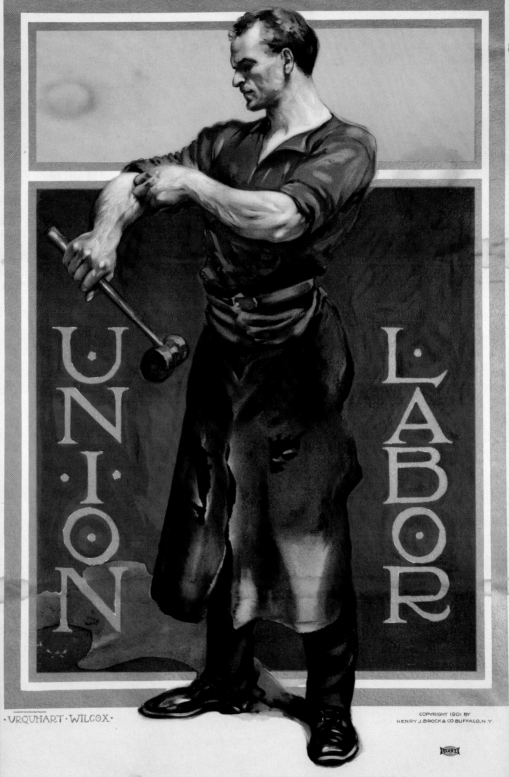

UNION · LABOR

COPYRIGHT 1901 BY
HENRY J. BROCK & CO. BUFFALO, N.Y.

THE BONE AND SINEW OF AMERICA.

Compliments of Henry J. Brock & Co.

MAKERS OF "**UNION LABEL**" CLOTHING.
BUFFALO, N.Y.

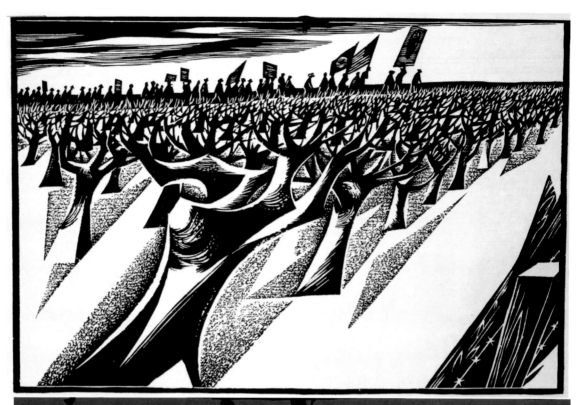

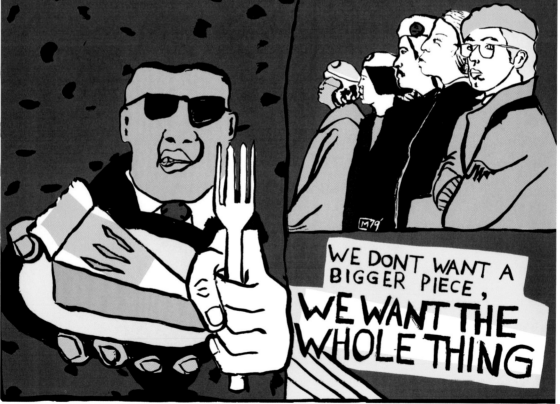

2.22 "Vineyard march." RICHARD V. CORRELL, client unknown, circa 1970. Offset, 43 x 56 cm.

2.26 "We don't want a bigger piece, we want the whole thing." DOUG MINKLER, self-published, 1983. Screenprint, 29.5 x 40 cm.

2.23 "I am somebody: Together we are strong." C.R.S. (initials on poster, artist name unknown), UFWA, circa 1977. Screenprint, 57 x 44 cm.

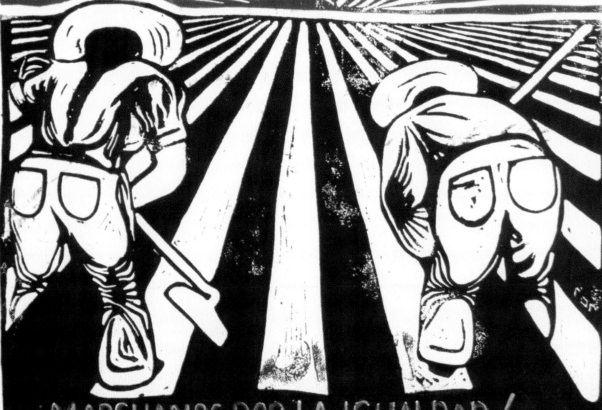

we are strong," a perfect articulation of the combination of dignity and collectivity the UFW has always sought to represent.

Carlos Cortez's "*Justicia para los campesinos!*" (Justice for farm workers), with a subtitle of "*Marchamos por la igualdad*" (We march for equality) stresses equality and justice, not even mentioning the back-breaking nature of stoop labor or the low wages paid to field hands (2.24). In the poster, the outline of Texas and the Texas Farm Workers Union (TFWU) logo are superimposed on a mighty tree at the end of long rows of vegetables. The sun of a new day rises around the tree and logo, which visually represents the hopefulness embodied in the union.

Some posters reflect an astute awareness of the class structure of U.S. society. An early labor poster offers a wedding cake–like design of the "Pyramid of the capitalist system" (2.25). This is a frequent motif in labor posters, especially in the early twentieth century. It is used to show the unfair burdens borne by workers in supporting the disproportionately consuming ruling classes. Continuing the dessert metaphor, San Francisco–area screen printer Doug Minkler's 1983 design offers a more radical message, saying "We don't want a bigger piece, WE WANT THE WHOLE THING" (2.26).

Sometimes posters, like the previous two, encourage workers to recognize that their labor is part of a larger system. Awareness of contexts extending beyond the workplace can be seen in living wage demands and in the structure of capitalism designs. Such awareness also raises questions about the social safety net. Who is responsible for providing it? Individual employees, employers, or the broader society through taxes and legislation? A radical political answer is expressed in a poster noting that "Our labor creates all wealth," with an illustration of a family, disabled citizens, railroad workers, office workers, taxi drivers, teachers, telephone operators, industrial workers, and a waitress, demonstrating that wages affect everyone (2.27). Making the same point in class terms, Carlos Cortez's poster, "It's all ours! With the general strike for industrial freedom," shows a hand in a business suit giving the keys of society to the workers (2.28).

The desire to be treated decently and fairly has led workers to band together in their struggle for justice, addressing first the concerns of individual workers and then taking on industry practices as a whole. Labor posters reflect this, but are also created to address more specific issues, as the following chapters will demonstrate.

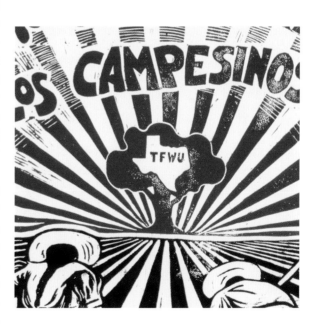

Facing page 2.24 *"Justicia para los campesinos."* Carlos Cortez, Chicago Texas Farm Workers' Union Support Committee, 1979. Linocut, 66 x 46 cm.

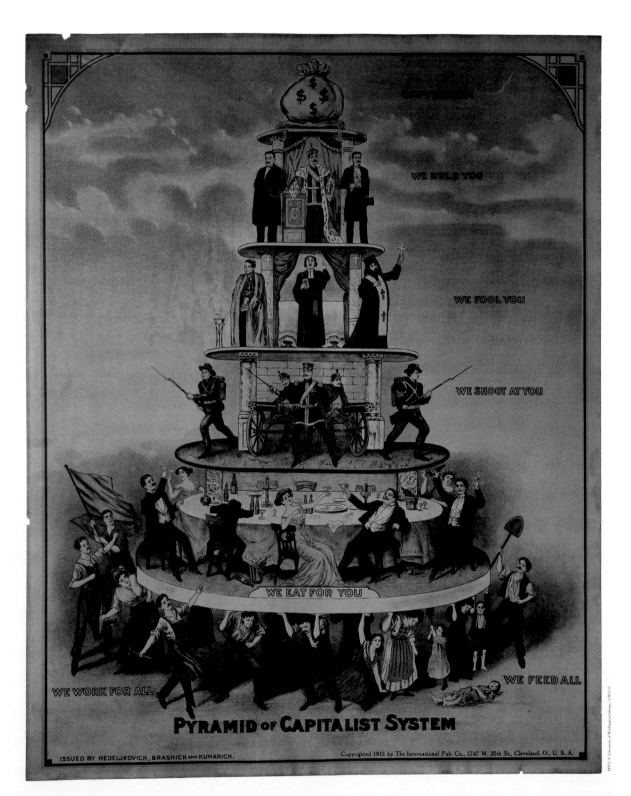

INDUSTRIAL WORKERS OF THE WORLD FOUNDED IN CHICAGO ON JULY 7TH, 1905

IWW GENERAL HEADQUARTERS, POST OFFICE BOX 13476, PHILADELPHIA, PENNSYLVANIA 19101 · (215) 222-1905

2.25 "Pyramid of capitalist system." Issued by Nedeljkovich, Brashich, and Kuharich, IWW, 2003 (1911 original).
Offset, 55.5 x 43 cm.

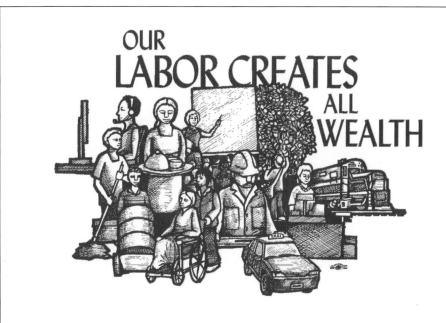

© 2004 Ricardo Levins Morales Northland Poster Collective (800) 627-3082 www.northlandposter.com

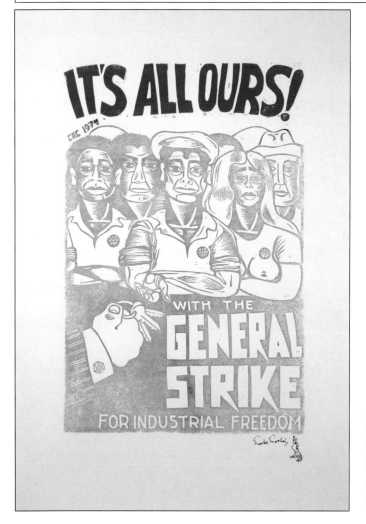

2.27 "Our labor creates all wealth." RICARDO LEVINS-MORALES, North-land Poster Collective, 2004. Offset, 56 x 56 cm.

2.28 "It's all ours!" CARLOS CORTEZ, IWW, 1974. Linocut, 89 x 58 cm.

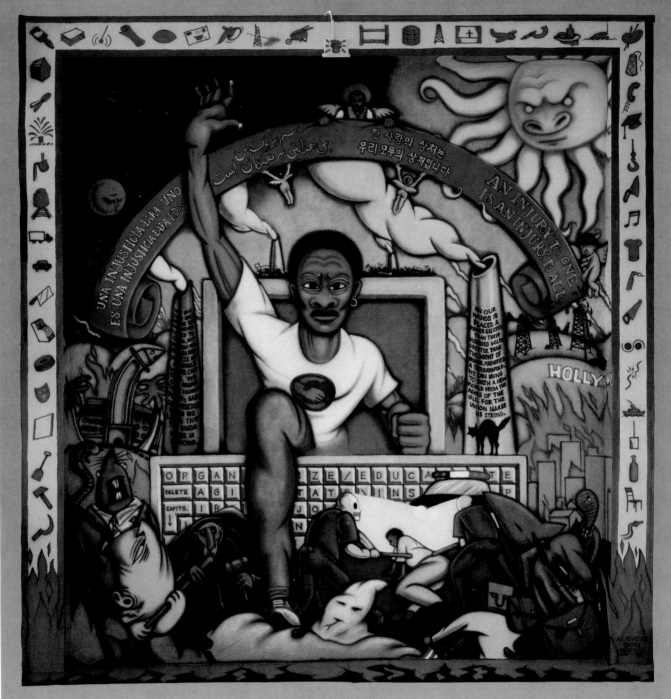

AN INJURY TO ONE
IS AN INJURY TO ALL

MIKE ALEWITZ

MURAL AT COMMUNICATIONS WORKERS OF AMERICA LOCAL 9000 BUILDING, LOS ANGELES, CALIFORNIA
DONATED AS AN ACT OF SOLIDARITY WITH THE PEOPLE OF LOS ANGELES.
DEDICATED TO THE VICTIMS OF RACISM, UNEMPLOYMENT AND POLICE VIOLENCE.

SPONSORED BY: LABOR ART AND MURAL PROJECT; LOS ANGELES COUNTY FEDERATION OF LABOR; NEW JERSEY INDUSTRIAL UNION COUNCIL, AFL-CIO; LABOR HERITAGE FOUNDATION; SAN CARLOS FOUNDATION; NY LOCAL, AMERICAN FEDERATION OF TELEVISION AND RADIO ARTISTS; HOSPITAL, PROFESSIONAL AND ALLIED EMPLOYEES OF NEW JERSEY, AFT; WHITEHEAD FACULTY ASSEMBLY, UNIVERSITY OF REDLANDS; INTERNATIONAL UNION OF ELECTRONIC, ELECTRICAL, SALARIED, MACHINE AND FURNITURE WORKERS; COMMUNICATIONS WORKERS OF AMERICA, DISTRICT 1; AND NUMEROUS UNION LOCALS AND INDIVIDUALS

HEALTH AND SAFETY

"Quick, Jurgis, we must recover the body from the lard vat," says the text of figure 3.01. The obvious purpose of this poster is to advertise the movie of Upton Sinclair's novel, *The Jungle*, which describes in vivid detail the struggles of workers in Chicago's meat packing industry at the beginning of the twentieth century. This isn't typical Hollywood ad copy but, then again, Sinclair's exposé of the Chicago meatpacking industry wasn't a typical movie script. Sinclair, eager to reach as wide an audience as possible, produced this silent film himself in 1914. The poster needs to both catch a viewer's attention and provide important information. Given a little more attention, it raises other issues, such as whose responsibility it is to take on dangerous jobs. Is work inherently dangerous? What effect do workplace conditions have on the surrounding community? Directly or indirectly, labor posters about health and safety pose these sorts of questions.

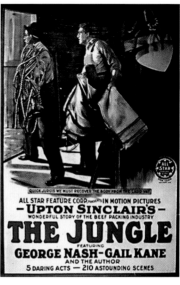

One of the fundamental challenges of work is coming home with all your fingers and toes. Work should not harm you or the community, and many posters created by unions and public health agencies focus on health and protection from immediate physical danger. They call attention to these issues in the workplace and to their wider implications for the surrounding community. Some of the dangers are neither immediate nor particularly visible, but they are nevertheless important, and are also represented in posters.

Above 3.01 *The Jungle* (film). Artist unknown, All Star Feature Film Corporation, 1914. Lithograph.

Facing page 3.10 "An injury to one is an injury to all" (Mural at CWA Local 9000, Los Angeles). MIKE ALE-WITZ, Labor Art & Mural Project [et. al.], 1994. Offset, 61 x 46.

Early government posters generally place the burden of responsibility for health and safety at work on the individual, telling him or her to "stay out of trouble." Posters calling on workers to be careful go back at least to the New Deal's "Work with care" and "To-day is another day: Make it safe!" (3.02 and 3.03) The people depicted are all male, representative of the strong industrial laborer on which the country's strength was most publicly said to be based. More recent posters on the same theme take a different tack. A Canadian Workman's Compensation Board poster uses a stark photograph to shock the viewer while warning him or her to be careful at work. "You can lose 30 pounds instantly (so stay alert)" is an effective parody of weight-loss advertisements (3.04). Occasionally unions address the role of individual behavior in preventing accidents. For example, a campaign by a coalition of rail transportation unions produced a series of posters on "Operation Redblock" about the dangers of drugs and alcohol on the job (3.05).

Attempts to legislate working conditions began in the early twentieth century, and were put into national bargaining agreements from the 1940s on, but it was not until the creation of the Occupational Safety and Health Administration (OSHA) in 1970 that legislative protections and

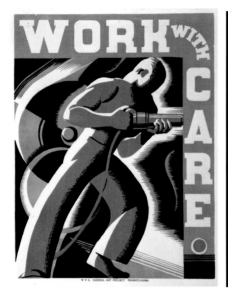

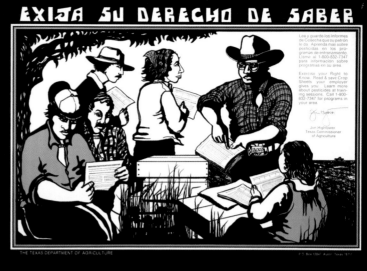

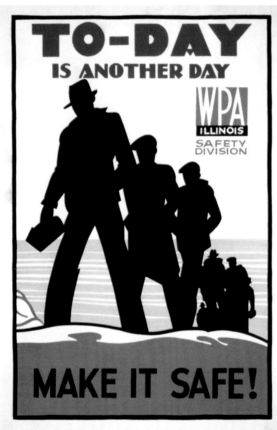

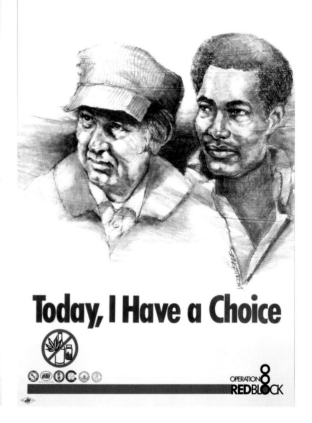

3.02 "Work with care." ROBERT MUCHLEY, Pennsylvania: Federal Art Project, 1937. Woodcut.

3.03 "To-day is another day: Make it safe!" Artist unknown, Illinois: Federal Art Project, 1937. Screenprint.

Facing page 3.04 "You can lose 30 pounds instantly (so stay alert)." Artist unknown, Workmen's Compensation Board of British Columbia, circa 1980s. Offset, 56 x 43.

3.06 *"Exija su derecho de saber"* (Demand your right to know) MALAQUIAS MONTOYA, Texas Department of Agriculture, 1988. Offset, 56 x 83.

3.05 "Today, I have a choice." Artist unknown, Operation Red Block (a coalition of railway and transportation unions), circa 1983. Offset, 56 x 33.

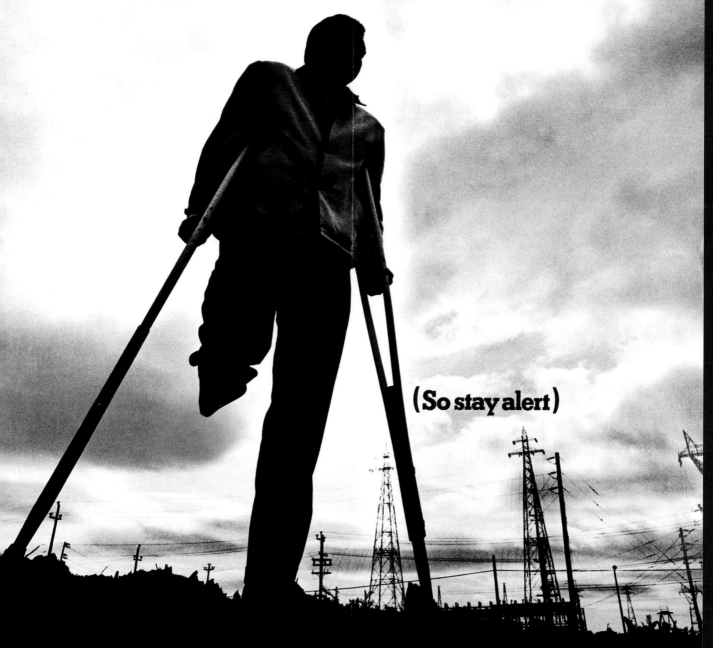

You can lose 30 pounds instantly

(So stay alert)

WCB *Published in the interests of safety by* **WORKMEN'S COMPENSATION BOARD** OF BRITISH COLUMBIA

7120.

enforcement became established. Some states, notably Texas and California, passed additional progressive laws protecting workers. One example is seen in a Malaquias Montoya poster from Texas when Jim Hightower was head of the State Agriculture Commission (3.06). It shows a man speaking with a group of farm laborers: "You have the right to know" about workplace dangers and toxics. Many workers were not (and probably are not) aware of this.

Young people are especially vulnerable in the workplace. They usually know little about their rights on the job, receive little or no health and safety training, and are reluctant to speak up at work. Since 2000, University of California Berkeley's Labor Occupational Health Program has conducted numerous community outreach efforts, including annual poster design competitions among high school students. The contest results in graphic designs that bring youth voice and perspective, such as "Safe jobs for youth month" (3.07).

With the creation of OSHA, health care professionals and union activists around the country formed Committee of Occupational Safety and Health (COSH) groups to make sure that the new legislation was implemented and enforced. A classic Chicago COSH poster wryly states the terrifying truth of automobile manufacturing by informing us that "America's workers are dying to build your car" (3.08). This poster is directed at people outside the industry, the general public, educating them about the range of illnesses and injuries directly related to work in an industry that many take for granted. Similarly, activists within progressive health care organizations such as the American Public Health Association (APHA) worked to use their professional skills for labor's needs.

Another group of posters speaks directly to dangers in the work environment. The peculiar image in "Health and safety: At work and play" stays with a viewer (3.09). The grotesque portrait—with over-colored lips, a purple rather than blue work shirt, distorted eyes, and the worker's incredulous and fearful expression—literalizes the disfigurement unhealthy and unsafe working conditions impose on workers. The poster mentions work *and* play, meaning health and safety is a broader issue than what happens to people on the job, but the problems begin at work.

Perhaps the strongest labor slogan of all, "An injury to one is an injury to all," is found in innumerable labor halls and on posters, murals, and t-shirts across the country. Mike Alewitz's multilingual poster, taken from his Los Angeles mural design for the Communications Workers of America (CWA), makes the point emphatically and humorously, promoting labor solidarity through an activist union (3.10, p. 36). The design is based on a classic IWW image from the Paterson silk workers strike of 1913, but instead of a white industrial worker rising over the factory, Alewitz's design updates it to a black worker rising over a computer keyboard like a soldier going over the top. The keyboard is placed on its edge, suggesting the factory building in the original playbill design. One foot steps on a Klansman while

in the background are ordinary L.A. lights—palm trees, oil wells, a . . . [flaccid, phallic] City Hall leaking scurrying rats, sharks with briefcases, and all over town, an eruption of fires that resembles waves of red flags surging toward you on May Day. In his usual manner . . . [Alewitz] uses subtle humor and peoples his canvas with images of Malcolm X, Zapata, Mother Jones, modestly shielding her décolletage, and . . . is that Mike himself as a winged *putto*? The . . . [poster] also shows a weasel-like

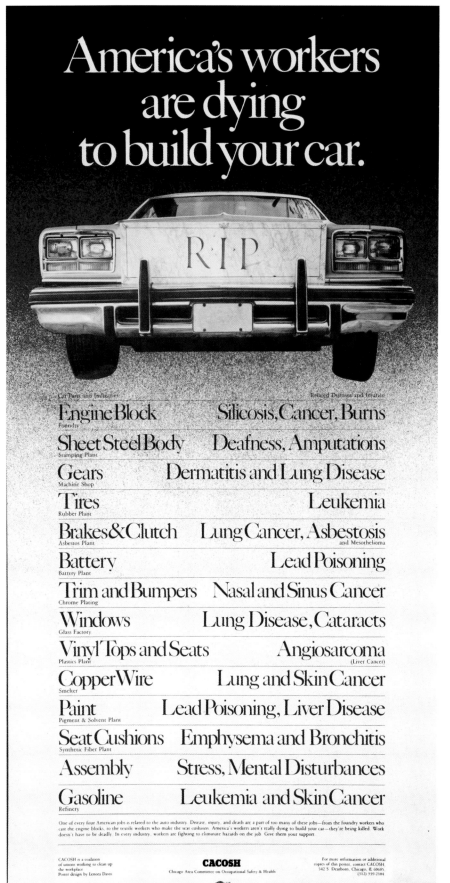

3.08 "America's workers are dying to build your car." LENORA DAVIS, Chicago Area Committee on Occupational Safety and Health (CACOSH), circa 1980. Offset, 71 x 35.5.

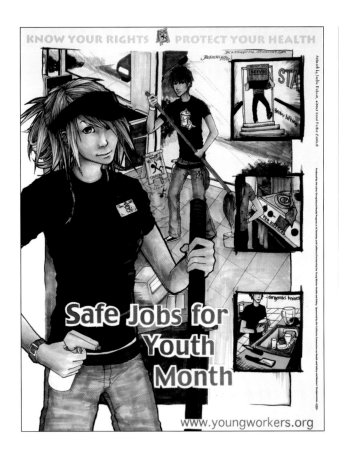

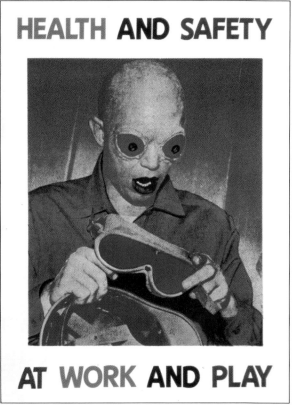

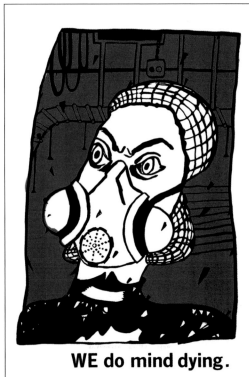

3.07 "Safe jobs for youth month." JACKIE DELEON, Labor Occupational Health Program (U.C. Berkeley), 2006. Offset, 56 x 43.5.

3.09 "Health and safety: At work and play." Artist unknown, client unknown, circa 1970s. Offset, 61.44.5.

3.12 "WE do mind dying." DOUG MINKLER, self-published, 1980. Screenprint, 59 x 34.5.

THEY HAVE TAKEN UNTOLD MILLIONS

FEDERAL RESERVE NOTE
THE UNITED STATES OF AMERICA
100 100
ONE HUNDRED DOLLARS

WORKERS MEMORIAL DAY APRIL 28, 1999

3.13 "They have taken untold millions." MIKE KONOPACKI (Huck/Konopacki Labor Cartoons), Southeast Michigan Coalition for Occupational Safety & Health (SEMCOSH), 1999. Offset, 35.5 x 56.

judge sucking the blood off the police nightstick, while a giant maggot crawls out of the judicial robe. The computer keyboard has been slyly transformed, the normal QWERTY key layout becoming ORGANIZE, EDUCATE, AGITATE, the DELETE button hovering over CAPITS. To facilitate impromptu labor songfests . . . Mike has helpfully [printed] two verses of "Solidarity Forever" on company smokestacks.[1]

Alewitz's humor is particularly effective in no small part because of its rarity in the usually earnest world of labor graphics. The slogan, "an injury to one is an injury to all," created by the IWW and later adopted by the International Longshore and Warehouse Workers' Union (ILWU) endures because it resonates with working people in four languages.

Red Pepper's poster "Your job is killing you" makes the point that "two and a half times as many [people] were killed on the job as in Vietnam" between 1961 and 1969 (3.11). The numbers are staggering: 46,000 Americans were killed in Vietnam in the period cited, but the 126,000 workplace deaths at the same time were not the focus of political or public attention, or covered in the mass media.

Doug Minkler's poster—showing an angry worker, face obscured (and thus dehumanized) by a respirator—says, "WE do mind dying" (3.12). This slogan was inspired by Dan Georgakas's and Marvin Surkin's 1975 book *Detroit: I Do Mind Dying* and informed by ten years of dangerous factory work. There will always be accidents, but many are preventable, and these posters rail against the deaths of those who have died unnecessarily. In a play on the famous phrase "They have taken untold millions that they never toiled to earn" from Ralph Chaplin's 1915 song "Sol-

idarity Forever," Mike Konopacki in 1999 asks us to celebrate Workers Memorial Day, April 28 (3.13). His poster uses an enlarged hundred dollar bill featuring Ben Franklin as a skull against a background of cemetery crosses. The illustration suggests that the "untold millions" the poster speaks of are people, not just dollars. Such ambiguous interpretation was earlier visually exploited by the famous photomontage artist John Heartfield in his 1932 anti-Hitler poster (not shown) with the subtitle "Millions stand behind me."

Northland Poster Collective's "Adding injury to insult" makes a similar point about exposure to workplace dangers through a single photograph by Ken Light (3.14). The ambiguity of the "Danger, Employees Only" sign is the basis of the poster's caption, which flips the common phrase on its head and suggests that it is okay for workers to be exposed to danger. Reducing risk, injury, and death is one of the most important roles of unions, but is relatively invisible to the general public.

In West Virginia, the Miners Art Group's poster, "Coal operators grow rich while miners die. Safety or else," moves from simply calling attention to safety problems at work to expressing a more militant position: "or else" (3.15). The image includes an extensive cast of characters, including dead miners, mourning widows, millionaire Nelson Rockefeller, corrupt politicians, and the Ku Klux Klan. This poster is a good example of linking one narrow issue, mine safety, with broader, community-level issues, such as racism, biased courts, and ruling-class arrogance. It implies that organized labor demands for safer work conditions benefit the entire community but not those holding themselves above it. It recognizes that labor has a stake in both safety and production, while the unstated contradiction is that owners can make greater

Facing page 3.11 "Your job is killing you." Barbara Morgan, Red Pepper Posters, 1976. Offset, 61.5 x 46.

profits by encouraging racism, using their wealth to influence court appointees and their decisions, and cutting costs on safety. We will see this theme several more times in the posters that follow.

Not all health problems caused by work environments are as visible as mine accidents and deaths on the production line. Doug Minkler's "More than a paycheck," shows that VDT (video display terminal, an early term for computer monitor) operators "bring home eye strain, back pain, headaches and stress," as well as a paycheck (3.16). These problems are not caused by personal work style but rather by "hours of high speed, detailed, repetitious work." The prevalence of such white-collar occupational hazards was just beginning to become evident in the mid 1980s. Minkler's 1987 poster is powerful because of the unorthodox nature of the image, a woman with an aching internal organ, covered with blotches shaped like keyboard characters, turning away from her monitor and grimacing. While viewers may not retain the details of Minkler's images, they do remember the uncomfortable feeling they got when seeing them. A sickly green background and the disproportionately large head of the woman at the monitor reinforce the discomfort.

Another poster from the same period by the Institute for Labor and Mental Health explores another little-known impact of work. "Stress at work . . . your invisible enemy" places a hard-hat silhouette against a bright red background composed of fine type listing work-related causes of stress (3.17). Three inset illustrations, parodying the Anacin aspirin commercials of the 1950s and 1960s, show overwork, time pressures, and tension exacerbated by a foreman looking over a worker's shoulder. The background "tension" lines emphasize the point. Similarly, in figure 3.18, a photograph of a wide-eyed nurse staring in shock

as she reads a patient's vital signs, makes the point that if you are "Fed up? Short Staffed? Stressed Out?" then you can fight back by calling the union, in this case the SEIU. It's a disturbing observation of the working world that most posters about job stress feature a woman's image. Image makers associate stress with women, either as a particular consequence of the jobs they are often given, or because they are more likely to admit suffering stress than are men.

Many posters relate community health dangers to businesses or industries. One of the unions at the forefront of campaigning for better health and safety for workers and the broader community was the Oil, Chemical, and Atomic Workers Union (OCAW) under the visionary leadership of Tony Mazzocchi. In the early 1970s, while he was citizenship-legislative director of the international union, he produced a series of posters on hazards in the industry. These were limited edition screen prints oriented to the membership by providing detailed information about specific chemicals such as asbestos. Later, in 1988, while he was secretary-treasurer, he promoted a second series of eight posters produced by the Labor Institute and the Hazardous Waste Training Program. Designed by Howard Saunders, these were printed in offset for broader distribution and specifically made the connection between hazards to workers and hazards to the community. One example is "29 known killers on the loose" (3.19). The dangers noted have killed more people than mass murderers, but receive less media exposure because they lack the flashiness on which mainstream news is based.

Perhaps the most powerful of these posters is Ester Hernandez's iconic 1982 detournment of "Sun Mad Raisins" (3.20). Her image is a parody of the Sun Maid Raisins box where the smiling young woman with an over-

YOUR JOB IS KILLING YOU

From 1961 to 1969, 126,000 people were killed on the job in the U.S., and 46,000 Americans were killed in Vietnam. Two and a half times as many were killed on the job as in Vietnam.

Red Pepper Posters, San Francisco, California, 1976. Statistics from Blue Collars and Hard Hats, by Patricia and Brendan Sexton.

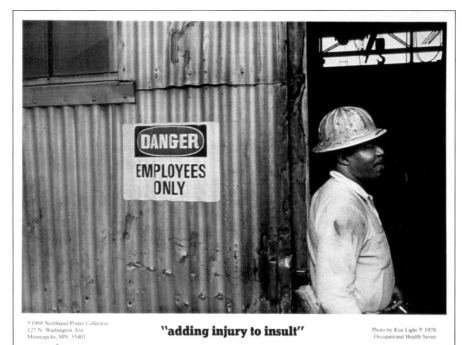

©1988 Northland Poster Collective
127 N. Washington Ave.
Minneapolis, MN 55401

"adding injury to insult"

Photo by Ken Light © 1978
Occupational Health Series

3.14 "Adding injury to insult." KEN LIGHT, Northland Poster Collective, 1988. Offset, 48 x 63.5.

3.15 "Coal operators grow rich while miners die: Safety or else." DAVID "BLUE" LAMM, Miners Art Group, WV, circa 1974. Offset, 56 x 35.

3.16 "More than a paycheck." DOUG MINKLER, VDT Coalition (Video Display Terminal Coalition), 1987. Screenprint, 66 x 51.

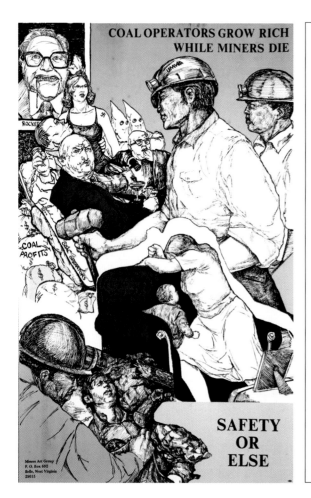

COAL OPERATORS GROW RICH WHILE MINERS DIE

SAFETY OR ELSE

Miners Art Group
P. O. Box 662
Belle, West Virginia
25015

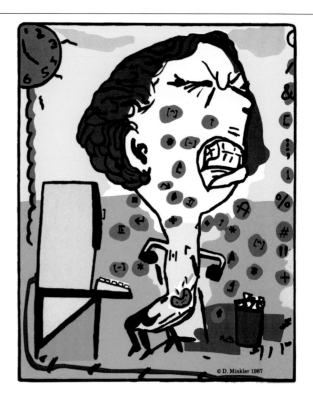

© D. Minkler 1987

MORE THAN A PAYCHECK

VDT (Video Display Terminal) Operators bring home more than a paycheck. They bring home eye strain, back pain, headaches and stress. These problems are not personal but the result of hours of high speed, detailed, repetitious work.

For more information contact; VDT Coalition, 2521 Channing Way, Berkeley, CA 94720 (415) 642-5507

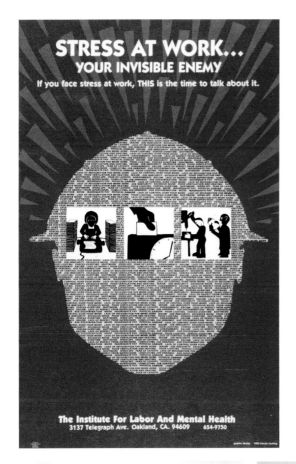

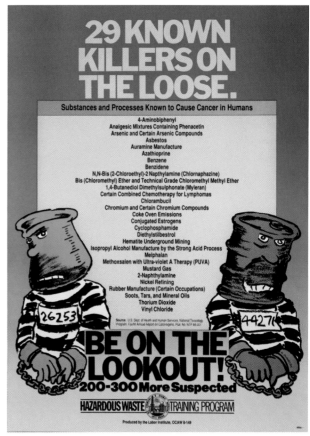

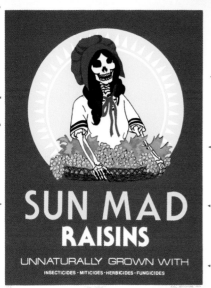

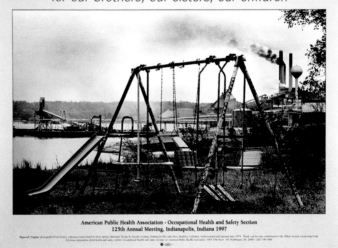

3.17 "Stress at work . . . your invisible enemy." LINCOLN CUSHING, Institute for Labor and Mental Health (Oakland), 1983. Offset, 42.5 x 27.

3.19 "29 known killers on the loose." HOWARD SAUNDERS (artist/writer), OCAW 8-149. Labor Institute, 1988. Offset, 67 x 49.

3.20 "Sun Mad Raisins." ESTER HERNANDEZ, self-published, 1981. Screenprint, 56 x 43.

3.21 "Safe jobs! Safe communities!" Photograph by EARL DOTTER, designed by LINCOLN CUSHING;

APHA—Occupational Health and Safety Section, 1997. Offset, 44 x 61.

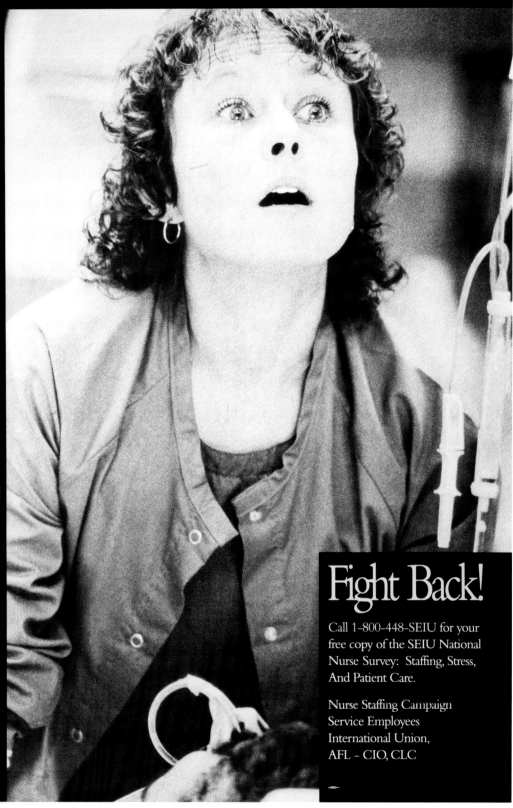

Stressed Out?

Short-Staffed!

Fed Up?

Fight Back!

Call 1-800-448-SEIU for your free copy of the SEIU National Nurse Survey: Staffing, Stress, And Patient Care.

Nurse Staffing Campaign
Service Employees
International Union,
AFL - CIO, CLC

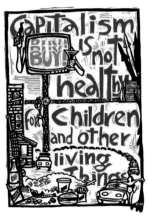

flowing basket of grapes is replaced by a bonnet-wearing, smiling *calavera* (skull). The brightly colored image gains power because the first glance identification is terribly wrong, and this surprise drives the message home with a rarely-matched intensity. Anyone who has toiled in the fields of California agribusiness will nod in wry recognition of the irony of this "advertising" (subvertising), telling the truth they know all too well as they walk to the hospital to visit a dying relative or friend. Hernandez's warning about the dangers of working in the fields makes the link between industry toxins that affect not only workers, but the general public (the community) as well—even if the raisins themselves are not tainted. Labor draws on community support here by pointing out that "our problem is your problem," not just as workers, but by saying "this industry in your community is polluting you. You as a community have an interest in better, safer production processes, just as unions do."

Another poster making the connection between jobs and communities is the American Public Health Association's Occupational Health and Safety Section "Safe jobs! Safe communities! For our brothers, our sisters, our children" (3.21). The photograph beside the text sends a powerful message because it features a children's swing set against the background of a factory whose conveyor belt and smokestacks are reminiscent of the play structure in shape, while the discharge from one smokestack seems to threaten the swing set.

A few posters occasionally take a step beyond the immediacy of local industrial causes of health and safety problems and extend their analysis to a wider framework. A Northland Poster Collective's poster from 2000 makes such a point: "Capitalism is not healthy for children and other living things," is an homage to Lorraine Schneider's

1966 classic "War is not healthy for children and other living things" (3.22). The background of both illustrations link consumer goods, television, guns, weapons, and a bikini-clad woman to the excesses of a consumer society. The structure of capitalism itself is indicted by saying that such excesses are unavoidable because of the inherent pressure to maximize profits, cut costs, and expand markets.

Like the posters in chapter 2, the posters here may be seen to move from individual to society-wide concerns, some pointing out specific dangers, some commenting on industry-wide issues, and some extending their analysis to the very structure of our society. Their main focus is on dangers to the health and safety of men and women at work, avoidable injuries and illnesses. The posters highlight not only immediate physical dangers, but problems extending beyond the workplace, and they include invisible consequences, too, such as stress and chronic backaches. Solutions range from individual worker responsibility to industry-wide safety measures. What is more, the posters make the link between decent working conditions and the larger community, pointing out the effect of unsafe or toxic conditions at a nearby plant on families and neighbors. A similar movement in the posters from individual concerns to increasingly wider and deeper, more structural contexts is seen in the following chapter on women.

Above 3.22 "Capitalism is not healthy for children and other living things." RICARDO LEVINS-MORALES, Northland Poster Collective, 2000. Offset, 43 x 23.

Facing page 3.18 "Fed up? Short staffed? Stressed out?" Artist unknown, SEIU Nurse Staffing Campaign, circa 1980, Offset, 71 x 50.

LIKE an ORGY,

IT ONLY WORKS IF THERE'S A LOT OF US.

4 WOMEN

Just as the work women do extends beyond irrational, biased, and harmful conditions at the workplace, so do the issues addressed in the following posters. The concern shown for women's unpaid work is a more focused version of other posters' extension of workplace issues into the greater community. The posters illustrate how women are subjected to pressures and stresses that men rarely are, and they show the role of unions in raising awareness of those issues and in trying to combat them. A poster featuring an old photograph of overcoat-wearing, mop-bearing, demonstrating women makes the basic point with a quotation from Rose Schneiderman, "Working women will never be handed their rights without a struggle. There is no harder contest than the contest for bread[1]" (4.01). The women pictured could be anyone's mother or grandmother. They are strong, good-humored, and ready to fight for decent treatment. The posters publicize "women's work," paid and unpaid, both necessary.

Posters about women and labor are constantly clarifying widely held misconceptions. In answer to the claim that women work only for "pin money," a poster from the mid 1950s replies with the simple truth: "Women work for the best of reasons," above a picture of children at a table cluttered with food, a paycheck, medicine, and schoolbooks (4.02). At the bottom a line reads "Equal pay, equal work, equal responsibility." Another poster from the same period says "Women have always worked to provide the things families need for daily living" (4.03). It features two drawings by John Gelsavage, an artist best known for his twenty-eight-print series on labor history (see 10.03). The image contrasts "then" (women picking potatoes in a field), and "now" (women on an assembly line), a radical statement because organized labor at the time rarely recognized agricultural or domestic labor. In the 1970s, a poster by the Chicago Women's Graphic Collective made its point by merely adding two letters to the ubiquitous "Men Working" signs to show that times had changed (4.04). That the image still has an impact today, even if reduced, testifies to just how surprising the sign was just a few decades ago.

Posters dealing with women and work often focus on the nature of work available to women. In the 1930s, the Illinois National Youth Association advertised jobs for girls, with promises of "pay, employment, security, and promotion," but illustrated the poster with menial, entry-level work as the height of girls' aspirations (4.05). Half a century later, the seventy-fifth anniversary of the Women's Bureau of the U.S. Department of Labor was recognized with "Women's work counts" posters, a series of artworks by women artists about women workers (4.06). This one shows a woman waiting tables in a diner. Both the artwork and the waitress show strength, but the daily reality is that in the later twentieth century (and early twenty-first century, for that matter) equality at work, equality in pay with men with similar qualifications, and equality in the kind of work women usually do, have not yet been achieved. The posters just cited, for

Facing page 4.18 "Like an orgy, it only works if there's a lot of us." Designer unknown, Exotic Dancers Alliance, circa 1990s. Offset, 61 x 45.5.

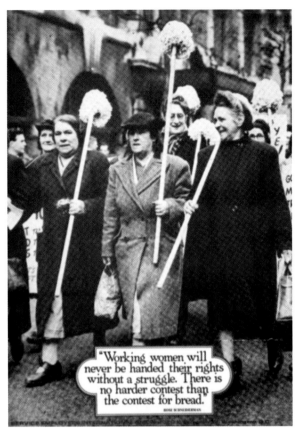

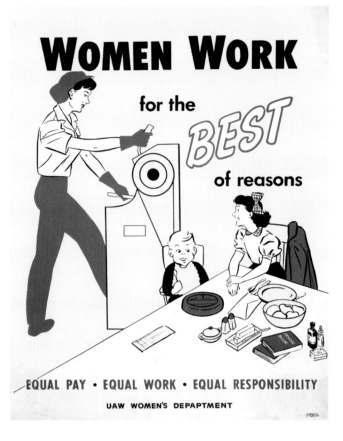

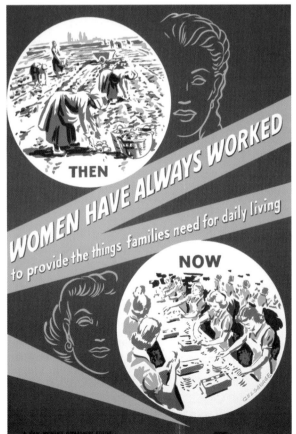

4.01 "Working women will never be handed their rights without a struggle." Artist unknown, SEIU, circa 1970s. Offset, 51 x 33.5 cm.

4.02 "Women work for the best of reasons." Artist unknown, UAW Women's Department, circa 1950 [?]. Screenprint, 51.5 x 43 cm.

4.03 "Women have always worked." JOHN ZYGMUND GELSAVAGE, UAW Women's Department, circa 1955 [?]. Screenprint, 76 x 56 cm.

example, note the dichotomy of traditional paid work and the much broader category of unpaid and largely unrecognized labor, which includes a great deal of "women's work." Occasionally, a poster addresses this issue, such as "Strike! While the iron is hot! Wages for housework" (4.07). The image says it all—if women leave unpaid domestic labor undone, the entire structure of society and the economy will either change radically or crumble entirely. This point is also recognized in Bay Area printmaker Nancy Hom's "Working women: We can shut this country down" (4.08).

Many posters remark on wage inequality. Hom, in a piece for the Women's Economic Agenda Project, shows a mother and child with an explanatory caption reading, "If women were paid the same wages that men of similar qualifications earn, about half the families now living in poverty would not be poor" (4.09). The sharp juxtaposition of the happy mother and child portrayed in a pastel-colored, flowing design with the disturbing statistical statement of the results of inequality reinforces the point. In figure 4.10, a baby boy and girl compare what's beneath their diapers, emphasizing the irrational nature of gender discrimination.

Not surprisingly, exploitation has motivated particularly strong images concerning women and work. Among the strongest of these is "$acred motherhood" by Barbara Morgan for the Red Pepper Poster Collective (4.11). Morgan modifies a vintage sweatshop illustration (the original 1907 image is by cartoon artist Luther Bradley) in a poster that combines issues of motherhood, childcare, exploitation, and the family. The stylistic reference to an earlier century claims historical longevity for the issues, and for the struggles to overcome them. The poster calls for decent treatment of workers, specifically mothers and

their infants and families. It makes the case that industrial exploitation has been a much larger factor in the destruction of the family than, say, feminism, which is often blamed by the political right and in popular stereotypes. The feminist movement has often argued for women's right to work under decent conditions and with decent, affordable childcare.

One response to exploitation is to join a union. Union posters about women always refer to "women's" issues as being part of union concerns. A CLUW demonstration placard uses bold text to declare "Pro Union, Pro Choice" (not shown). Another CLUW poster by Lincoln Cushing, "Union women build the future," shows eight tradeswomen of different races and ethnicities (4.12). The black background of the red-bordered vignettes gives the poster a starkness along with the (still surprising to some) illustrations of the wide range of jobs held by women, including trades traditionally identified as "male."

Women working in the trades have been an important part of the workforce as depicted in posters since at least World War II. A 1940s poster hails "Women in the war" with a photograph of a woman using a power driver to assemble military ordinance, "We can't win without them" in patriotic red, white, and blue (4.13). Before World War II only men were allowed to work in the trades.[2] The war changed that, when tradesmen served in the military and women stepped into their jobs. Perhaps the best-known example of this genre of images is "Rosie the Riveter," memorialized in posters, magazine covers, t-shirts, coffee mugs, magazine covers, and advertisements ever since she appeared on a Norman Rockwell cover of a 1943 *Saturday Evening Post,* although the "We can do it!" image of a woman flexing her bicep (see 1.01–1.06) is commonly misidentified as Rosie. Later in the century, Rosie

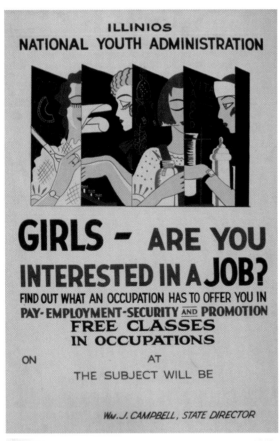

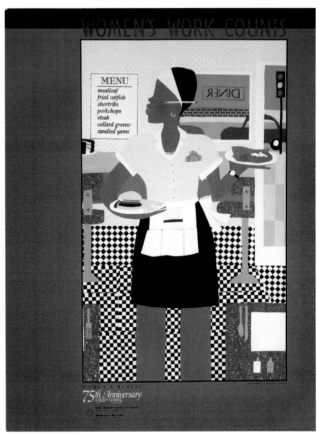

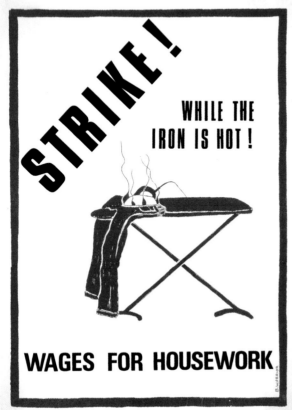

4.05 "Girls—Are you interested in a job? Find out what an occupation has to offer you in pay, employment, security, and promotion. Free classes in occupations." Artist unknown, Illinois: Federal Art Project, 1936 or 1937. Screenprint.

4.06 "Women's work counts." VARNETTA P. HONEYWOOD, U.S. Department of Labor, Women's Bureau, 1995. Offset, 81 x 61 cm.

4.07 "Strike! While the iron is hot! Wages for housework." BETSY WARRIOR, self-published, circa 1972. Screenprint, 48 x 35.5 cm.

WORKING WOMEN:
We can shut this country down.

INTERNATIONAL WOMEN'S DAY
MAR 8 9AM-10:30PM Panel Discussions ○ Workshops ○ Entertainment
REGISTRATION: KROEBER HALL, U.C. BERKELEY For info & advanced child care call 982-8963

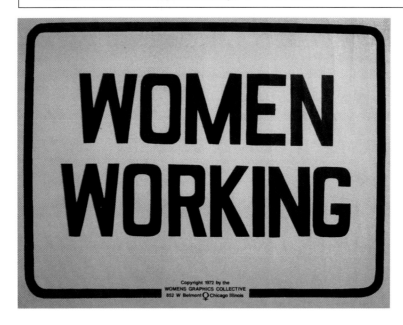

4.04 "Women working." Chicago Women's Graphics Collective, 1972. Screenprint, 28 x 43 cm.

4.08 "Working women: We can shut this country down. International Women's Day." NANCY HOM, U.C. Berkeley International Women's Day Committee, 1980. Screenprint, 43.5 x 42 cm.

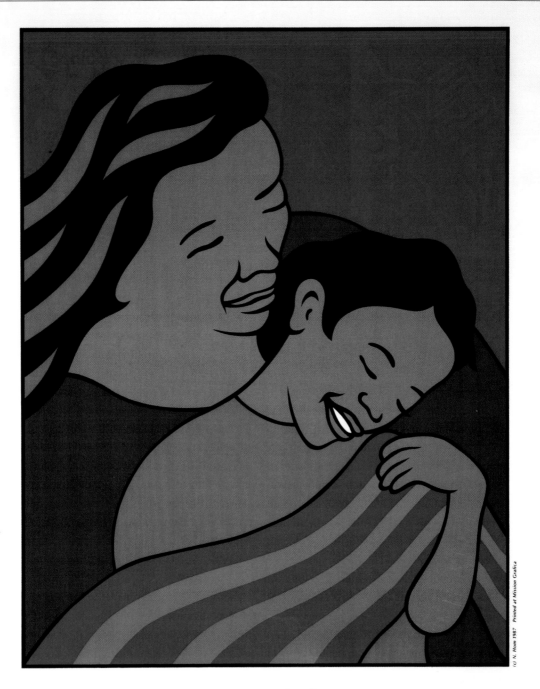

If women were paid the same wages that men of similar qualifications earn, about half the families now living in poverty would not be poor.

WOMEN'S ECONOMIC AGENDA PROJECT

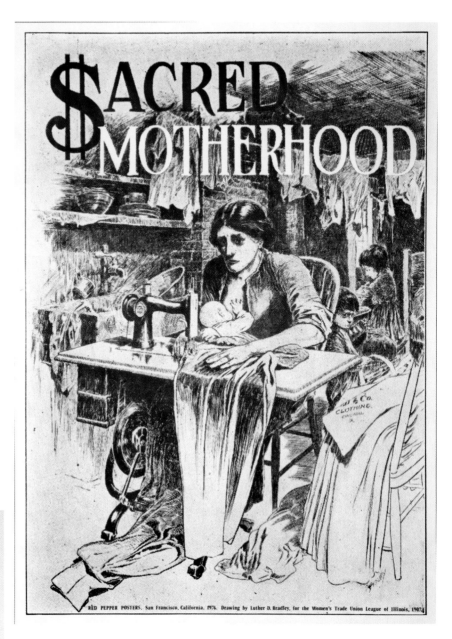

RED PEPPER POSTERS. San Francisco, California. 1976. Drawing by Luther D. Bradley, for the Women's Trade Union League of Illinois, 1907.

Oh, so that explains the difference in our salaries!

Facing page 4.09 "If women were paid the same wages that men of similar qualifications earn . . ." NANCY HOM, Women's Economic Agenda Project, 1987. Screenprint, 67.5 x 43 cm.

4.10 "Oh, so that explains the difference in our salaries!" Artist unknown, Equality Products/Northern Sun Merchandising, circa 1980. Offset, 43 x 28 cm.

4.11 "$acred motherhood." Artwork 1907 by LUTHER D. BRADLEY, poster designed by BARBARA MORGAN; Red Pepper Posters, 1976. Offset, 64 x 46 cm.

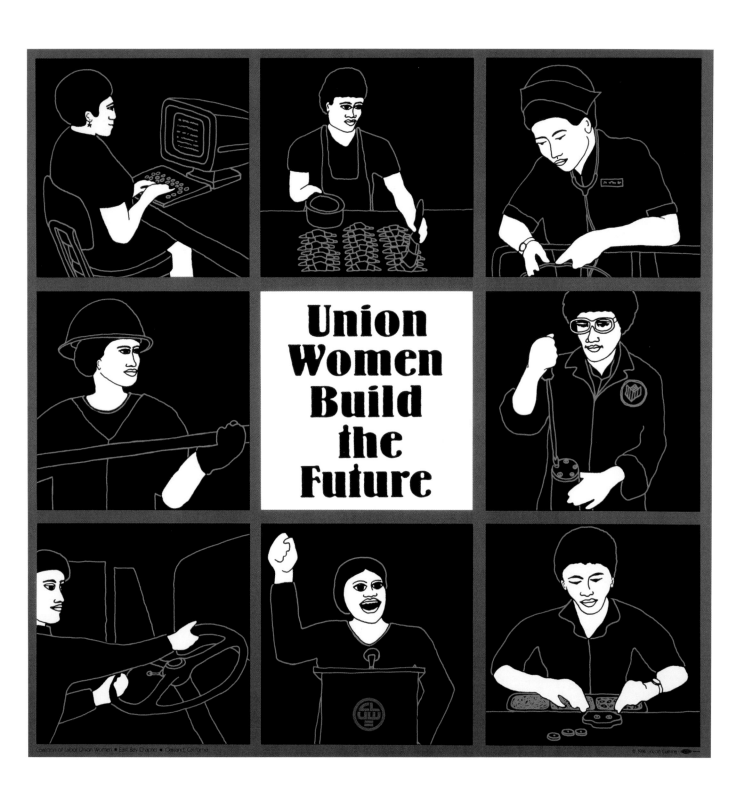

Union Women Build the Future

4.12 "Union women build the future." Lincoln Cushing, CLUW—East Bay Chapter, 1986. Offset, 44.5 x 44.5 cm.

Facing page 4.13 "Women in the war." Artist unknown, War Manpower Commission, Washington, DC, circa 1943. Offset, 101.5 x 72 cm.

Women
in the war

WE CAN'T WIN

WITHOUT THEM

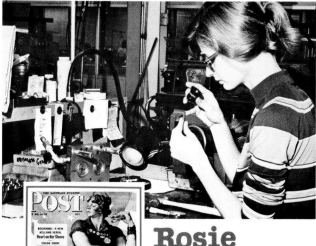

4.14 "Rosie doesn't just rivet anymore." Artist unknown, U.S. Department of Labor, circa 1970. Offset, 56 x 43 cm.

4.15 *The Life and Times of Rosie the Riveter* (film). CONNIE JEUNG-MILLS, JANO OSCHERWITZ, AND FRED LONIDIER, Labor/Community Action Committee (San Diego), 1981. Screenprint, 58.5 x 44.5 cm.

Facing page 4.16 "United to stop abuse now." J. F. PODEVIN, DESIGNED BY L. MEANS; SEIU Local 535, circa 1980s. Offset, 56 x 35.5 cm.

4.17 "This dept. has gone [blank] days with no sexual harrassment [sic]." RICARDO LEVINS-MORALES, Northland Poster Collective, 1990. Screenprint, 35.5 x 20.5 cm.

UNITED TO STOP ABUSE NOW

DESIGN L. MEANS, ART J.F. PODEVIN

LABOR CARES

SEIU
local
535

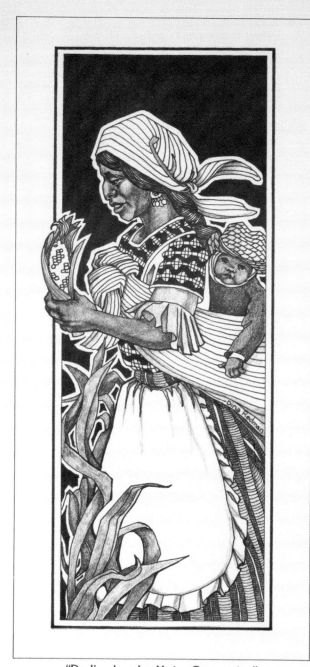

"Dedicada a La Mujer Campesina"

FARM LABOR ORGANIZING COMMITTEE

2ª Convención Constitucional
7 de agosto 1982

4.19 "Farm Labor Organizing Committee: *Segunda convención constitutional.*" DINA REDMAN, FLOC, 1982. Offset, 56 x 25.5 cm.

expanded her job training to appear in other, non-war-related jobs. Figure 4.14, "Rosie doesn't just rivet anymore! She's alive and well as an apprentice tool and die maker. Apprenticeship for women is working," announces a U.S. Department of Labor poster with an inset of the Rosie magazine cover and a photograph of a woman working at an electronics bench. San Diego's Labor/Community Action Committee used illustrations of a black woman in the same pose in each of three eras to show how women's labor has shifted over the past century and a half (4.15). In the first she is holding a mop, in the second using a blowtorch at her World War II job, and in the third holding a manila file folder above a typewriter. The poster announces a film, *The Life and Times of Rosie the Riveter*. The impact of the poster derives from its use of an iconic photo of a World War II–era woman welder (Rosie), and the contrast with her in an earlier, more demeaning job and a more recent, "better," pink-collar position. The progression is powerful. "Rosie" has come to represent all women who work.

A number of posters call attention to sexual abuse and harassment. The SEIU published "United to stop abuse now. Labor cares" with a powerful illustration of a woman breaking the frame of the poster border, crouching and holding her hands up for protection (4.16). Gold lettering emphasizes "united" and "now." It communicates fear and pain and danger. Significantly, a labor union here recognizes that its members might also suffer when not at work, and chooses to help defend them.

A sarcastic poster about sexual harassment at work presents the common "this department has gone [X] days without injury" design, but in the poster, the term "injury" is replaced with "sexual harassment" and the empty box is black, indicating that sexual harassment is a daily occurrence (4.17).

Traditional labor unions do not have a place for sex workers, so for protection against sexual abuse and harassment in San Francisco they decided to organize themselves into the Exotic Dancers Alliance and made their logo a graphic version of "We can do it!" Figure 4.18 is one of a series of four posters encouraging women in the sex industry to join the alliance by showing a photo of an attractive woman wearing a low-cut top below the headline "Like an orgy, it only works if there's a lot of us (p. 50)."

All the examples so far in this chapter relate to urban labor, but many women are rural workers and have received poster attention also. The Farm Labor Organizing Committee (FLOC), recognizing the crucial roles of women in agribusiness, dedicated its second Constitutional Convention to farm worker women, and produced a poster illustrated by Dina Redman combining both wage labor (working in the fields) and unpaid labor (she carries a baby on her back) (4.19).

The posters in this chapter show that great strides have been made in recognizing "women's work" of all kinds. However, as these last few posters demonstrate, we still have a long way to go before we reach true equality—a fact that is true for issues of race as well.

PROTECT YOURSELF

FROM THIS MENACE —

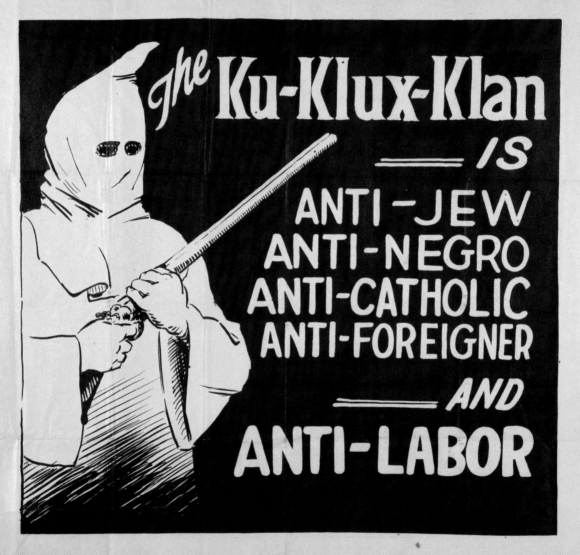

The Ku-Klux-Klan IS

ANTI-JEW
ANTI-NEGRO
ANTI-CATHOLIC
ANTI-FOREIGNER

AND

ANTI-LABOR

ORGANIZE INDUSTRIALLY
LINE UP! Join The I.W.W.

RACE AND CIVIL RIGHTS

U.S. labor posters are often concerned with racial issues because the U.S. economy was developed by slave labor and unequal treatment of workers based on skin color. The trajectory of labor posters dealing with race and civil rights closely follows the historical pattern of race relations in the country, so it makes sense to trace poster development chronologically.

In the early twentieth century, exclusion acts were passed banning Asians from land ownership, from holding certain kinds of jobs, and from testifying against whites in court. The original purpose of the "union label" was to proudly indicate that only white unionists had worked on the product. Organized labor was, by and large, deplorably racist—with rare exceptions such as the Knights of Columbus, the IWW and in many cases later on, the CIO. Blacks were excluded from membership in most unions, and black-white racism was overlooked as the public issue that it would later become, but Chinese workers were seen as a threat. A circa 1898 poster from the Silver Bow Trades and Labor Assembly and Butte Miners' Union (Montana) represents this early history when it asks for assistance "in this fight against the lowering Asiatic standards of living and of morals" (5.01)

By the second decade of the twentieth century, things had changed considerably. The IWW produced a poster warning of the divisive effects of racism, among other dangers to working people (5.02). It declared "Protect yourself from this menace" linking socially despicable ideas with anti-labor attitudes (compare 9.02, which also sees "foreignism" as a threat to democracy.) The poster's visual impact comes from two sources. One is the shock value of a hooded and armed Klansman, an iconic symbol of bigoted ignorance in the United States. The text lists Klan prejudices against other groups of people, a list including a large majority of the United States population. The poster says that by joining the IWW one fights all these biases simultaneously, and the fight is not merely a matter of industrial solidarity, but also of self-interest: "Protect yourself." The IWW was one of the first labor organizations to move beyond craft with its frequent insistence on the inclusion of broad social transformation as part of its mission. This poster points out that racism has no place in the building of an effective labor movement.

Posters also reflect societal changes when waves of immigrants expanded the workforce and became major participants in the labor movement, changes that began in the late nineteenth century and continue today. Languages other than English began to appear on posters, a characteristic indicating the diversity of union membership.

World War II posters displayed multiracial cooperation in the war effort, and shortly thereafter unions began to produce occasional posters condemning racism and celebrating racial equality. For example, in "United we win," a poster depicting a black worker and a white worker together, the men are appropriately shown in a black and white photograph, but it is placed

Facing page 5.02 "Protect yourself from this menace." Artist unknown, IWW, circa 1921. Offset, 91 x 61 cm.

BOYCOTT

A General Boycott has been declared upon all CHINESE and JAPANESE Restaurants, Tailor Shops and Wash Houses. Also all persons employing them in any capacity.

All Friends and Sympathizers of Organized Labor will assist us in this fight against the lowering Asiatic standards of living and of morals.

AMERICA vs. ASIA
Progress vs. Retrogression
Are the considerations involved.

BY ORDER OF
Silver Bow Trades and Labor Assembly
and Butte Miners' Union

to give them a break...

REGISTER
VOTE

5.01 "Boycott: America vs. Asia." Artist unknown, Silver Bow Trades and Labor Assembly; Butte Miner's Union, 1881. Letterpress.

5.04 To give them a break . . . register, vote." Artist unknown, CIO Political Action Committee, 1946 [?]. Offset, 101.5 x 76.5 cm.

Facing page 5.06 "There is no prejudice in kids unless adults put it there." Artist unknown, UAW Fair Practices Department, circa 1963. Offset, 42 x 29.5 cm.

THERE IS NO PREJUDICE IN KIDS
UNLESS ADULTS PUT IT THERE

200

A UAW FAIR PRACTICES DEPARTMENT POSTER

200

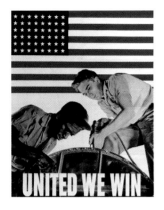

5.03 "United we win." Photograph by HOWARD LIBERMAN, Office of War Information, 1943. Offset, 102 x 72 cm (also issued as 71 x 56 cm).

Facing page 5.05 "Knock him out! Labor can do it." BILL SEAMAN, National Labor Service (American Jewish Committee); CIO Committee to Abolish Racial Discrimination, 1945. Offset, 53 x 39.5 cm.

against an American flag background in red, white, and blue, making the point that not only is cooperation required to produce today's products, but that this is also a patriotic social achievement (5.03). The enemy here is not a foreign wartime foe, but a racially divided country. Developing out of this early phase, the UFW began by the late 1960s to call for equality for everyone, recognizing that Chicanos, Filipinos, and others were the labor force backbone of California's agribusiness fields. By the 1980s, with the advent of identity politics and the obviously multiracial nature of the workforce in the United States, posters became ever more inclusive.

After the IWW, the CIO was the next major labor organization to take on racism as an important part of its organizing, notably in the post World War II period, at the beginning of the national civil rights campaign. Figure 5.04, "To give them a break . . . register, vote," shows three black children playing together, and proclaims the importance of voting and legislative representation in fighting racism. The CIO continued this campaign with "Knock him out!" showing a huge fist labeled "labor" knocking out a cartoon figure of a businessman labeled "discrimination" (5.05). Identifying racism with management is another way of saying that racism is not in our best interests as workers, because it provides a way to divide people at work who should unite for the common good. In the same vein, but emphasizing integration, is the sweet poster "There is no prejudice in kids unless adults put it there," showing a black child and a white child smiling, walking to or from school together, carrying identical plaid book bags (5.06). Although the immediate lesson taught by the image is simply one of racial solidarity, the youth of the two boys goes beyond that and shows simple friendship is not divided by race. The dominant green border reinforces a spring-like, youthful

hope. The lower caption relates this image to labor when it announces that it is a "UAW Fair Practices Department Poster." With its use of positive imagery, there is no need to portray the harmful impact of racial segregation at the workplace.

As the century moved past the halfway point, the CIO continued its strong opposition to racism—which had been a part of its program since its inception—and issued numerous anti-discrimination posters. This coincided with national legislation around these issues, such as the reestablishment of the Fair Employment Practices Commission (FEPC, in effect in some industries during World War II). A CIO poster encouraged members to pressure Congress to pass FEP because "If *his* right to work is taken away . . . You're next!" (5.07) The "his" refers to a black worker, the "you're" to a white worker. It took nearly half of the twentieth century, but finally unions were pushing for anti-discrimination legislation. Another poster portrays two hands (again, wearing a business suit) offering the viewer a classic con game (5.08). The text warns: "It's the old shell game . . . you can't win . . . Don't be a sucker. Hate and discrimination threaten *your* freedom too!"

An abstract portrait poster makes the point that progressive unions were supporting "Equal work, equal pay, equal rights" as racial integration became part of the national political and social agendas at mid-century (5.09). The elegance of this poster's design is seen in the faces looking out at the viewer, but also by the yellow and brown profiles facing inward. This poster extends the notion of social equality directly to the workplace, and offers a simple, straightforward formula for achieving an integrated society. Visually, Tannenbaum's design combines generically indistinguishable yellow-, white-, and brown-skinned figures into a single, complex shape, fus-

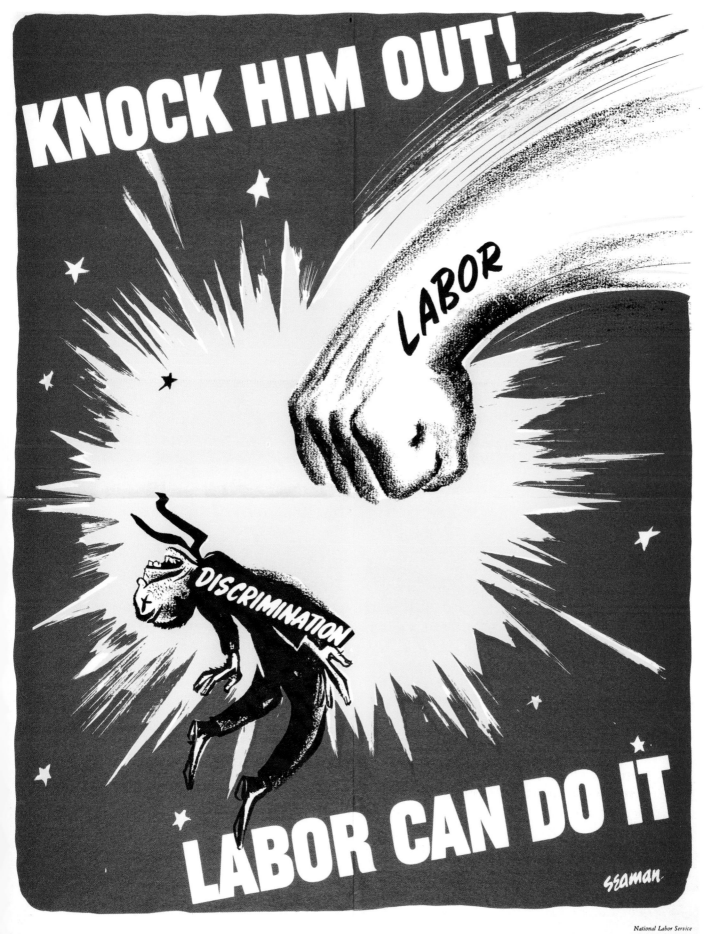

KNOCK HIM OUT!

LABOR

DISCRIMINATION

LABOR CAN DO IT

Seaman

National Labor Service

CIO COMMITTEE TO ABOLISH
RACIAL DISCRIMINATION

DISTRIBUTED BY CIO DEPARTMENT
OF RESEARCH AND EDUCATION

LITHO. IN U. S. A.

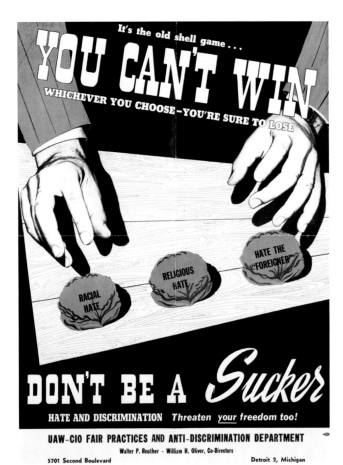

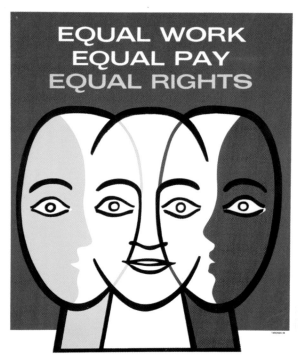

5.08 "You can't win: Don't be a sucker." Artist unknown, UAW—CIO Fair Practices and Anti-Discrimination Department, circa 1946. Offset, 56 x 43 cm.

5.09 "Equal work, equal pay, equal rights." TANENBAUM, UAW [?], circa 1960. Screenprint, 33 x 27 cm.

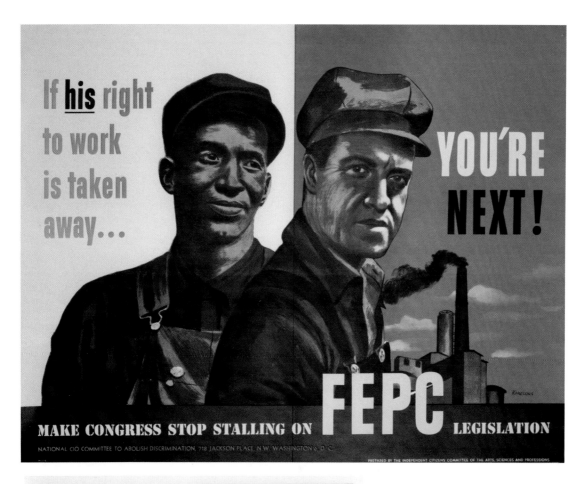

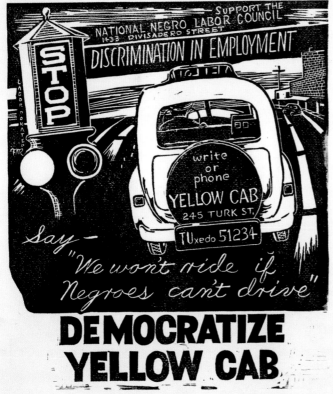

5.07 "If *his* right to work is taken away…
You're next!" [GEORGE?] KANELOUS,
National CIO Committee to Abolish Dis-
crimination, 1942–1949 (range). Offset,
56 x 43 cm.

5.10 "STOP discrimination in employ-
ment: Democratize Yellow Cab." FRANK
ROWE, National Negro Labor Council [?],
circa 1953. Linocut, 42 x 38 cm.

LABOR SUPPORTS SIT-INS!

"HE'S NEXT!"

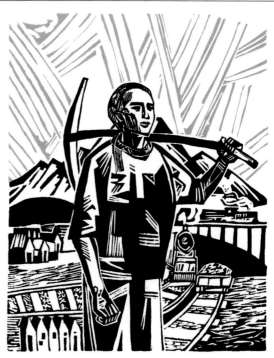

CHINESE RAILROAD WORKERS

During the 1860's, Chinese laborers were brought in to help construct the first U.S. trans-continental railroad between the Atlantic & the Pacific coasts. They worked long hours & were underpaid, and most of the time in extreme weather conditions. Many lost their lives in this historic epic, but their contributions were buried & their history untold.

5.11 "Labor supports sit-ins!" BILL SEAMAN, publisher unknown; cartoon from the Jewish Labor Committee, circa 1960. Offset, 56 x 43 cm.

5.14 "We share the dream" (Rev. Dr. Martin Luther King). AVERY CLAYTON, SEIU, 1979. Offset, 55 x 43 cm.

5.15 "Build diverse leadership." Artist unknown, SEIU Western Region, 2000. Offset, 61 x 46 cm.

5.16 "Chinese railroad workers." YI KAI, Northland Poster Collective, 1993. Screenprint, 58.5 x 44.5 cm.

Facing page 5.12 "National conference: Black Workers Congress."
Artist unknown, Black Workers Congress, 1971. Screenprint, 56 x 40 cm.

ing profile and frontal aspects, evoking a Venn diagram portraying the goals of a socially progressive (read "decent") society. One could criticize placing a white person in the center, as if other races play only supporting roles, but the overall impact recognizes the complexity of our society, and, indeed, of our racial make-up, what Chicanos call *mestizaje,* or "mixedness." The design makes its point forcefully, with no compromise allowed in the idea that these equalities are inextricably connected, that only the achievement of all three can bring about the achievement of any of them. Civil rights cannot be divorced from equal pay for equal work.

Some antidiscrimination campaigns took place at a local level. In San Francisco after World War II an independent campaign was waged to "Democratize Yellow Cab" (5.10). The poster by local artist Frank Rowe reads "Stop discrimination in employment. Say– 'We won't ride if Negroes can't drive.'" The illustration shows a receding cab, with the telephone number of the company on the spare tire, and encourages viewers to "write or phone" the company. Public political posters such as this were rare during the McCarthyism of the 1950s; Rowe suffered harassment and blacklisting, and was eventually fired from his teaching position at San Francisco State University.

In the 1960s, a poster by the Jewish Labor Committee endorsed civil disobedience, saying "Labor supports sit-ins!" with two men seated at a lunch counter, the white man pointing to the black man next to him and instructing the counterman, "He's next!" (5.11) Significantly, the white worker is drawn to look like a manual laborer, while the black man standing up for dignity wears a suit—in the era before student radicals wore jeans and t-shirts.

In the mid 1960s the rise of the black power movement (the precursor to later identity politics) and other move-

ments for social change encouraged broad social demands. The Black Workers' Congress (BWC, a short-lived splinter group from the League of Revolutionary Black Workers) in Detroit published a poster in 1971 celebrating Toussaint L'Overture's 1791 slave rebellion in Haiti (5.12). The message is strength, leadership, and pride in racial heritage, all of which are encouraged by the BWC. A weathered picket sign from Students for a Democratic Society (SDS), the Student Mobilization Committee (SMC), and alternative media producer Newsreel announces that "We support black workers' just demands," an example of New Left organizations including a class analysis in their challenge to institutional racism (5.13).

Similarly, unions supported the civil rights movement. An SEIU poster states, "We share the dream," an example of unions acknowledging that anti-racist ideas and civil rights are crucial to effective labor organizing (5.14). SEIU also sought to formally diversify its own leadership, and in 2000 the Western Region Conference issued a poster saying just that (5.15). The poster sponsors include a veritable ethnic/excluded group rainbow—African American, Asian Pacific Islander, First Americans, Latino, lavender lesbian, gay, bisexual, people of disabilities, retired member caucus, and women's caucus.

The struggle for inclusion continued in many other places, as individuals created posters with positive depictions of a wide variety of people, such as the one about Chinese railroad workers designed by Yi Kai (5.16). An American Federation of Teachers (AFT) poster about Asian Pacific Heritage Month, with an illustration of historical roles played by the group, shows a range of trades (5.17). SEIU local 707's "Brown and white: Unite!" and the Union of Needletrades, Industrial and Textile Employees (UNITE) founding convention poster by well-known

National Conference

DETROIT 1971

BLACK WORKERS CONGRESS

AUG 22

TOUSSAINT L'OVERTURE

led slave rebellion in Haiti - 1791

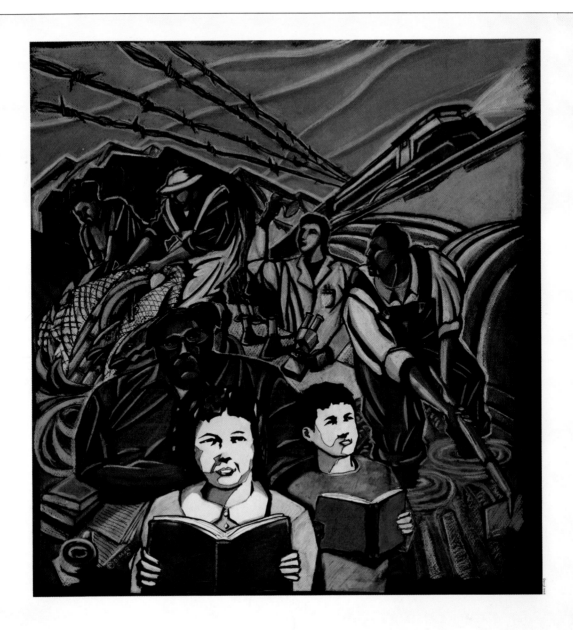

Asian Pacific Heritage Month

American Federation of Teachers, AFL-CIO

Facing page 5.13 "We support black workers' just demands." Artist unknown, Student Mobilization Committee (SMC); Students for a Democratic Society (SDS); Newsreel, circa 1968. Letterpress, 56 x 36.5 cm.

5.17 "Asian Pacific Heritage Month." DARRYL MAR, AFT Civil and Human Rights Committee, circa 1993. Offset, 71 x 56 cm.

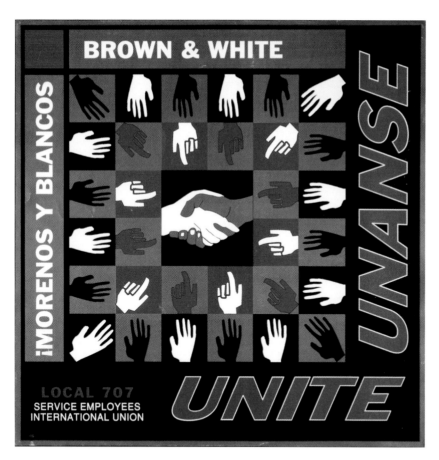

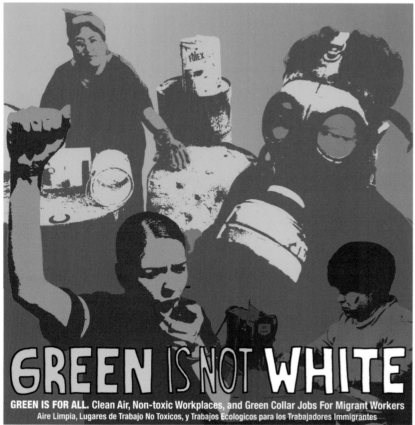

5.18 "Brown and white: Unite!" Artist unknown, SEIU Local 707, circa 1980s. Offset, 62 x 46 cm.

5.20 "Green is not white." FAVIANNA RODRIGUEZ, self-published. 2007. Digital print, 86 x 86 cm.

artist Paul Davis amplify the theme (5.18–5.19). In the early twenty-first century, Favianna Rodriguez produced "Green is not white, green is for all. Clean air, non-toxic workplaces, and green collar jobs for migrant workers," arguing that environmental safety should be a demand for people of all races (5.20).

In the twenty-first century, the dramatic expansion of globalization means that the labor movement has to deal with capital flight, outsourcing, guest workers, and greater interdependence with foreign markets. This has posed a significant policy challenge for U.S. labor unions. One typical position is that globalization is bad for the interests of local workers and must be resisted at every turn, but other analyses suggest that protective measures such as tariffs and quotas are unproductive and that labor must organize beyond national borders. The issue is at the root of contentious debates about such things as NAFTA and the subsequent Central America Free Trade Agreement (CAFTA) (see chapter 6). Northland Poster Collective's globalization poster depicts foreign workers being moved about the world much as slaves were in Thomas Clarkson's 1789 poster described in the chapter 1 (5.21). Wage laborers are still "wage slaves," even if they now travel by jumbo jet. Note the additional cargo of firearms, hinting at the mercenary nature of global labor brokering.

Because the attention given by posters to race and civil rights involves increasing attention to issues of immigration and the global workforce, we turn next to labor posters about war, peace, and internationalism before returning to domestic examples.

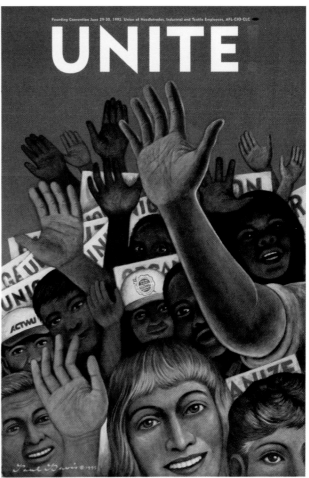

5.21 "Globalization: The next generation." RICARDO LEVINS-MORALES, Northland Poster Collective, 1992. Offset, 43 x 56 cm. Courtesy Yi Kai.

5.19 "Unite!" PAUL DAVIS, UNITE, 1995. Offset, 66 x 45.5 cm.

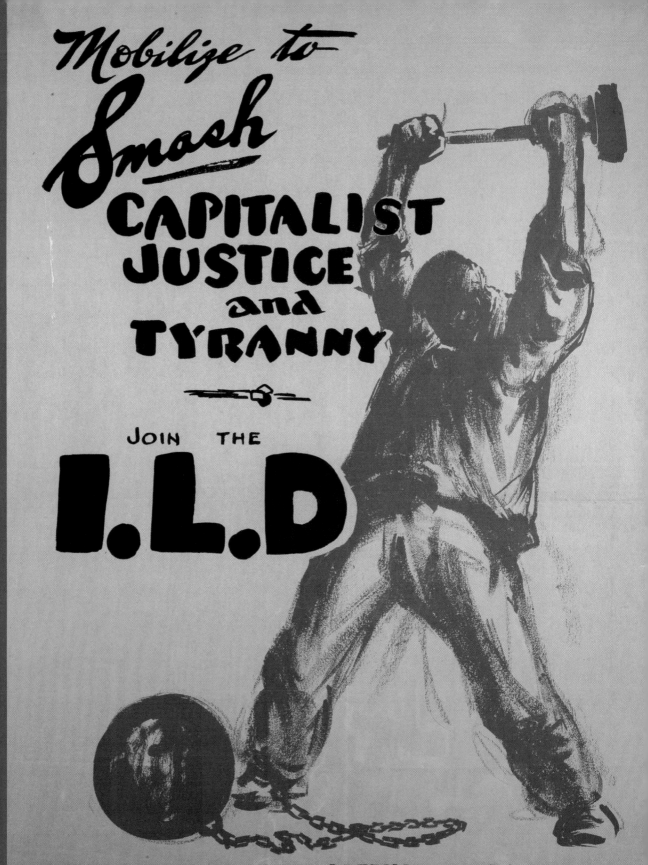

Mobilize to
Smash
CAPITALIST
JUSTICE
and
TYRANNY

JOIN THE
I.L.D

INTERNATIONAL LABOR DEFENSE 80 E. 11th ST. N.Y.C NEW YORK

THOUSANDS OF NEW MEMBERS To Build our WORKERS' DEFENSE ORGANIZATION • FUNDS To Save WORKERS From CAPITALIST DUNGEONS • SUBSCRIBE TO THE LABOR DEFENDER

WAR, PEACE, AND INTERNATIONALISM

"Do you strike for only economic reasons? Have you no moral concept?" asks a poster in this chapter. Often, especially in the early years of the twentieth century for organized labor, the answer was "no." By mid-century, increasingly large numbers of people fought openly against racism and for decent treatment for everyone, and that eventually included workers in foreign countries, goaded by the New Left's challenge to labor for its support of the Vietnam War and by posters like the one just quoted. Although working people have been used as cannon fodder for wars between the rich and powerful throughout history, working people's response to war and their relationships to foreign workers has varied enormously over time.

International Labor Defense (ILD) lasted only a brief time but its message is made clear in a poster depicting workers as prisoners with a need to "Mobilize to smash capitalist justice and tyranny" (6.01). Literalizing the metaphor of "wage slavery," the powerful, dynamic drawing of a worker could as easily be a convict breaking rocks as a worker trying to break the chains binding him. The ILD argued that because capitalism is international, so must be labor's concerns. By the late 1930s, as fascist forces were spreading in Europe, the newly formed Jewish Labor Committee produced a poster encouraging workers to "Fight Nazism and fascism!" that was endorsed by and imprinted for distinct memberships within the labor community (6.02).

The most obvious example of labor's internationalism is in the yearly celebration of International Workers' Day (May Day), recognizing both international ties and local issues. It is an occasion for the left to publicly show its support for working people. A 1972 poster of indeterminate origin includes a list of workers' demands, all of which relate to the government and not to any specific employer (6.03). Included are demands to get out of the Vietnam War and fight racism on the job and in the community, two issues that extend beyond the workplace. It serves us all well to remember that May Day originated in the United States. Jos Sances' 2005 May Day poster is derived from, and elegantly credited to, Walter Crane's classic 1895 "A garland for May Day" poster (6.04 and 6.05). Sances is a Bay Area master printmaker and muralist. In his poster, a teacher and a nurse take the place of Crane's goddesses, and the aspirations woven through the garland are updated. This is an American poster derived from an English one, published at a U.S. union print shop announcing a benefit for a Middle Eastern peace group—International Workers' Day incarnate.

Mike Alewitz, a scenic artist, muralist, and professor at Central Connecticut State University created a series of five posters called "The worker in the New World Order" (6.06–6.10). The title piece is a variation on another Crane poster, "Workers of the world, unite!" The revised banderol across the globe now reads *"La solidaridad obrera no tiene fronteras"* (Worker solidarity has no borders), and the series shows that the experiences of workers everywhere

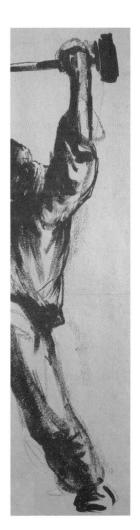

Facing page 6.01 "Mobilize to smash capitalist justice and tyranny." Artist unknown, ILD (NY), circa 1928. Offset, 92 x 61 cm.

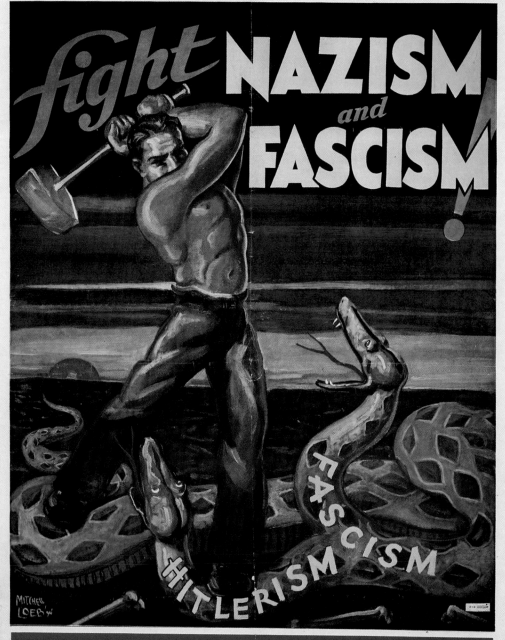

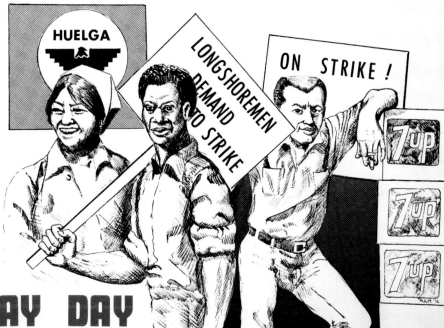

INTERNATIONAL WORKERS DAY

RALLY

SUNDAY, APRIL 30
12:00 NOON
SAN ANTONIO PARK
FOOTHILL BLVD.
(btw. 16th & 18th Ave.)
OAKLAND

HUELGA

LONGSHOREMEN DEMAND TO STRIKE

ON STRIKE !

WORKERS DEMAND:

1. Defeat the government's anti-labor laws. Defend the right to strike!

2. End speed-up & harrassment on the job!

3. Jobs or income while unemployed! Stop the welfare "work projects"--We won't be slaves or scabs!

4. For workers' solidarity--fight racism on the job & in the community!

5.
End the bosses' war in Vietnam, Laos & Cambodia!

MAY DAY

·A·GARLAND·FOR·MAY·DAY·1895·
·DEDICATED·TO·THE·WORKERS·BY·WALTER·CRANE·

Facing page 6.02 "Fight Nazism and fascism." Mitchell Loeb, Jewish Labor Committee (original poster attributed), with subsequent imprintings by ILGWU and other labor organizations, 1934. Lithograph, 89.5 x 52 cm.

6.03 "International Workers Day. May Day." R.K.M. (initials on poster), artist name unknown, client unknown, 1972. Offset, 36 x 51 cm.

6.05 "A garland for May Day" (reprinted edition). Walter Crane, client unknown, 1895 original (date of reprint unknown). Offset, 59 x 44 cm.

**In Celebration of International Workers Day,
the 17th Anniversary of Middle East Children's Alliance
and the 15th Anniversary of Alliance Graphics**

6.04 "May Day 2005." Jos Sances (after Walter Crane), Middle East Children's Alliance; Alliance Graphics, 2005. Screenprint, 57.5 x 43 cm.

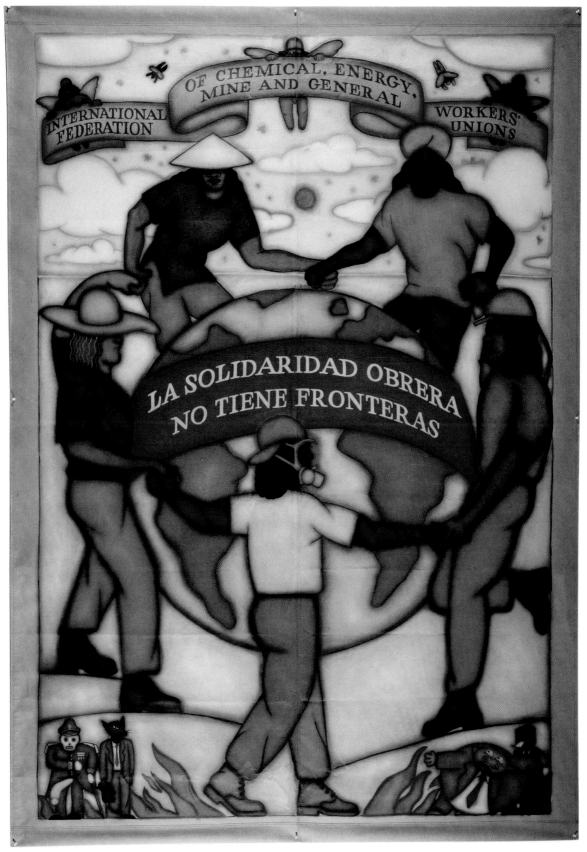

6.06 "International solidarity: The worker in the New World Order." MIKE ALEWITZ, ICEM, 1995. Offset, 36 x 28 cm.

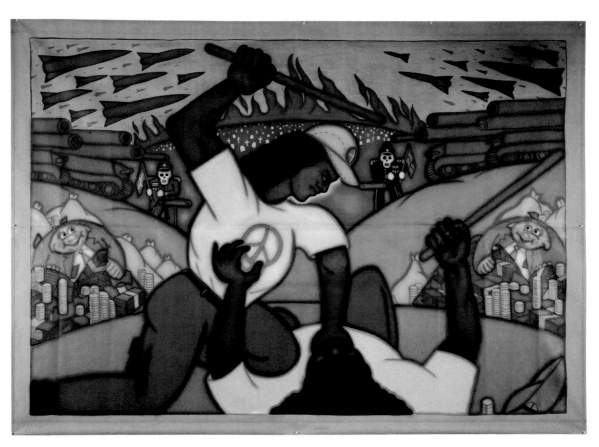

6.07 "Competition: The worker in the New World Order." MIKE ALEWITZ, ICEM. 1995. Offset, 28 x 36 cm.

6.08 "Bureaucracy: The worker in the New World Order." MIKE ALEWITZ, ICEM, 1995. Offset, 28 x 36 cm.

6.09 "Production: The worker in the New World Order." MIKE ALEWITZ, ICEM, 1995. Offset, 28 x 36 cm.

6.10 "Unity: The worker in the New World Order." MIKE ALEWITZ, ICEM, 1995. Offset, 28 x 36 cm.

Facing page 6.11 "Ceylon tea: Product of European exploitation." RUPERT GARCIA, self-published, 1972. Screenprint, 66 x 51 cm. Courtesy Rupert Garcia and the Rena Bransten Gallery, San Francisco.

are similar. Significantly, this series was commissioned by an international labor union (the International Federation of Chemical, Energy, Mine and General Workers Unions) to emphasize the fact that labor issues are global.

Rupert Garcia's "Ceylon tea" provides a sarcastic "deep reading" of a Lipton's tea package (6.11). Tea is a classic colonial product (consider our own Boston Tea Party). But contrasted with a supergraphic from the original product label, Garcia hits us with the provocative subtitle "Product of European Exploitation" to destroy any naiveté about the consumer relationship to foreign labor. Figure 6.12, *"Solidaridad con las costureras de Guatemala"* (Solidarity with the seamstresses of Guatemala), is similar to Garcia's when it asks, "Was your shirt made by Guatemalan women earning 65 cents an hour?" The bird depicted above the woman and machine is a Guatemalan quetzal, its breast stained red. It is not a peace dove, but surely reminiscent of one.

The Central American Trade Unionists' poster, using the iconic gear wheel image calls for support of labor in three Central American countries, and an end to U.S. intervention in Central America (6.13). Two decades later, poster emphasis shifted to Mexico and targeted NAFTA, eventually passed by the U.S. Congress but opposed by the AFL-CIO. Union warnings about its damage to the U.S. labor force, including job loss "off shore" (mainly to Mexico) proved accurate. The anti-NAFTA poster here puts a human face on the different kinds of people and jobs threatened by NAFTA (6.14). NAFTA is one example of the "globalization airplane" ferrying workers and jobs across international borders[1] (see 5.21).

Figure 6.15, "Mexican Workers—*Trabajadores Mexicanos,"* announces an exhibit by longtime labor photographer, author, and activist David Bacon documenting the dignity of the Mexican workforce. Another poster dealing with much the same population is "Farmworkers demand," which challenges the exploitation of migrant workers here in the United States (6.16). The issue is politically framed as immigration of workers called illegal aliens by those who want to raise racist fears, but as undocumented workers by those more humane. The poster pictures a hole torn in a chain link fence forming the silhouette of a farm worker with fields stretching out beyond. The bottom tag is a reversal of the classic U.S. desire when it says "Don't fence us out!", an example of verbal detournment.

Historically, leaders of organized labor have taken both progressive and conservative stances in the name of their memberships. During the cold war, the AFL-CIO was deeply aligned with anticommunist efforts at home and abroad carried out by the U.S. government and international businesses. This included the formation of the American Institute for Free Labor Development, part of the AFL-CIO in 1962, which worked with the CIA and was committed to destabilizing foreign unions that were not sympathetic to capitalism. When the independent Polish shipyard union Solidarność (Solidarity) encountered government repression in 1980, the AFL-CIO provided massive overt and covert support in the name of international labor brotherhood. This led to the ironic situation of organized labor being aligned with forces that were busting unions at home while it was assisting unions of the "right type" overseas. This apparent hypocrisy is the unspoken background of the AFL-CIO Polish Workers Aid Fund poster, featuring striking workers and the words "Polish workers have told the world. We want free and independent unions. Support the Polish Workers…Support Free Unions" (6.17). It was not until the 1995 election of

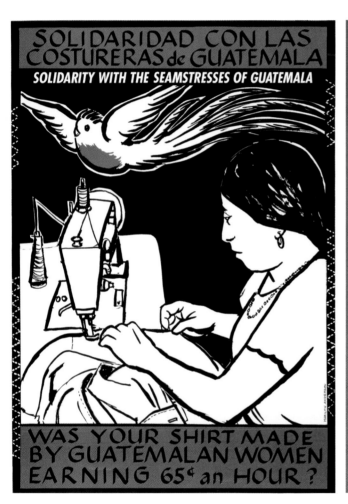

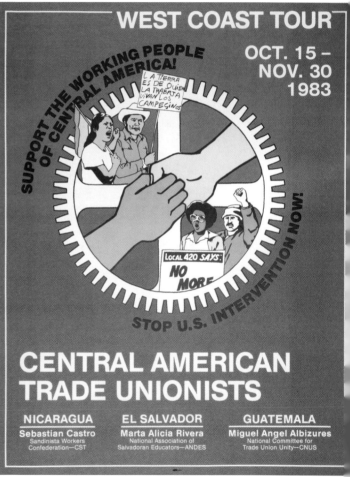

6.12 "Solidarity with the seamstresses of Guatemala: Was your shirt made by Guatemalan women earning 65 cents an hour?" MARILYN ANDERSON, U.S.—Guatemala Labor Action Project, 1991. Screenprint, 61 x 45 cm.

6.13 "West Coast tour: Central American trade unionists." Artist unknown, Trade Unionists in Solidarity with El Salvador (TUSES), 1983. Offset, 56 x 43 cm.

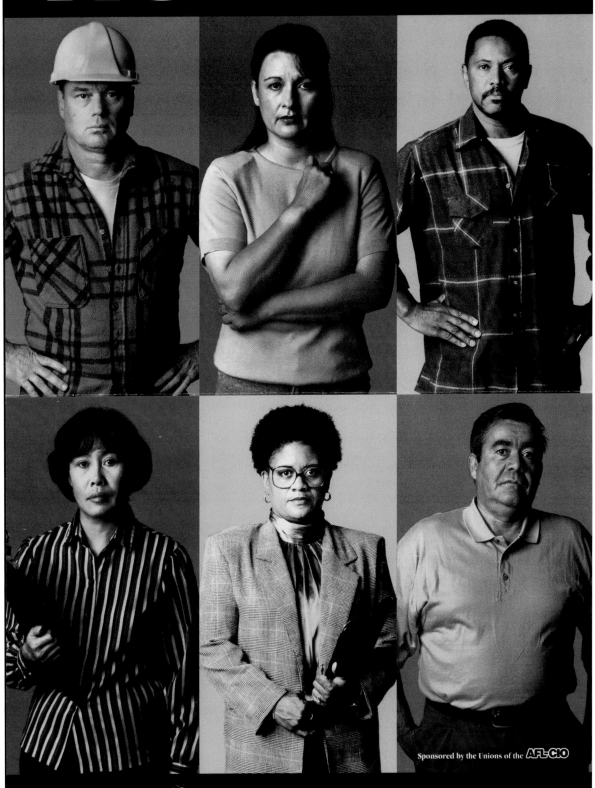

NO NAFTA.

Sponsored by the Unions of the **AFL-CIO**

6.14 "No NAFTA." Artist unknown, AFL-CIO, circa 1993. Offset, 43 x 28 cm.

6.15 "Mexican Workers—*Trabajadores mexicanos*"
(exhibit). DAVID BACON, Northern California Coalition
for Immigrant and Refugee Rights, 1996. Offset, 51 x
41 cm.

6.16 "Farmworkers demand: Don't fence us out!"
DAVID (DAVE) LOEWENSTEIN, Workforce Development
Institute, Bread and Roses Cultural Project, SEIU
1199, Justseeds, 2007. Offset, 64 x 48 cm.

6.17 "Polish workers have told the world: We want
free and independent unions." Artist unknown,
AFL-CIO Polish Workers Aid Fund, 1980. Offset,
76 x 58.5 cm.

SEIU's John Sweeney to head the AFL-CIO that international-al labor support became more moderate . The AFL-CIO's Solidarity Center now works with labor activists around the globe challenging globalization and exploitation by multinationals. Similarly, the independent labor/human rights organization Labor Rights Now produced "China: Free Yao, free Xiao," addressing obstacles to workers' rights in an ostensibly socialist country committed to proletarian leadership but in reality a form of capitalist state with few worker protections (6.18).

Because the core of its business is transportation across borders, the ILWU has often been at the forefront of supporting international labor rights. With a dash of humor, Doug Minkler shows how multinational corporations rise above the laws of nations. His poster is cast in the form of a show presented by the ILWU titled "Training your multi national" (6.19). The multinational corporation is depicted as a bulldog sitting on the *Neptune Jade* freighter, which the ILWU refused to unload because it was being sanctioned by English dockworkers. This action, which relied heavily on the Internet to spread the word, marked a new chapter in the history of international solidarity that has been the ILWU's trademark since the 1930s. The bottom tag says to "Defend the right to picket and honor picket lines, stop the witch hunt, drop the lawsuits," referring to tactics used by the government to quash solidarity with laborers elsewhere in the world.

Several posters address a worker's right to dignified labor (see chapter 2). Figure 6.20, "End apartheid," from 1986 is not about labor so much as racism and international human rights. The poster's impact comes from the blood-like splatters of red ink in front of the protesters. This poster is a generic work with blank space to be filled in with time and place details of rallies in different cities across the

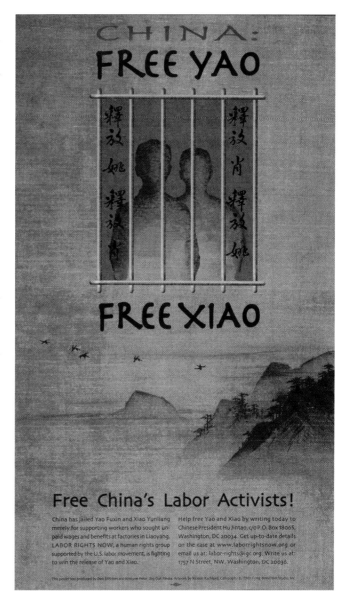

6.18 "China: Free Yao, free Xiao." Kirsten Rachford, Don Stillman / Kristyne Peter, 2004. Offset, 74 x 43 cm.

United States. The Africa Fund Labor Desk produced "Apart-heid regime: Hands off labor" around the same time, focusing specifically on South African workers and their demands for justice (not higher wages or workplace-related issues) (fig. 6.21). The United Steel Workers of America (USWA), as part of its series on labor, calls for "Human rights for all workers," and shows multinational workers marching beneath the U.N. flag against a rainbow background (6.22).

Organized labor and working people are also concerned with international peace, and see recognition of foreign workers as fellow laborers suffering exploitation as one step toward a more peaceful world. Ben Shahn's early CIO poster raises the idea that labor unions support peace through democratic elections (6.23). Showcasing Shahn's exquisite artwork, the poster powerfully depicts a young boy asking for peace (rather than a handout). During World War II, organized labor was wholeheartedly behind winning the war. Aside from practical questions of wartime contracts favoring business, the war effort itself was beyond question.[2] However, a significant shift occurred during the Vietnam War. Historian Philip Foner noted that, at first, "Labor spoke with a Neanderthal voice. In May of 1965, George Meany declared that the AFL-CIO would support the war in Vietnam 'no matter what the academic do-gooders say, no matter what the apostles of appeasement may say.'"[3] Unions were initially very hawkish, but eventually came to support left demands for an end to the war because it was increasingly unpopular and had an enormous impact on the economy at home.

This acceptance of an antiwar message within organized labor is exemplified by the 1971 "March for peace" poster endorsed by San Francisco Bay Area Central Labor Councils with such slogans as "Construction yes—destruction no," and "The Vietnamese never froze my

6.19 "ILWU presents: Training your multi national." DOUG MINKLER, ILWU, 1997. Screenprint, 74 x 47 cm.

wages" (6.24). The 1970 Poster Factory poster appeals to broader human values with a Vietnamese woman holding her bleeding baby beneath U.S. warplanes labeled "Labor" (6.25). It asks U.S. workers: "Do you strike only for economic reasons? Have you no moral concept?" In 2004, U. S. Labor against the War produced a poster calling on businesses to "Stop the corporate invasion of Iraq! Respect labor rights in Iraq & USA!!! Bring the troops home NOW!"[4] (6.26) The poster's insignia is a peace dove with olive branch perched on a raised fist holding a wrench/pencil. On May 1, 2008, members of the ILWU stopped work at twenty-nine West Coast ports to protest the impact of the U.S. military intervention in Iraq and Afghanistan on workers in this country as well as overseas. Doug Minkler's poster animates the container ship cranes and makes them militant allies in defense of social justice (6.27).

The targeting of specific corporate interests and the impact of multinational corporations on daily life across the planet is part and parcel of the internationalization of labor. Minkler's Chico Mendes poster is a good closing example of a poster noting how issues in one location affect those in other locations, even internationally (6.28). Mendes was murdered because his actions as a Brazilian labor organizer threatened corporate developments there, but his commitment to organizing labor unions and fighting the destruction of the rainforest connects him with workers around the world.

6.20 "End apartheid." FOSTER, AFL-CIO, 1986. Offset, 68.5 x 43.5 cm.

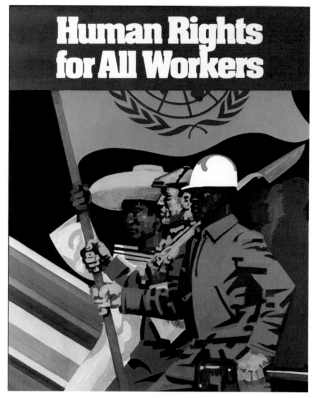

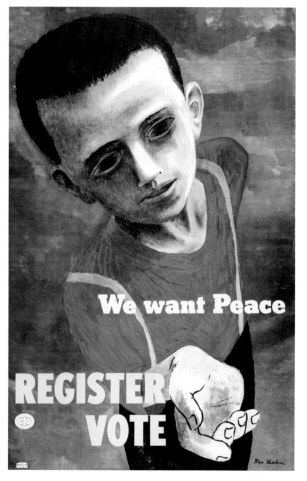

6.21 "Apartheid regime: Hands off labor" SARAH HODGSON, Africa Fund, 1992. Offset, 61 x 46 cm.

6.22 "Human rights for all workers." Artist unknown, USWA, (uncredited, derived from hardhat logos), circa 1980s. Offset, 76 x 61 cm.

6.23 "We want peace." BEN SHAHN, CIO Political Action Committee, 1946. Offset, 105.5 x 68.5 cm.

Facing page 6.24 "March for peace April 24." Artist unknown, San Francisco Bay Area labor councils, 1971. Offset, 56 x 43 cm.

LABOR CONTINGENT ASSEMBLE AT 10:00 A.M., KIMBELL PARK, GEARY AND STEINER STREETS

MARCH TO RALLY 1:30 P.M., POLO FIELD, GOLDEN GATE PARK

ENDORSED BY SAN FRANCISCO, SANTA CLARA, CONTRA COSTA AND SAN MATEO LABOR COUNCILS, AFL-CIO

NATIONAL PEACE ACTION COALITION, Labor Support Committee, 755 Market Street, San Francisco • Phone 989-9320

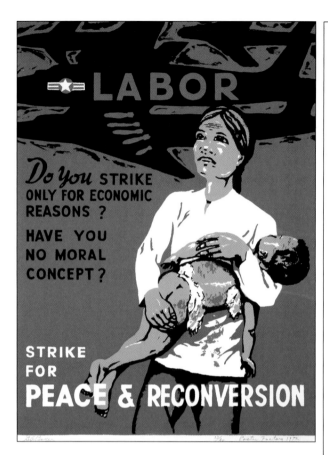

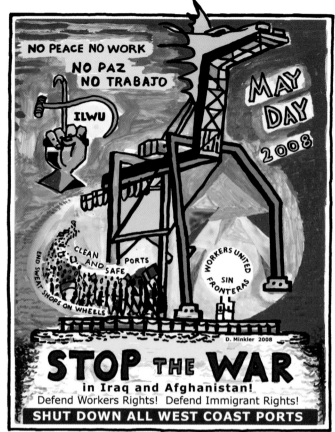

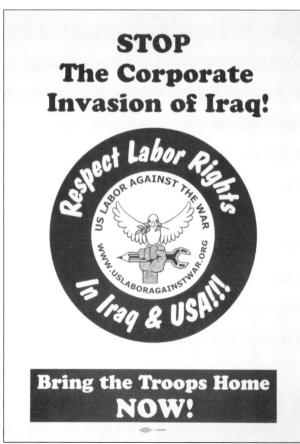

6.25 "Labor: Do you strike for only economic reasons?" GEORGE BEYER, Poster Factory (Minneapolis), 1972. Screenprint, 57.5 x 44.5 cm.

6.26 "STOP the corporate invasion of Iraq!" Artist unknown, U.S. Labor Against the War, 2004. Offset, 60 x 43.5 cm.

6.27 "Stop the war." DOUG MINKLER, ILWU, 2008. Offset, 48 x 23 cm.

Chico Mendes 1944-1988

Father of three, Union Organizer and founder of the Alliance of the People of the Forest.

Working with rubber tappers and the Union of Indigenous Nations, he pioneered the creation of extractive reserves (areas set aside for collecting sustainable forest products such as rubber and Brazil nuts). He opposed the cattle barons and plantation owners who were turning the fertile rainforest into barren desert, and who eventually ordered his murder.

To help carry on Chico's work and to join in the international demand that his killers be brought to justice and cease attacks on union organizers and rubber tappers, please contact:
Rainforest Action Network, 301 Broadway, San Francisco, CA 94133

6.28 "Chico Mendes 1944–1988." Doug Minkler, Rainforest Action Network, 1989. Screenprint, 37.5 x 33 cm.

THE LABOR MOVEMENT!
THE FOLKS THAT BROUGHT YOU...
FOUGHT FOR: SUPPORTED: DEFENDS: DEMANDS
OVERTIME PAY
LIVING WAGE LAWS
DOMESTIC PARTNER BENEFITS
PAID VACATIONS
CHILD LABOR LAWS
PARENTAL LEAVE
SICK LEAVE
SOCIAL SECURITY
CIVIL RIGHTS
PENSION BENEFITS
OSHA
GRIEVANCE PROCEDURES
WORKPLACE POWER
HEALTH BENEFITS
WORKERS' COMP.
MINIMUM WAGE
FARM LABOR RIGHTS!
UNEMPLOYMENT INSURANCE
THE WEEKEND
EQUAL PAY FOR EQUAL WORK
POWER CONCEDES NOTHING WITHOUT A DEMAND. IT NEVER DID AND IT NEVER WILL. FREDERICK DOUGLASS

7 SOLIDARITY AND ORGANIZING

The top of a rickety staircase looms ahead. The walls seem to close in and creaks grow louder as you climb higher. At the top, the boss's door is open a crack so you can see him sitting behind his desk, self-satisfied, powerful, waiting for you. With union membership, you don't have to climb those stairs alone. The concepts of "organizing," internal to the workplace, and "solidarity," external to it, are two major thrusts of the union movement insuring that workers have representation when facing bosses who command power, which too often includes fear, over their lives.

The posters in this chapter are of two basic types. One encourages workers to organize, to form or join a union, the other encourages support for union and labor actions by people who are not members themselves—solidarity posters.

Why organize? Some of these examples show why a union is a good thing for workers. A Northland poster notes that it will not be easy either to build or join a union, but that efforts in the past have paid off (7.01). "The labor movement" brought such benefits as living wage laws, child labor laws, sick leave, pension benefits, grievance procedures, workers' compensation, equal pay for equal work, and the weekend. A crowd holds signs listing these and other benefits, with a quotation from Frederick Douglass: "Power concedes nothing without a demand. It never did and it never will." Is it worth the battle? Franklin D. Roosevelt thought so; his quote, "If I were a worker . . . the first thing I would do would be to join a union," is often repeated in labor publications because unions can offer immediate and practical benefits. One organizing poster shows a portrait of a smiling woman who was saved from dismissal because the Amalgamated Clothing and Textile Workers Union (ACTWU) intervened on her behalf (7.02). Another poster features an intimidating photo of a boss's office and the headline, "With a union, you don't have to go in there alone" (7.03) It then lists worker rights including taking an elected steward with you, "to defend you, to be your witness, and to protect your rights under a union contract."

Bob Carol's and Estelle Simpson's poster makes the point: "It's your right to have a union!" (7.04) It shows a white collar worker and a blue collar worker, both wearing buttons saying "Union and Proud," and a non-union worker whose collar is a chain around her neck. Lest it be thought that these are just historical posters whose message no longer applies in today's world, note Nicole Schulman's 2007 design encouraging Starbucks workers to join the IWW (7.05). It features a strong woman at the center, holding a wrench and wearing a green apron and a union baseball cap. "You have the right to organize," the poster reminds us. The illustration echoes the "We can do it!" image, and thus ties this twenty-first-century campaign to earlier job actions. Visually, it also suggests that if organizing isn't allowed perhaps a wrench

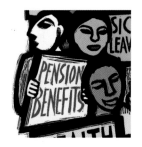

Facing page 7.01 "The labor movement! The folks that brought you…" RICARDO LEVINS-MORALES, Northland Poster Collective, 2007. Offset, 43 x 23 cm.

Facing page 7.02 "Saved."
Artist unknown, ACTWU, 1978.
Offset, 57 x 44.5 cm.

will be thrown into the works.

Once a union is established, Doug Minkler reminds us with a picture of a boss driven mad with anger, "A good indicator of your union or shop paper's strength is management's reaction to it" (7.06). Beneath the boss's feet are union newspaper scraps advocating such benefits as parental leave, childcare, safety, privacy, and no hiring tiers.

Another group of posters captures the challenge and the spirit of union organizing. An OCAW poster directed to union members touts "Organizing as a way of life," educating the organizers so they can be more effective (7.07). It reminds viewers of the union's track record of "jumping to the side of a union member," and "jumping the boss when he tells a lie." The illustration is a bold line drawing by Rini Templeton, an artist who never copyrighted her work so that it could freely be used within the struggle. The AFL-CIO Organizing Institute issued a poster with a smiling woman and a caption reading "Union organizer, the best job in America" (7.08). A USWA poster has a large still from the movie *Norma Rae* showing Sally Field's character holding up a sign saying simply, "Union" (7.09). The photograph itself is dynamic, because it reminds us of an exciting moment in the movie. It also gains credibility by in effect having a movie star promote the union. The USWA also produced a poster titled "Don't mourn, organize!" with a painting by Ben Shahn linking the union with patriotism. This classic working-class exhortation is a paraphrase from Joe Hill's declaration at his execution in 1915, and was popularized through song: "Proud Steelworker. Proud Citizen" (7.10). The man carries a piece of steel on which is written, "Organize." Milton Glaser, one of the country's leading designers, created a poster honoring labor historian Moe Foner (7.11). The word "Or-

ganize!" is arranged vertically in the shape of an exclamation point, an homage to revolutionary Soviet artist Aleksandr Rodchenko's classic constructivist study for a 1923 cover design for B. Arvatov's *On Mayakovsky*.

Organized labor has always been involved in the electoral arena (see chapter 9). One recent effort was the formation of the Labor Party, founded in 1996 and commemorated in a poster by Mike Alewitz—a reminder that voting and participating in democracy are important gestures of solidarity and, potentially, organizing (7.12).

Anti-union posters have also been produced. In the intense Red Scare period during and immediately after World War I, a series of posters was produced decrying criticism of bosses under the guise of industrial patriotism. One poster betrays discomfort at what wage work does to people, disingenuously declaring: "We are human 'round here . . . Let us help each other," an empty notion when employers control not only working conditions but employment itself (7.13). Another poster warns to "Watch out for the union trap!" the last two words being written in scary, jagged letters (7.14). A wryly humorous anti-union poster, un-credited and apparently part of the office poster genre shows a pen filled with turkeys and the caption "Now that we're organized, what do we do?" (7.15) Of course, this might also be a humorous in-house union poster hung after winning a recognition vote.

Unions are acutely aware of attacks from the right and have mounted their own responses. One anti-anti-union poster shows a man's arms while he rolls up his sleeve and calls to "Demonstrate!" Bust up the union busters!" (7.16) The poster announces a demonstration at a convention of "professional scabs [who] teach the methods used by Big Business to weaken and break our unions and block union organizing." "A 'bean-ball' is *pilau*" was created by

On January 12, 1978
J.P. Stevens in Roanoke Rapids
tried to fire Linda Blythe

LINDA BLYTHE — Hired: July 21, 1975

On February 2, 1978
ACTWU saved her job.

WITH A UNION, YOU DON'T HAVE TO GO IN THERE ALONE.

When the boss calls you in the office, chances are it's <u>not</u> to give you a pat on the back.

With a union, you have a right to take an elected steward with you. That person is trained to defend you, to be your witness, and to protect your rights under a union contract.

Of course, you can still speak for yourself.

But with a union, you never have to face the boss alone.

And that's the law.

7.03 "With a union, you don't have to go in there alone." Artist unknown, J. P. Stevens Boycott Campaign [?], circa 1975. Offset, 57 x 44.5 cm.

7.04 "It's your right to have a union." ESTELLE CAROL, BOB SIMPSON; Merced—Mariposa Labor Council, circa 1985. Offset, 63.5 x 5 cm.

Facing page 7.05 "You have the right to organize. Starbucks workers union." NICOLE SCHULMAN, Workforce Development Institute, Bread and Roses Cultural Project, SEIU 1199, Justseeds, 2007. Offset, 64 x 48 cm.

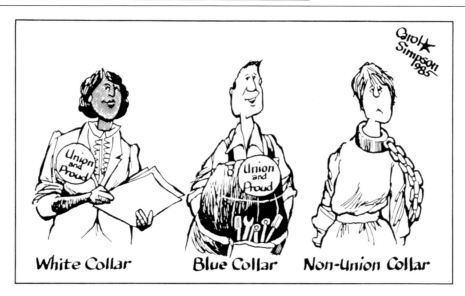

It's your Right to have a Union!
MERCED-MARIPOSA LABOR COUNCIL — AFL-CIO

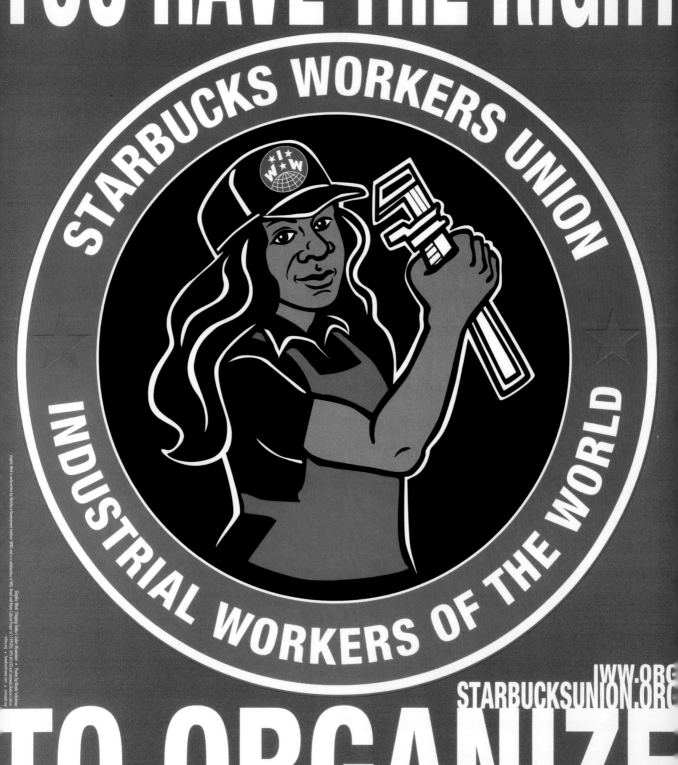

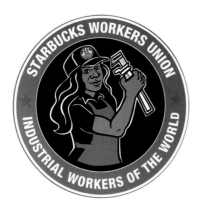

ILWU Local 142's education director David Thompson as a brave response to the indictment of ILWU Hawaiian Regional Director Jack Hall under the Smith Act during the anticommunist labor attacks of the 1950s (7.17). This is an example of reaching out to a diverse membership through multilingual text and a common interest—baseball. *"Pilau"* is pidgin for "stinks." A 1993 poster issued during a bitter three-year strike by the United Paperworkers International Union (UPIU) Local 7837 against the corporate subsidiary A. E. Staley exhorts the community to "Stop ADM/Tate & Lyle union-busting" (7.18). Part of successful organizing, as these three posters recognize, is resisting efforts to destabilize union movements. Positively oriented campaigns, however—those focused on the best ideals of collectivity—are the most effective and the foremost of these ideals is the concept of solidarity.

Solidarity is the most important defense against attacks on organized labor. The concept is so important it is one of the basic songs on picket lines and in union halls across the country: "Solidarity forever . . . the union makes us strong!" Bargaining gains are made through collective bargaining, and the more unified the unit is, the stronger its position against management. Solidarity captures another basic union tenet: "an injury to one is an injury to all." These principles have been articulated in posters, too. The Allied Industrial Workers Union (AIW) printed a drawing of a heron gobbling green frogs labeled "union" and "solidarity" with the motto, "Don't *ever* give up! Fight corporate greed with union solidarity!" The frogs may be holding on for dear life, but these frogs have teeth (7.19).

The AFL-CIO declared September 19, 1981, Solidarity Day in its support of the 1981 Professional Air Traffic Controllers Organization (PATCO) strike, and unions across the country turned out to celebrate this fundamen-

tal principle and to make their strength visible. A poster announcing the demonstrations used a typeface similar to the Polish union Solidarność, with a man and woman standing together against their foe (7.20). The UAW poster for this event had a fist decorated like the American flag, declaring labor solidarity to be patriotic (7.21).

Another example of community among working people is the annual Labor Day picnic. One poster for this event shows a line of contemporary workers backed up by a line of workers from a century ago as it celebrates "One hundred years of solidarity" (7.22). With relatively small changes, the poster was reproduced in another version the following year, and in yet another form, using just one section of the longer line of workers in the original poster.

While "solidarity" has been a slogan for nearly all of the twentieth century, a multiracial presence is relatively new, making its way into posters during World War II when the government proclaimed, "We're all in this together." A question arises here concerning the relationship between calls for solidarity and "identity organizing" (organizing limited to working with single groups defined by their gender or racial identity), because the latter is to some extent divisive and counter to the principle of solidarity. Nevertheless, groups sharing particular characteristics have formed, and issued posters addressing their specific concerns. Examples include the Black Workers' Congress (BWC), a group working within the union movement as a whole, but recognizing the specific needs of black workers and functioning as a caucus to address those needs and make sure the larger union does too. SEIU's Justice for Janitors (J4J) campaign in the early twenty-first century is another example, where appeals were made through posters to bring justice to this particular group of workers within the larger union movement: "One union, one indus-

try, one contract: April one" (the day of the union representation vote) (7.23). A San Francisco J4J poster with the organization's slogan in four languages has a hand holding a broom against the San Francisco skyline (7.24).

As part of its campaign to gain union recognition, the UFW not only picketed fields and wineries but held community meetings to encourage solidarity in support of the union, as exemplified by an announcement by the Royal Chicano Air Force (RCAF) with the UFW black eagle modified into almost quetzal-like proportions (7.25). Another UFW poster from Atlanta, Georgia, displays the traditionally black UFW eagle reversed out of a rainbow-like background against the paper color (7.26). These are unusual representations; the angular black-on-red UFW graphic quickly became established not only as the union logo but also as a broader symbol for Chicano activism and community. Figure 7.27, by Malaquias Montoya, announces National Farmworker Week and has a cityscape background, not the usual fields, and information in English, Spanish, Tagalog, and Arabic, an indication of the diverse ethnicities of the agribusiness work force.

Finally, one of the most familiar calls for solidarity with unions is the campaign to buy union products, facilitated by consumers looking for the "union label," although the meaning has changed since the early twentieth century. Figure 7.28, "Keep the wheel turning," illustrates recycling money within the union movement. A 1948 poster from the American Federation of Labor (AFL) shows a muscular male, arms extended like Vitruvian man, saying "Labor. The backbone of America . . . Demand the union label, use union services" (7.29). In the 1970s, the International Ladies' Garment Workers Union (ILGWU) produced a poster of a woman hugging her husband on Christmas morning, having just unwrapped a special union-made present

(7.30). Sometimes, however, ideals and well-intentioned negotiations break down, so we now turn to posters about strikes and boycotts, each testing notions of solidarity and organizing to their limits.

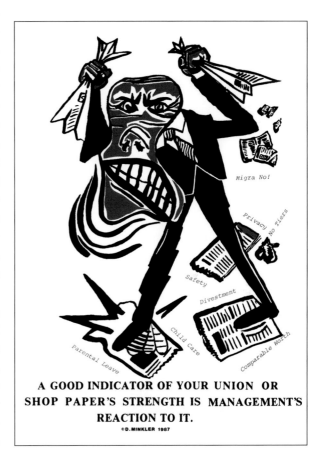

A GOOD INDICATOR OF YOUR UNION OR SHOP PAPER'S STRENGTH IS MANAGEMENT'S REACTION TO IT.
©D. MINKLER 1987

7.06 "A good indicator of your union or shop paper's strength is management's reaction to it." Doug Minkler, self-published, 1987. Screenprint, 58.5 x 40.5 cm.

Organizing
AS A WAY OF LIFE

Remembering our history of:

Standing for something and not falling for anything —
or at least most anything;

Standing at the graveside of a fallen union brother
or sister;

Taking up a collection for a union brother in need;

Taking the blame for a brother or sister in trouble;

Taking responsiblity for more than yourself;

Walking the picket line;

Walking the ragged edge at 4 a.m. — 30 below —
with a steam hose in your hand;

Walking the walk, more than talking the talk;

Living in the twilight zone of rotating shifts;

Living from paycheck to paycheck;

Living better than the previous generation because
they fought and sacrificed for you;

Being into heavy metal (not the music) and under the
influence of dangerous chemicals (legally), all
without our permission;

Being dusted by asbestos, poisoned by
pesticides, gagged by sour gas,
splattered with bottom slurry, fouled by
flue gas;

Being told we want to hear what you have
to say about your job, without wanting to
give you a say at your job;

Jumping to the side of a union member;

Jumping the boss when he tells a lie;

Jumping when you hear a loud noise;

Organizing your group to wear black arm bands for a
fellow worker who was *fired* for the crime of being
injured on the job;

Organizing the unorganized (who can sometimes be
seen in the mirror).

And looking to a future of:

Standing together;

Taking part in our union;

Walking the line;

Living a better tomorrow because of what we
do today;

Being strong and caring;

Jumping for joy when we win, which will come
when year after year, we

Organize As a Way of Life.

By Don Holmstrom, President of OCAW Local 2-477. Presented at the
50th anniversary celebration of Local 2-477 on January 23, 1993.

Art by Rini Templeton (1935-1986) from *The Art of Rini
Templeton; Where There Is Life and Struggle.*

7.07 "Organizing as a way of life." Rɪɴɪ Tᴇᴍᴘʟᴇᴛᴏɴ,
OCAW Local 2-477, 1993. Offset, 43.5 x 28 cm.

7.08 "Union organizer: The best job in America."
Artist unknown, AFL-CIO Organizing Institute, circa
1980s. Offset, 72 x 51 cm.

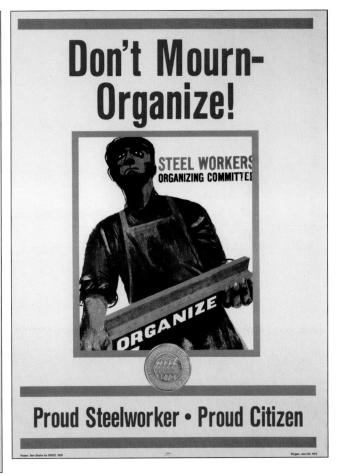

7.09 "Union: United Steelworkers of America." Artist unknown, USWA, circa 1980. Offset, 86.5 x 54 cm.

7.10 "Don't mourn, organize!" BEN SHAHN (1936), USWA, 1986. Offset, 80.5 x 60.5 cm.

7.11 "Organize! For Moe Foner." MILTON GLASER, SEIU Local 1199, 1999. Offset, 61 x 46 cm.

7.12 "Labor Party Founding Convention." MIKE ALEWITZ, photograph by Tony Masso; Labor Party, 1996. Offset, 43 x 28 cm.

7.13 "We are human 'round here." PHIFER, National Industrial Conservation Movement, NY, circa 1914. Lithograph, 63.5 x 48.5 cm.

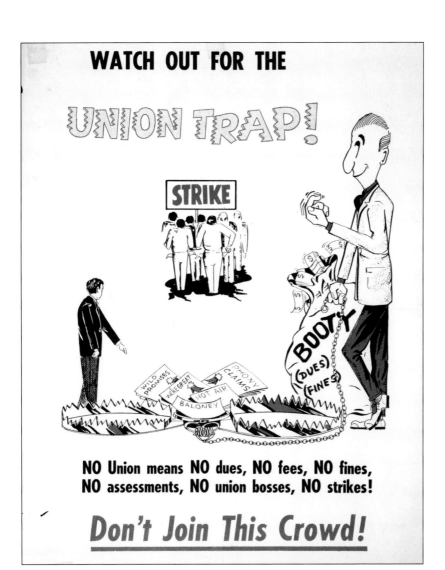

7.14 "Watch out for the union trap!" Artist unknown, client unknown, circa 1950s. Offset, 56 x 43 cm.

7.15 "Now that we're organized, what do we do?" Artist unknown, client unknown, 1980s [?]. Offset, 43 x 56 cm.

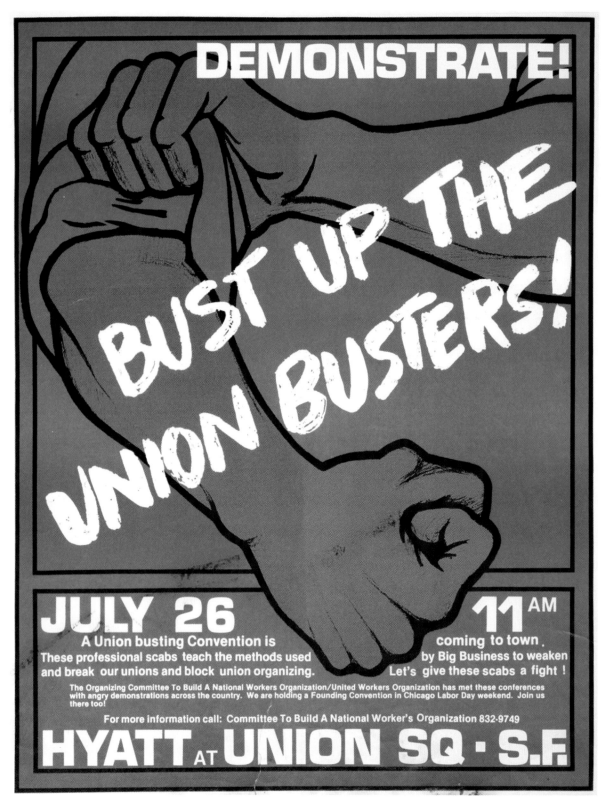

7.16 "Bust up the union busters!" Artist unknown, Committee to Build a National Workers Organization, 1977. Offset, 57 x 45 cm.

Facing page 7.17 "A "bean-ball" is *pilau*." DAVID THOMPSON (education director, ILWU Local 142), ILWU Local 142 (Hawaii), 1952. Offset, 47 x 35.5 cm.

A "BEAN-BALL" IS *PILAU*

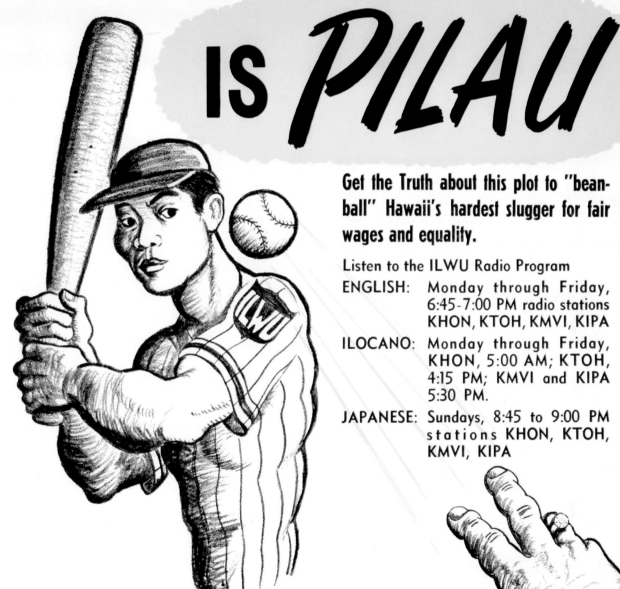

Get the Truth about this plot to "bean-ball" Hawaii's hardest slugger for fair wages and equality.

Listen to the ILWU Radio Program

ENGLISH: Monday through Friday, 6:45-7:00 PM radio stations KHON, KTOH, KMVI, KIPA

ILOCANO: Monday through Friday, KHON, 5:00 AM; KTOH, 4:15 PM; KMVI and KIPA 5:30 PM.

JAPANESE: Sundays, 8:45 to 9:00 PM stations KHON, KTOH, KMVI, KIPA

THE SMITH ACT PITCH AT JACK HALL IS A BEAN-BALL AGAINST THE ILWU

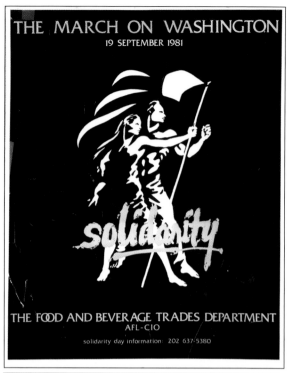

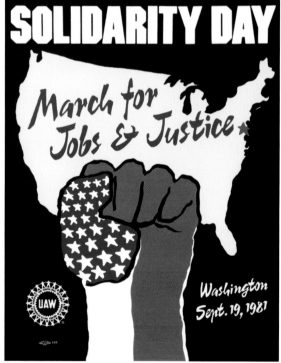

7.18 "ADM: Supermarket to the world . . . or playground for the rich?" Artist unknown, AIW Local 837/UPIU, 1993. Offset, 56 x 43 cm.

7.19 "Don't ever give up! Fight corporate greed with union solidarity!" Artist unknown, AIW Local 837/UPIU, circa 1990s. Offset, 56 x 41 cm.

7.20 "The march on Washington . . . Solidarity." Artist unknown, AFL-CIO Food and Beverage Trades Department, 1981. Offset, 56 x 43 cm.

7.21 "Solidarity Day: March for jobs & justice." Artist unknown, UAW, 1981. Offset, 56 x 43 cm.

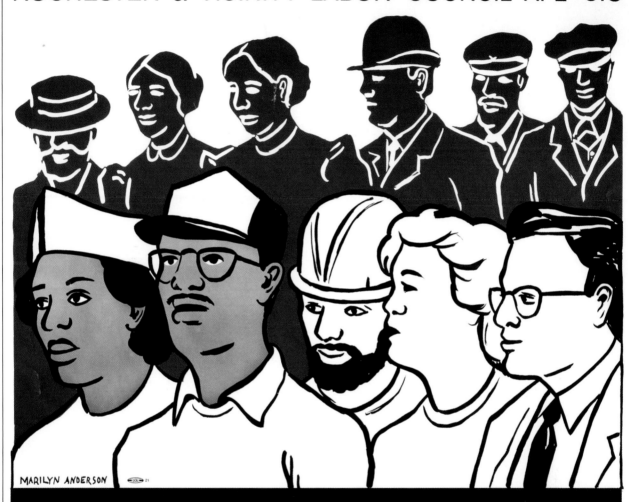

7.22 "1888–1988: One hundred years of solidarity: Centennial Labor Day parade." MARILYN ANDERSON, Rochester & Vicinity Labor Council, AFL-CIO (New York State), 1988. Screenprint, 56 x 42 cm.

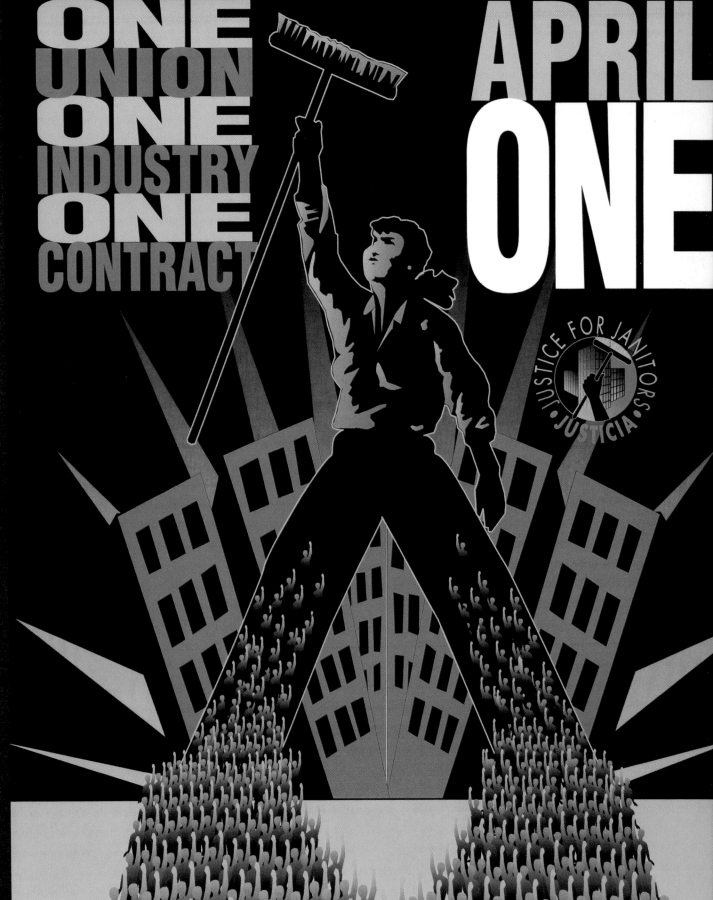

ONE UNION
ONE INDUSTRY
ONE CONTRACT

APRIL ONE

JUSTICE FOR JANITORS · JUSTICIA

SERVICE EMPLOYEES INTERNATIONAL UNION · LOCAL 399

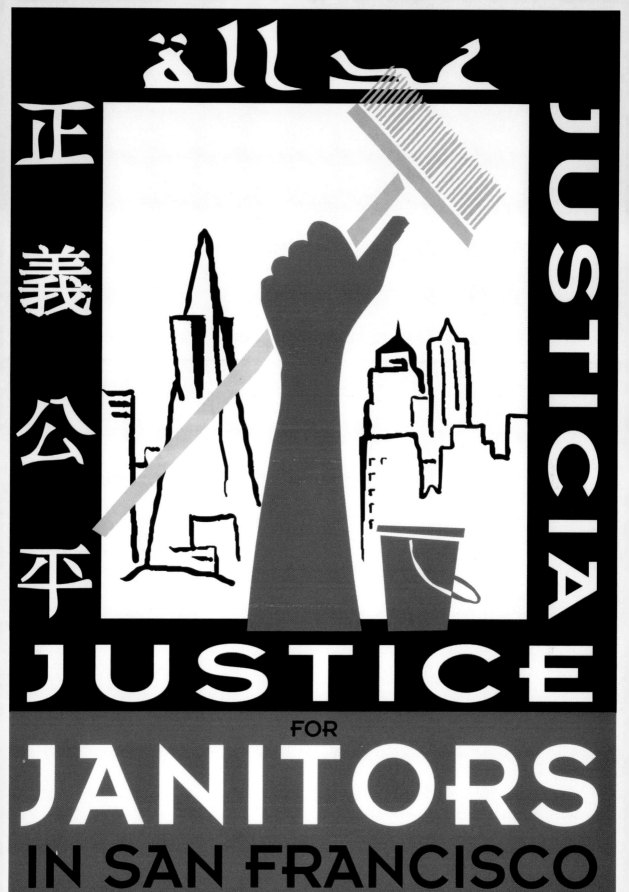

Previous two pages 7.23 "One union, one industry, one contract: April one." Artist unknown, SEIU Local 399—Justice for janitors, 1995. Offset, 56 x 43 cm.

7.24 "Justice for janitors." Kristin Prentice, SEIU Local 87, 1995. Offset, 61 x 41 cm.

7.25 "UFW community meeting." Ricardo Favela, RCAF. UFW, 1977. Screenprint, 57.5 x 44 cm.

7.26 "United Farm Workers Atlanta." Artist unknown, UFW, circa 1970. Offset, 50 x 43.5 cm.

7.27 "National Farmworker Week." Malaquias Montoya, unspecified UFW support group, 1977. Offset, 57 x 45 cm.

7.28 "Keep the wheel turning—buy union label products!" Artist unknown, AFL-CIO Union Label Service Trades Department, circa 1960. Offset, 29 x 38 cm.

Following two pages 7.29 "Labor: The backbone of America." J. V. Hudak, AFL, 1948. Offset, 33 x 52 cm.

7.30 "'Tis the season to look for the union label." Artist unknown, ILGWU, circa 1975. Offset, 61 x 46 cm.

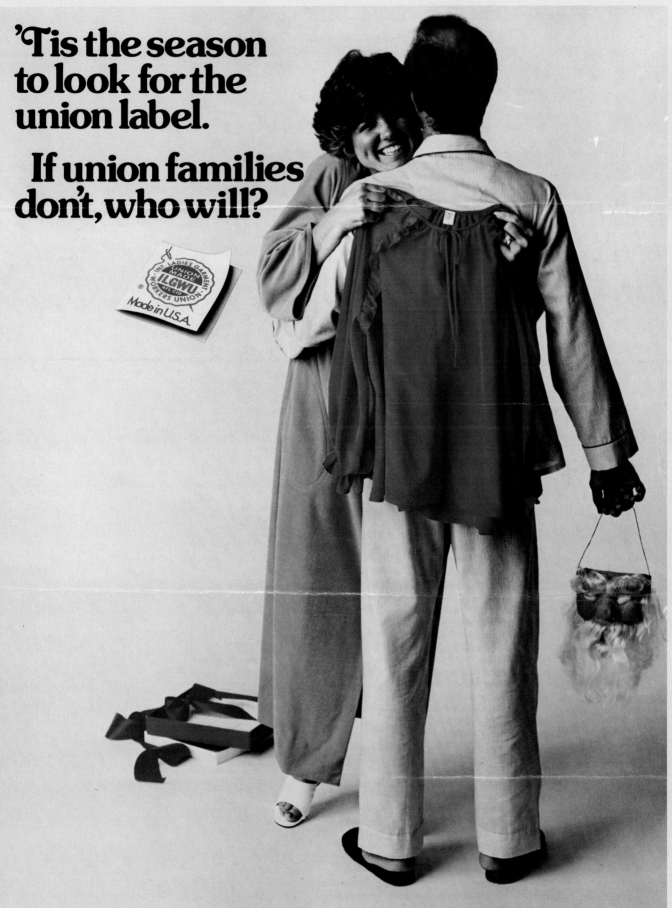

'Tis the season to look for the union label.

If union families don't, who will?

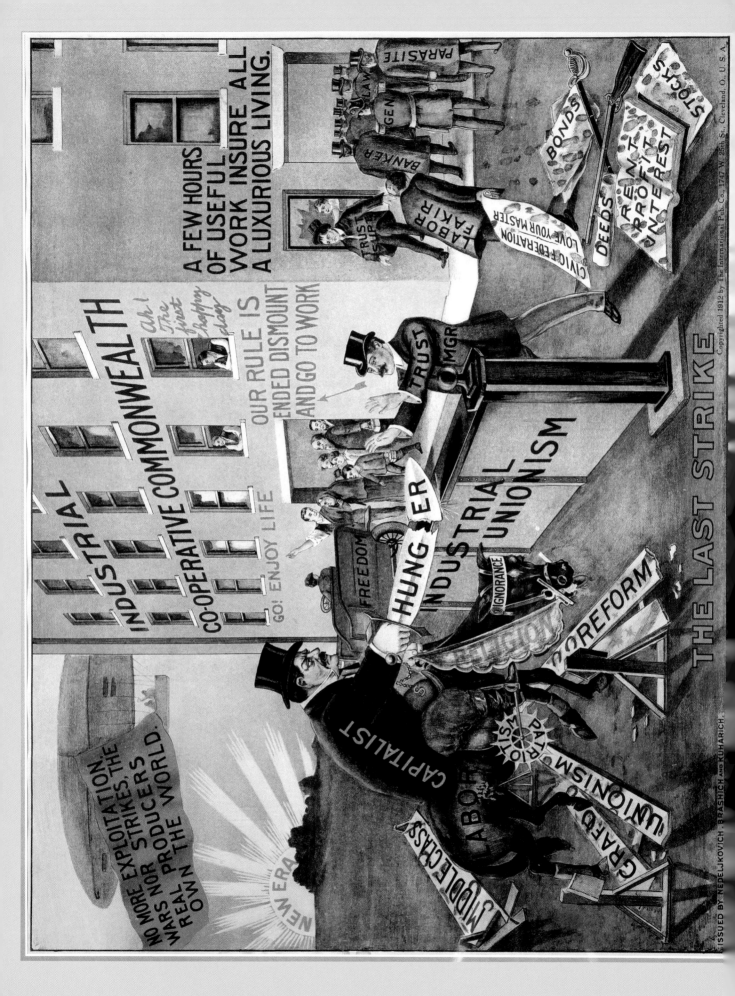

STRIKES AND BOYCOTTS

The word "strike" evokes anxiety in both workers and bosses, but for workers, it also carries hope. Workers literally put their incomes and futures on the line when they vote to strike, so it is not surprising that some of the most powerful labor posters are generated in support of strikes and boycotts.

A strike is the fundamental expression of union strength—withholding labor power as a means of gaining bargaining leverage with employers. The most basic of these images are the placards carried while walking picket lines. A step removed from picket lines are the posters informing about the strike, created either by the unions or by activist supporters, and distributed within the labor community. A third level of involvement is the boycott poster directed at consumers.

One early poster in particular stands out as an articulation of an ideal vision toward which all workers, and union members especially, strive. Figure 8.01, "The last strike," was published in 1912 in Cleveland. Its beautifully colored design with typically detailed nineteenth-century engraving depicts the dawn of a new era, when there will be "no more exploitation, wars nor strikes, the real producers own the world." Everything is meticulously labeled in this poster. While it must be understood as a utopian vision, its purpose is not to map out a future, but simply to illustrate who is on which side of the fence. Historically, the road from here to there is strewn with real-life strikes and boycotts and labor actions.

Picket signs are a narrow genre of posters, simple and homely in appearance, but they are an important visual aspect of any strike. They are carried by those walking the picket line, constantly moving, so their message must be quickly understood. Usually, they are only text outlining the simplest of messages.

Behold the archetypal "Don't be a scab" picket sign (8.02). It explains to the viewer what a scab is, as well as calling for support in this strike. It is scraped and battered, mute witness to the reality of walking a picket line. Doug Minkler's "Taking out the scabs. A big job for the 80's" reiterates worker attitude toward scabs, showing a worker peeling off giant, ugly growths and tossing them in the "scab bin" (8.03). As is usual with Minkler's work, viewers are left with an uncomfortable feeling, in this case empathy with a worker needing to keep scabs from taking his or her job. The final picket sign example, just the silhouette of a rat, is generic (8.04). It can be used in any picket situation. All a marcher needs to do is add his or her own text and hit the pavement, the rat standing for any employer that has pushed workers to go on strike.

Further up the aesthetic ladder is the Screen Actor's Guild/American Federation of Television and Radio Artists (SAG-AFTRA) picket sign, which exemplifies the importance of a catchy slogan: "End Mickeymouse bargaining" (8.05). This design thus shows *who* is striking—

Facing page 8.01
"The last strike."
Issued by Nedeljkovich,
Brashich and Kuharich,
International Publishers
Company, 1912.
Lithograph, 40 x 50 cm.

exploited actors and other workers—and *why*—in the double entendre of the term "Mickey Mouse." Very clever, very quick. Too much text often diminishes a poster's effectiveness, however useful the information it contains. Because strikes have a major impact on entire communities and need community support to succeed, their posters must be understandable to those outside the workplace. Everybody "gets" Mickey Mouse here.

Posters relating to strikes are of two sorts. One is produced by the union itself (or supporters) and announces the strike, the other is produced by community members who support strikers and their issues. An example of the first is from the Mississippi Freedom Labor Union (MFLU) about a strike against growers (8.06). This particular poster incorporates an iconic hoe (a tool often used to symbolize agricultural work) and a worker standing in a field. A 1971 ILWU strike poster lists the issues on the table: "wages, conditions, guarantee pensions, safety" (8.07). The image is a portrait of a stevedore wearing the iconic ILWU "Harry Lundberg Stetson" white cap.

A problem on some picket lines is the use of "two-gate." This occurs at a construction site when a second gate is opened so that members of unions that are not honoring the striking workers can deliver goods or services without crossing a picket line. As figure 8.08 says, "2-Gate sucks the lifeblood of unionism," reinforcing the message with a vampire portrait. As noted before, collectivity and unity are everything in making unions successful, and methods that detract from this, such as two-gate, should be opposed.

Occasionally, posters memorialize previous strikes, such as Homestead[1] or the 1912 Lawrence, Massachusetts, "Bread and Roses" strike. In 1996 Lincoln Cushing designed a poster celebrating the fiftieth anniversary of the 1946 Oakland, California, general strike—the "for-

gotten" labor action of the Bay Area (8.09). This poster was created for a major museum exhibit by the California Federation of Teachers, and promoted visibility of labor's role to a broader community audience. The photomontage brings together militant workers on the right advancing toward the Oakland police on the left, merging at the Oakland intersection where trolley workers following local union officer Al Brown "pulled their controls" in support of retail clerks and shut down the city. General strikes, where all workers go out at once, shutting down whole cities, are rare in U.S. labor history. Posters memorializing general strikes, such as Cushing's here and others honoring the 1934 San Francisco general strike, all reiterate the message expressed by Doug Minkler, Carlos Cortez, and Ricardo Levins-Morales in chapter 2: they are a way for workers to remind owners that "Our labor creates all wealth" (see 2.26).

James Dombrowski was a professional organizer with the Southern Conference Educational Fund and the Highlander Center as well as a talented artist. His colorful, visually complex poster, "It takes a sharp axe, a strong back, and a weak mind to cut bugwood for $1 per day," concludes by saying "Let's strike!" (8.10) The Worker's Solidarity Legal Defense Fund in Youngstown, Ohio, produced a powerful support poster in 1984 as a commentary on employers' frequent allies, the police (8.11). It features a photograph of a man being dragged away by nightstick-carrying police, with the sarcastic title, "Labor leader cooperates with Warren police."

A powerful drawing can make a big difference in a poster's impact. A particularly strong 1988 poster gains its power from two collaged drawings by Giacomo Patri[2] (8.12). The title, in large capitals, says, "Strike back!!" and shows a despairing worker, just fired by the boss

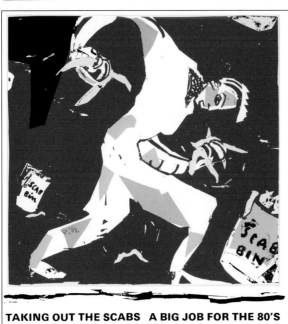

DON'T **SUPPORT**
BE A **THE**
SCAB. **STRIKE**
(Substitute Worker)

TAKING OUT THE SCABS A BIG JOB FOR THE 80'S
©D. MINKLER 1984

8.02 "Don't be a scab (substitute worker): Support the strike." Artist unknown, client unknown, circa 1950s [?]. Letterpress, 36.5 x 56 cm.

8.03 "Taking out the scabs: A big job for the 80s." Doug MINKLER, self-published, 1984. Screenprint, 66.5 x 51 cm.

8.04 [rat]. Artist unknown, client unknown, 1980s [?]. Offset, 56 x 35.5 cm.

Facing page 8.05 "SAG-AFTRA on strike! End Mickeymouse bargaining." Artist unknown, SAG, AFTRA, 1980. Offset, 61 x 46 cm.

standing in the doorway of the plant in Pittsburg, California. Another worker comforts his brother, and shakes his fist at the boss. The dynamic drawing, with its sharp opposition of workers and boss, gives this rally announcement its force. Another poster by the San Francisco Poster Brigade shows an angry miner and a woman looking directly at the viewer and announces a benefit for striking miners in Stearns, Kentucky, over 2,000 miles away (8.13). This reveals a breadth of national support not common in labor actions until the late twentieth century. Usually, posters are locally produced and speak to local communities and workers. In another poster about the Stearns strike, a photograph anchors the image (8.14). In this instance, the Miners Strike Labor Community Support Coalition in San Francisco produced a poster announcing a rally. The committee used an Earl Dotter photograph of two dozen miners, white and black, wedged into a long cart for the ride down into the mine. The miners' expressions as they look directly toward the camera offer a human interest incentive for viewers to attend the benefit.

Boycotts and strikes have both stimulated poster production. The most famous consumer boycott[3] in U.S. history was a protest against the British in colonial times, resulting in the Boston Tea Party and eventually contributing to the American Revolution. Perhaps the earliest union-called national consumer boycott was one from 1960 called by the Retail Clerks International Association against Sears, Roebuck stores. The text of a poster (not shown) reads "Stop. Don't Shop Sears," but the large red letters in the first and last words encourage an alternate reading of "Stop Sears."

Deborah Green's support poster for Watsonville cannery workers is also directed toward nonworkers (8.15). It portrays a highly stylized group of workers, a lively tableau with the clever text calling viewers to "Preserve the rights of the people who preserve our food."

The UFW and its supporters in particular have produced a large number of strong posters, among them Andy Zermeño's famous *"Huelga!"* (Strike!) (8.16) The angry, running farm worker wears a United Farm Worker Organizing Committee (UFWOC) vest and carries a UFW flag. The shouted slogan exemplifies the intensity felt throughout the Chicano community about the strike against non-union grape growers. It comes across as an imperative demand of the viewer, who would understand the emotion, and probably agree with the demand. The cartoon-like depiction of the activist is both amusing and self-deprecating, two attractions of the poster's content.

Xavier Viramontes' 1973 "Boycott grapes, support the United Farmworkers Union" poster is highly detailed, which is typical of Viramontes' graphic style (8.17). It also demonstrates the attention being given to the UFW and the grape boycott a decade after it began. The powerful Aztec figure stares straight out at the viewer while he squeezes two bunches of grapes (red and white) and juice drips like blood down the poster. This poster combines ethnic identification with the labor issue without ever having to spell it out, simply through the clarity of the image.

There are at least two versions of a rat hiding behind a Gallo wine bottle, one in black, one in dark grey, green, and red, as if the generic rat designed for picket sign duty had moved on to posters as well (8.18). The poster in black (not shown) says to "Join the United Farm Workers AFL-CIO. Leave Gallo for the rats!" and gives a telephone number for the union. The other has a different text, locates Gallo in Modesto, California, and changes the "join" (which could be interpreted as "join the union" or "join with the union in protesting Gallo") to "Side with the farm worker."

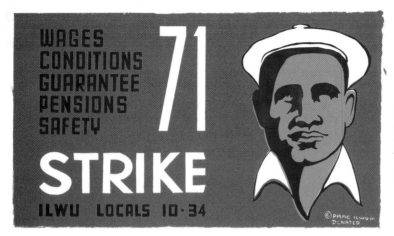

8.07 "71 strike: Wages, conditions, guarantee pensions, safety." Arts & Activities Committee, ILWU Locals 10 & 34 (Larry Yamamoto), ILWU, 1971. Screenprint, 38 x 58.5 cm.

The grape boycott inspired numerous posters presenting the use of pesticides on grapes as bad for your health with visual clues such as skulls and blood. One poster in Spanish, clearly directed at the Mexican and Latino community, features movie and television star Ricardo Montalbán, backed up by smaller portraits of actors including Lou Diamond Phillips, Martin Sheen, Emilio Estevez, and Edward James Olmos (8.18). After the first boycott succeeded and several years had passed, the UFW called for another boycott because of the toxic pesticides. Figure 8.20 repurposes the title of John Steinbeck's novel, becoming "The wrath of grapes: Join the boycott . . . Again!" with miniature toxic waste barrels in the grape bunch.

Although they were the object of the most famous modern boycott, grapes were not the only product targeted by Chicano activists. Because of its hiring policies (lie detector tests were required of all employees) and the right-wing politics of its owner, Coors beer was also boycotted when its workers went on strike (8.23). Andy Zermeño's exquisite 1975 poster shows a grinning, deliberately stereotyped *bandido* with thin legs, a huge chest, and a Zapata moustache, wearing a sombrero bearing a UFW eagle (8.24). He holds two guns, chews on a cigarillo, and delivers an unmistakable message: *"¡Orale! Cabrones. No tomen Gallo."* (Listen up, you bastards. Don't drink Gallo). The good-natured profanity and humor recognize the communal spirit of everyone joining together in the boycott. This is underscored when upon careful inspection we see that the guns are pop guns with corks in their barrels. He may look bad to some, but he is on the side of the people here.

A copy of this poster held by the Walter Reuther Memorial Archive in Detroit has a mimeographed sheet of comments and instructions from the artist on how to use

the attached image. The original proposed art mockup was modified for the final print version to enhance the toy nature of the guns by adding the corks and strings. This is a rare archival example of the give and take that goes on between designers and clients, both committed to the same struggle, both working to be sure the poster is as strong as possible.

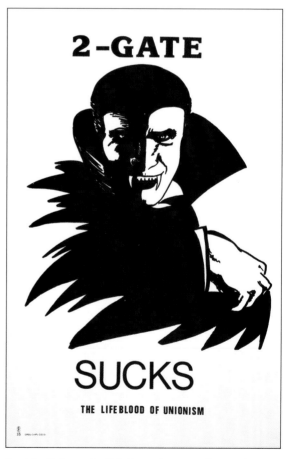

8.08 "2-Gate sucks." Artist unknown, client unknown, 1980s [?]. Offset, 43 x 28 cm.

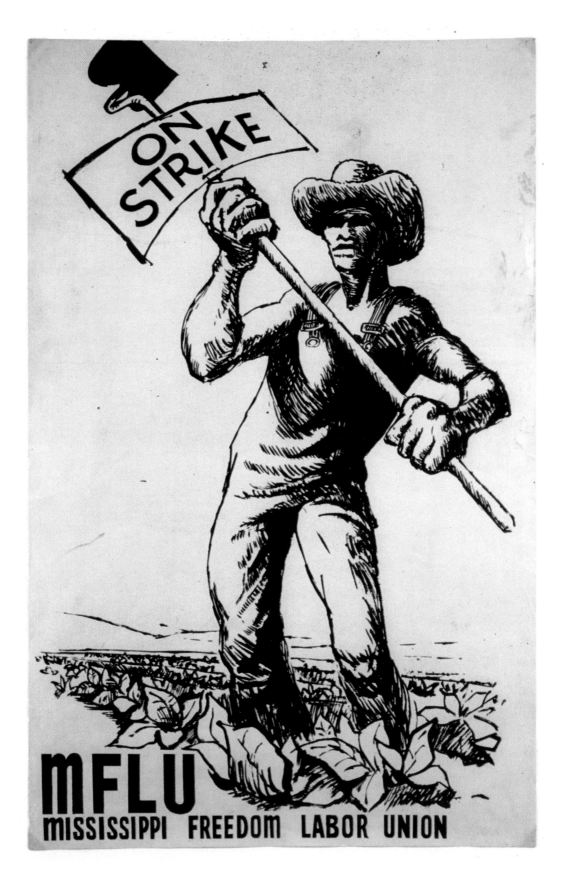

8.06 "On strike." Artist unknown, Mississippi Freedom Labor Union, circa 1965. Offset, 89.5 x 57 cm.

GENERAL STRIKE

WE Called It A WORK HOLIDAY!

the 1946 Oakland General Strike

An exhibition on the occasion of the 50th anniversary of the 1946 Oakland General Strike

November 23, 1996 - February 23, 1997
Breuner Gallery
Oakland Museum of California, 1000 Oak Street

OAKLAND MUSEUM of CA

Exhibit sponsored by the California Labor Federation, A.F.L.-C.I.O., the California Federation of Teachers, and the Central Labor Council of Alameda County and its affiliated unions.

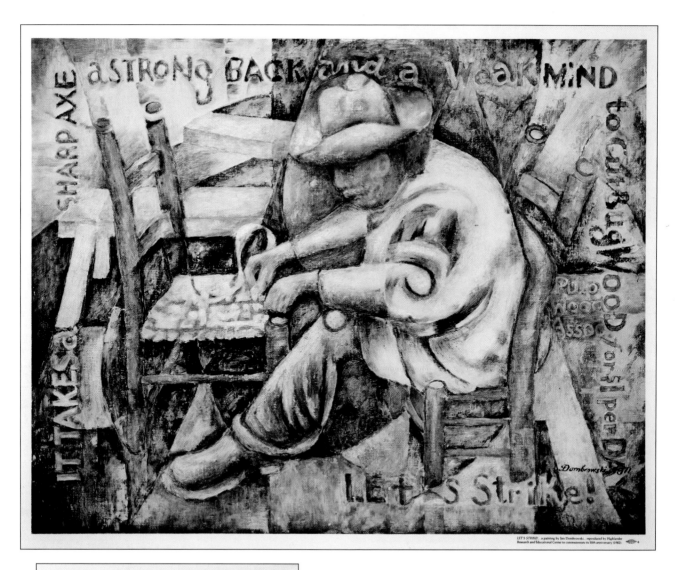

LET'S STRIKE!...a painting by Jim Dombrowski...reproduced by Highlander
Research and Educational Center to commemorate its 50th anniversary (1982)

Facng page 8.09 "General strike." LINCOLN CUSHING, Oakland Museum of California, California Labor Federation, 1996. Offset, 60 x 41 cm.

8.10 "Let's strike! It takes a sharp axe, a strong back, and a weak mind to cut bugwood for $1 per day." JAMES A. DOMBROWSKI, Highlander Research and Educational Center, 1982. Offset, 59 x 72 cm.

8.11 "Labor leader cooperates with Warren police." Photograph by MARK MORETTI, Workers Solidarity Legal Fund, Youngstown, Ohio, 1982. Offset, 51 x 40.5 cm.

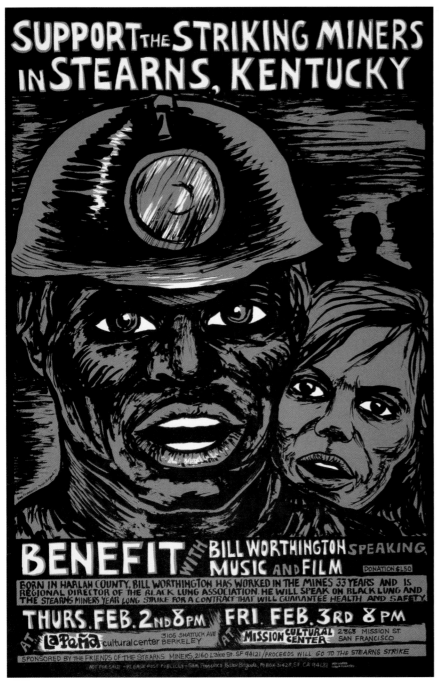

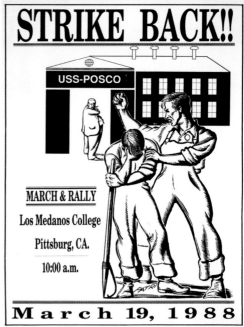

8.12 "Strike back!! March and rally against USS-Posco." GIACOMO PATRI, CORP, 1988. Offset, 63 x 48 cm.

8.13 "Support the striking miners in Stearns, Kentucky: Benefit" (program). San Francisco Poster Brigade (Rachael Romero), Friends of the Stearns Miners, 1977. Offset, 43 x 28 cm.

Facing page, top 8.14 "Rally for striking mine workers." Photograph by EARL DOTTER (www.earldotter.com), United Mine Workers of America (UMWA), 1978. Offset, 28 x 35 cm.

Facing page, bottom 8.15 "Preserve the rights of the people who preserve our food" (Watsonville strike). DEBORAH GREEN, self-published, 1986. Screenprint, 29 x 44.5 cm.

8.16 *"Huelga!"* ANDREW (ANDY) ZERMEÑO [?], UFW Organizing Committee, circa 1970. Offset, 60.5 x 47 cm.

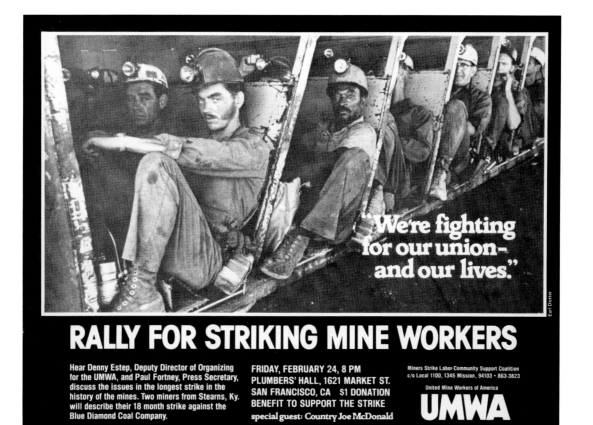

"We're fighting for our union – and our lives."

RALLY FOR STRIKING MINE WORKERS

Hear Denny Estep, Deputy Director of Organizing for the UMWA, and Paul Fortney, Press Secretary, discuss the issues in the longest strike in the history of the mines. Two miners from Stearns, Ky. will describe their 18 month strike against the Blue Diamond Coal Company.

FRIDAY, FEBRUARY 24, 8 PM
PLUMBERS' HALL, 1621 MARKET ST.
SAN FRANCISCO, CA $1 DONATION
BENEFIT TO SUPPORT THE STRIKE
special guest: **Country Joe McDonald**

Miners Strike Labor-Community Support Coalition
c/o Local 1100, 1345 Mission, 94103 • 863-3823

United Mine Workers of America

UMWA

Co-chairmen: Jim Herman, Internat'l President, ILWU and Walter Johnson, President, Retail Clerks 1100; Endorsed by John F. Henning, Exec. Sec.-Treas. Calif. State AFL-CIO; Central Labor Councils of San Francisco, Alameda, San Mateo and Santa Clara Counties; Teamsters 315; and many other unions and community groups.

design: Jessie Bunn

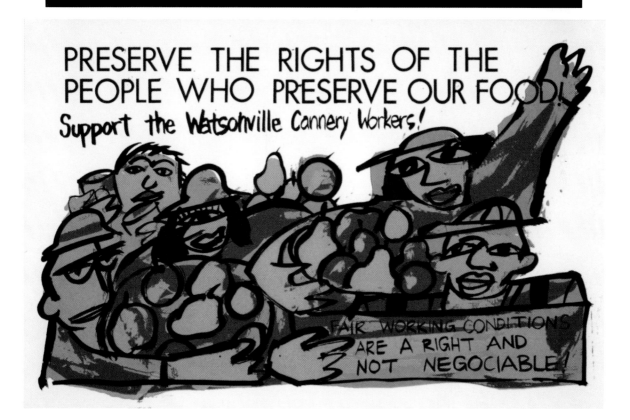

PRESERVE THE RIGHTS OF THE PEOPLE WHO PRESERVE OUR FOOD! Support the Watsonville Cannery Workers!

FAIR WORKING CONDITIONS ARE A RIGHT AND NOT NEGOCIABLE!

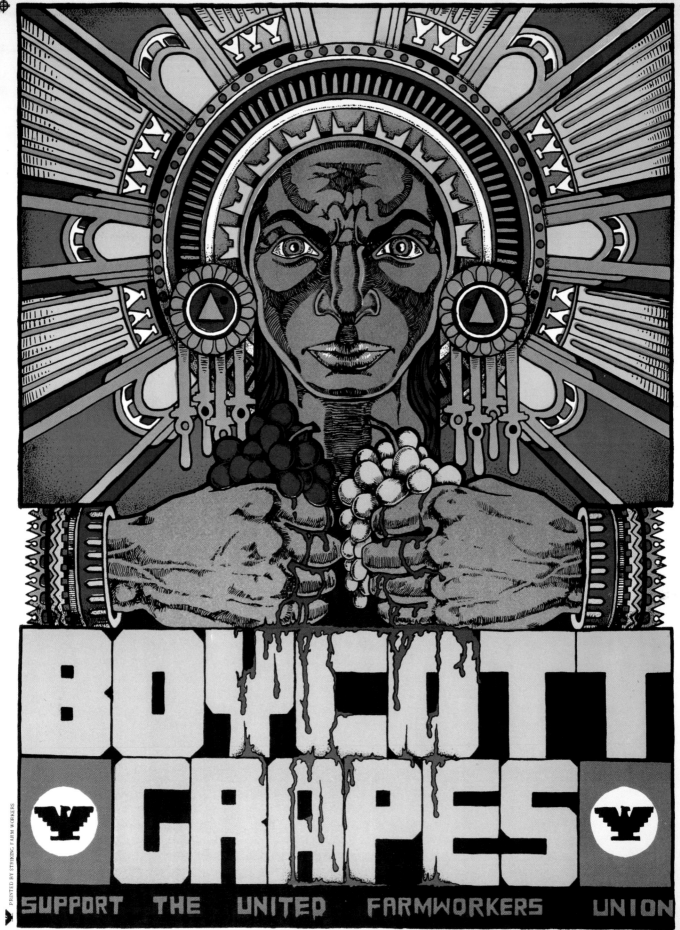

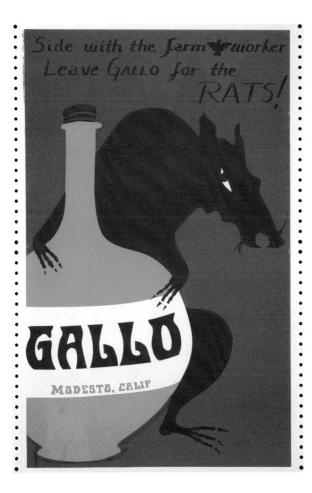

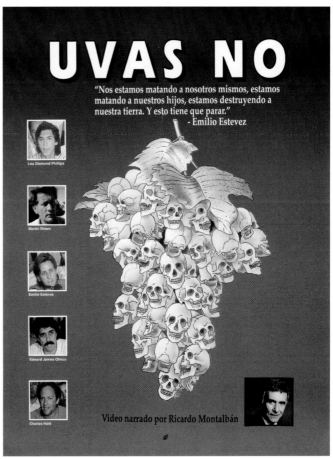

Facing page 8.17 "Boycott grapes."
Xavier Viramontes, self-published, 1973.
Screenprint, 59 x 44 cm.

8.18 "Side with the farm worker" (UFW Gallo boycott).
MeChicano Art Center [?], unspecified UFW support
group, 1978 [?]. Screenprint, 56 x 38 cm.

8.19 *"Uvas no."* Artist unknown, UFWA, 1992. Offset,
61 x 46 cm.

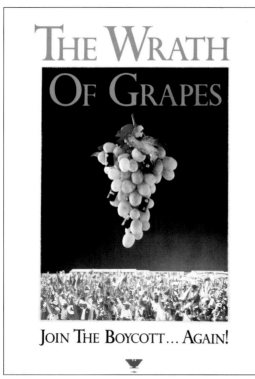

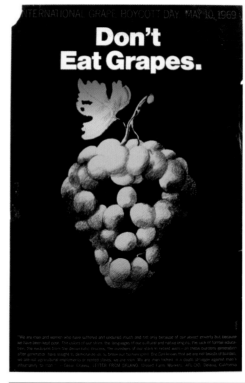

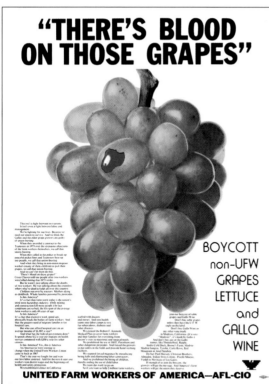

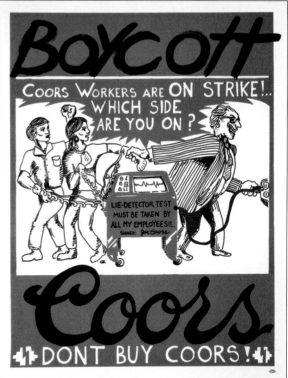

8.20 "The wrath of grapes: Join the boycott . . . again!" Artist unknown, UFWA [?], circa 1985. Offset, 61 x 46 cm.

8.21 "There's blood on those grapes." Artist unknown, UFWA, circa 1974. Offset, 57 x 44 cm.

8.22 "Don't eat grapes." Milton Glaser, UFWA, 1969. Offset, 92 x 59 cm.

8.23 "Boycott Coors." G.R. (initials on poster, artist name unknown), circa 1973. Screenprint, 57 x 44 cm.

Facing page 8.24 *"¡Orale! Cabrones"* Andrew (Andy) Zermeño, UFW, 1975. Offset, 57 x 44 cm.

¡ORALE!
CABRONES

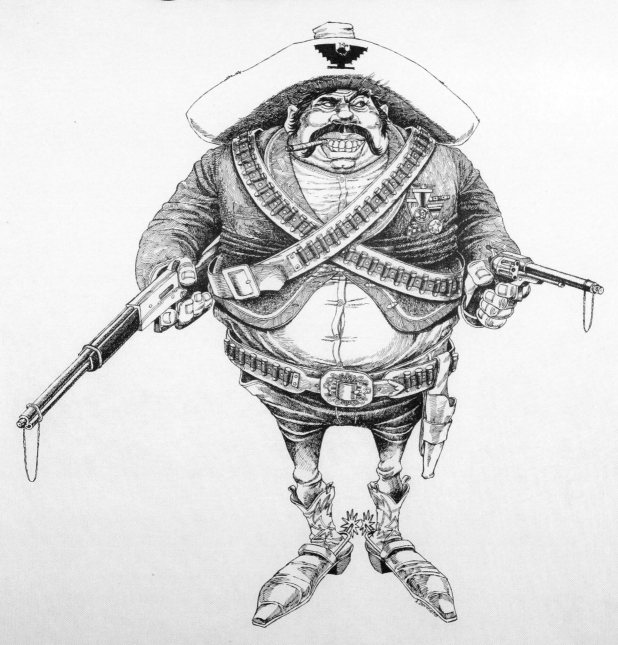

NO TOMEN GALLO.

IS COLORADO IN AMERICA?

MARTIAL LAW DECLARED IN COLORADO!

HABEAS CORPUS SUSPENDED IN COLORADO!

FREE PRESS THROTTLED IN COLORADO!

BULL-PENS FOR UNION MEN IN COLORADO!

FREE SPEECH DENIED IN COLORADO!

SOLDIERS DEFY THE COURTS IN COLORADO!

WHOLESALE ARRESTS WITHOUT WARRANT IN COLORADO!

UNION MEN EXILED FROM HOMES AND FAMILIES IN COLORADO!

CONSTITUTIONAL RIGHT TO BEAR ARMS QUESTIONED IN COLORADO!

CORPORATIONS CORRUPT AND CONTROL ADMINISTRATION IN COLORADO!

RIGHT OF FAIR, IMPARTIAL AND SPEEDY TRIAL ABOLISHED IN COLORADO!

CITIZENS' ALLIANCE RESORTS TO MOB LAW AND VIOLENCE IN COLORADO!

MILITIA HIRED TO CORPORATIONS TO BREAK THE STRIKE IN COLORADO!

THESE are absolute facts and are not the only outrages that have been perpetrated in Colorado in the name of law and order. It has been charged and never successfully denied that the corporations contributed $15,000.00 towards the election of the present Republican administration, but Governor Peabody has been unable to "DELIVER THE GOODS."

THE unions have not been nor can they be abolished, and before the strikes in Colorado are settled, we will have demonstrated the right to organize for mutual benefit. The eight-hour day as decreed by over forty thousand majority of the voters will be established.

IF you desire to assist the striking Miners, Mill and Smeltermen of the Western Federation of Miners of Colorado in this battle for industrial and political freedom, send donations to Wm. D. Haywood, Sec'y-Treas., 625 Mining Exchange, Denver, Colorado.

Charles Moyer.
PRESIDENT.

Wm D Haywood
SEC'Y-TREAS.

9

DEMOCRACY, VOTING, AND PATRIOTISM

When votes are counted in a union election, rooms are full, the electricity of expectation palpable. For many workers, engaging in the political process of their own union is the closest they will ever get to direct democratic participation in their own lives. A microcosm of the parallel civic electoral structure, the premise has always been that a union's power is only as strong as the commitment and participation of its membership base. Too many elections have been fraudulent, but honest elections, and casting votes that count, are at the heart of working peoples' belief in patriotism and democracy, as the following posters make clear.

Since the beginning of the nineteenth century the labor movement has been involved in assuring that working people (at first just white male working people) were properly represented in our democratic system. Among the many constitutional limitations to voting was the requirement of property ownership, a restriction that workingmen's associations successfully challenged. Labor organizations are part of the fabric of American democracy, despite authoritarian practices within some unions and protestations of selfish "pressure group" tactics by corporate-subsidized politicians.

An early twentieth-century poster uses patriotism to raise crucial questions about democracy and civil rights (9.01). The image of a giant flag frames the issue, asking "Is Colorado in America?" and points out, with one complaint per stripe, that in this fine western state undergoing a mining strike, constitutional rights have been suspended, free speech denied, militias hired by corporations to break a strike, and so on. The message is that corporate complicity in dismantling civil rights is unpatriotic.

Such biting commentary using patriotic icons is rare among most unions and labor groups. The traditional treatment is reverence bordering on jingoism. A typical example is this 1948 "Union label" poster declaring support for democracy, capitalism, unionism, productivity, and prosperity (9.02). The other side of the Statue of Liberty lists things the AFL tells us are national weaknesses: "Foreignism, collectivism, slavery, chaos, and poverty." Here is also a silhouette of a bedraggled, perhaps foreign family (a reality preferably denied or ignored). The creators of this poster seem unaware of the inherent contradictions between capitalism and democracy, that unionism is a form of collectivism, and that poverty is as identified with United States society as with many other countries. But the large Statue of Liberty across the poster makes its sympathies clear. It is, above all else, patriotic, and so the contradictions are ignored in favor of what today we call "spin." Even though they have dramatically different messages, the conclusion we are asked to draw from both posters is to support unions if you love your country.

The underlying reason to support a union is simple, a Depression-era WPA poster tells us, it is because "Work pays America!" (9.03) It shows a farmer and industrial worker shaking

Facing page 9.01 "Is Colorado in America?" WILLIAM "BILL" HAYWOOD, Western Federation of Miners, circa 1906. Offset, 51.5 x 41 cm.

139

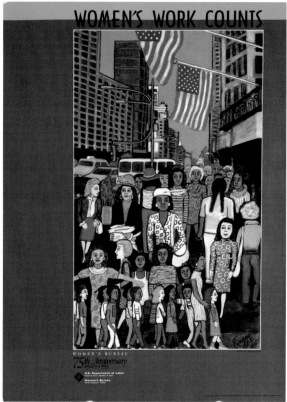

9.02 "Back a winning team." J. V. Hudak, AFL, 1948. Offset, 52 x 33 cm.

9.03 "Work pays America!" Vera Bock, New York: Federal Art Project, between 1936 and 1941. Screenprint.

9.04 "Women's work counts." Faith Ringgold, U.S. Department of Labor, Women's Bureau, 1995. Offset, 81 x 61 cm.

hands over a wheat stalk labeled "prosperity." In 1995, a Faith Ringgold painting used by the U.S. Department of Labor Women's Bureau, showed many different women and girls beneath a headline reading, "Women's work counts" (9.04). The crowd stands on an urban street beneath prominent American flags proclaiming that it is patriotic to recognize the value of women's work—of all kinds. Just under two decades earlier, Full Employment Week was celebrated with a poster titled, "Americans want jobs and there's plenty of work to do" (even though 1975 was a recession year when the federal government created the Comprehensive Employment Training Act to provide jobs) (9.05).

Ideas connecting patriotism and work were an easy sell during the two World Wars. Patriotism is a national currency during wartime, though it's worth noting that few such posters seem to have been produced during the Korean, Vietnam, or Iraq wars. A World War I poster shows a riveter at work in a pose mirrored by a silhouette of a soldier against an American flag (9.06). The caption reads, "Rivets are bayonets. Drive them home!" A World War II poster shows a lumberjack swinging his axe into a tree with a similar caption: "A blow to the Axis" (9.07). Figure 9.08 shows the gloved hand of an industrial worker shaking a business suit–wearing hand, and on both, as if in blessing, the hand of Uncle Sam, with the caption "*Together* we win."

Other World War II posters focus on specific issues. Figure 9.09 has a large, lunch pail–carrying cricket with the caption "Don't be a job hopper. Our soldiers are sticking to their guns. Stick to your job!" Designed by notoriously anti-union media impresario Walt Disney, it sought to reduce workforce volatility. These posters suggest that workers trying to improve their own lot are unpatriotic,

9.05 "Americans want jobs." Artist unknown, UAW, 1977. Offset, 82.5 x 36 cm.

a cynical and opportunistic ploy by employers profiting from the war effort. An iconic World War II labor poster linking patriotism to labor features a photograph of a welder pulling on a thick leather glove in front of a giant flag, with the caption "Free labor will win" (9.10)

After the September 11, 2001, attacks on the World Trade Center and Pentagon, flags were everywhere—they appear generally during periods of stress with foreign enemies. The flag first symbolized togetherness, national solidarity, and mourning/respect, but within a few months had become a symbol of war and aggression. Flags often initially symbolize positive abstractions (freedom, patriotism, democracy), but can morph into symbols of repression and limitation (Big Brother is watching you, listening to your phone calls, reading your internet communications, discouraging you from changing jobs for better pay or job advancement . . .).

Labor posters have supported the idea that the best way for workers to show their patriotism, the best way to exercise their democratic prerogatives, is to vote. There are at least three messages common to voting posters. One is to vote in general elections, without endorsing a candidate, issue, or even political party. Another is to vote on ballot propositions concerning labor. The third is to vote in union elections, not only concerning union representation, but also within unions, and in some cases for a change in the union itself.

A United Steelworkers of America (USWA) poster called for "Political action for good laws," with a painting of hands placing ballots in boxes while wearing gloves symbolizing different trades (9.11). In the 1960s, the AFL-CIO Committee for Political Representation produced a poster in the psychedelic lettering style popular at the time, saying "One vote counts, your vote counts, every vote counts,

register and vote" (9.12). An earlier CIO poster illustrated by Ben Shahn said "For all these rights we've just begun to fight. Register. Vote" (9.13). Shahn's painting shows a man with an upraised fist who is mostly obscured by banners listing rights to have decent pay, shelter, education, security, and so on. The CIO encouraged members and supporters to consider a decent life as part of what should be paid for decent work. A later poster, probably from the 1980s, shows two hands clutching or hugging an American flag, the hands crossed above the heading "In our hands is placed a power greater than their hoarded gold," a line from the classic labor song, "Solidarity Forever" (9.14).

In figure 9.15, the Laborers' International Union of North America (LIUNA) makes recognition of union members' power clear by quoting Samuel Gompers, the first and longest-serving president of the AFL: "Reward our friends, punish our enemies! Register to vote!" Note the militancy here. There is not a hint of self-doubt.

"Union democracy" means unions should be run democratically, should represent workers, and should hold union elections without coercion. It is one thing to say that unions are part of a democratic society, but quite another to assume that unions themselves are always run democratically. Different unions have different track records. Harry Bridges of the ILWU insisted on putting issues to members' votes. But several international unions, such as the Teamsters and the Steelworkers, have experienced vibrant movements to oust perceived corrupt or entrenched leadership and replace it with younger, more responsive leadership. Perhaps the best known of these movements is Teamsters for a Democratic Union (TDU), whose simple bilingual poster presents its case for changing the union's current way of doing business (9.16). A poster put

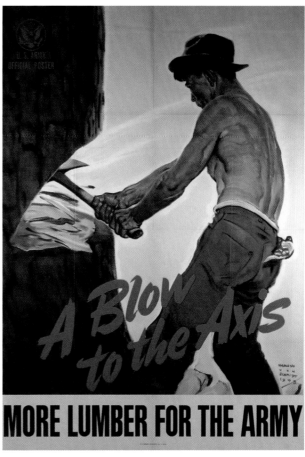

9.07 "A blow to the Axis: More lumber for the Army."
HAROLD VON SCHMIDT, U.S. Army, 1943. Offset,
102 x 73 cm.

9.06 "Rivets are bayonets."
JOHN E. SHERIDAN, U.S. Shipping Board Emergency Fleet,
1917. Offset, 97 x 69 cm.

out by the UAW-CIO Education Department and promoting democracy within the union shows a man cornered by a group of fellow workers with the headline "Let him speak," and a quotation from John Stuart Mill (9.17).

Posters urge labor to vote its interests on specific proposed legislation. Figure 9.18, which was produced by the Equal Rights Congress, says "'Right to work' attacks right to organize. Repeal Taft-Hartley 14B." At the time, right to work laws were "in effect in 20 states and spreading." The poster notes that "per capita income in these states is well below the national average." Still an issue in the twenty-first century, "right to work" refers to cleverly named statutes allowing people to work at a shop even if they are not in the union. It is legislation designed to weaken unions' and workers' ability to stand up to bosses. Another poster shows two elegantly dressed bosses, one black and one white, with a caption asking, "Who are they? Meet 'Mr. Divide' and 'Mr. Conquer' . . ." (9.18). The point is not about race, but that bosses act in their own interests, and in voting "no on Prop #18, the so-called 'right to work' law" workers are voting in their own interests, regardless of race. A 1977 TFWU poster announces a March for Human Rights, advocating the repeal of section 14B of the Taft-Hartley Act and for laws guaranteeing collective bargaining for farm workers throughout the United States (9.20). The drawing in the poster (produced at La Raza Graphics in San Francisco) uses an image of farm workers standing in a 1939 stake bed truck, being taken to the fields to work.

Printed on the backside of a UFW poster, figure 9.21, "Farm worker initiative. Guarantee free elections. Sign here," is the actual petition form. The power of this poster resides in its being simultaneously what it talks about (the petition) and a poster advertising it.

Faced with the contradiction between democratic ideals and the reality experienced by workers, labor posters have often fought for workers' rights in the face of bosses' undemocratic attitudes. Posters have promoted not only union democracy, but union members' participation in general elections, too. During times of war, labor posters have been unreservedly patriotic, occasionally in the face of justice for workers.

Ironically, in a country claiming to be based on democracy, many of the most respected labor heroes throughout history have been people who had to fight for democratic rights within and outside their unions. Some were martyred. We turn to these heroes next.

9.09 "Don't be a job hopper. Our soldiers are sticking to their guns. Stick to your job!" Walt Disney, War Manpower Commission, Washington, DC, 1944. Offset, 51 x 36 cm.

9.11 "Political action for good laws." Artist unknown, USWA, uncredited, series attribution, circa 1980s. Offset, 76 x 61 cm.

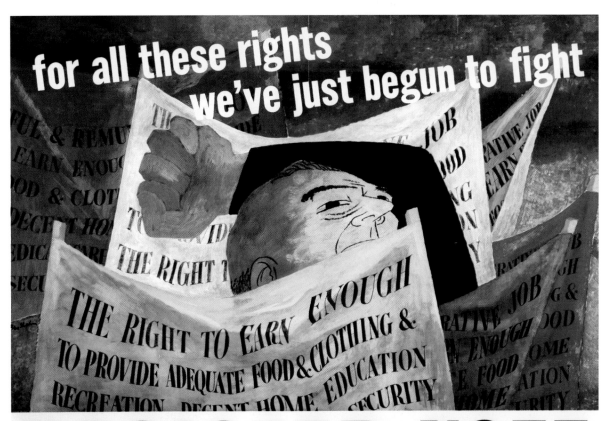

9.13 "For all these rights we've just begun to fight: Register. Vote." BEN SHAHN, CIO Political Action Committee, 1946. Offset, 74.5 x 98.5 cm.

Anton Bruehl Photo

FREE LABOR
WILL WIN

WAR PRODUCTION BOARD
WASHINGTON, D.C. A-18

ONE VOTE COUNTS
YOUR VOTE COUNTS
EVERY VOTE COUNTS
REGISTER AND VOTE

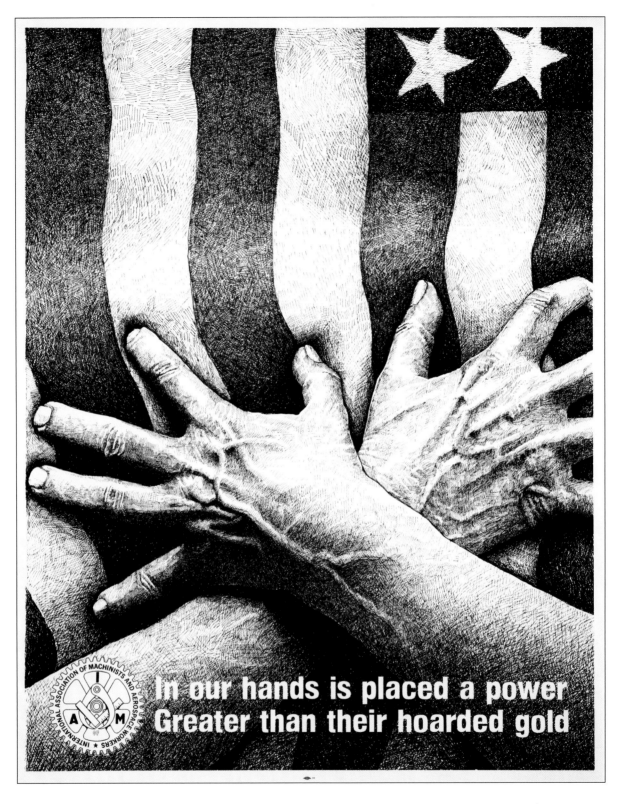

In our hands is placed a power
Greater than their hoarded gold

Previous pages 9.10 "Free labor will win." Photograph by ANTON BRUEHL, War Production Board, 1942. Lithograph, 101.5 x 72.5 cm.

9.12 "One vote counts, your vote counts." Artist unknown, AFL-CIO COPE, circa 1968. Offset, 56 x 43 cm.

9.14 "In our hands is placed a power . . ." (poster series). R. MILHOLLAND [?], IAM, 1980s [?]. Offset, 73.5 x 58.5 cm.

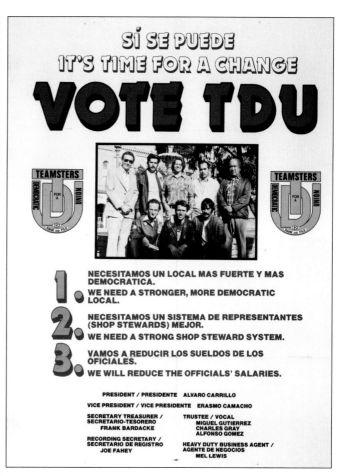

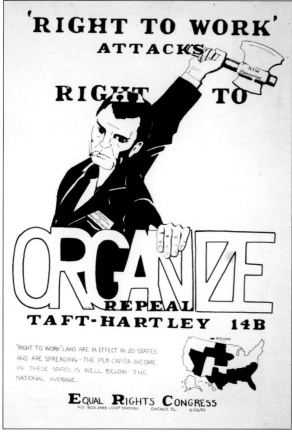

9.15 "Reward our friends, punish our enemies." Artist unknown, LIUNA, 1980s [?]. Offset, 89 x 57 cm.

9.16 "Vote TDU." Artist unknown, TDU, circa 1982. Offset, 57 x 45 cm.

9.18 "'Right to work' attacks right to organize." Artist unknown, Equal Rights Congress (Chicago), circa 1965. Offset, 51 x 35.5 cm.

9.17 "Let him speak" (John Stuart Mill quotation). J. Maschhoff, UAW-CIO Education Department, circa 1950. Screenprint, 94 x 66 cm.

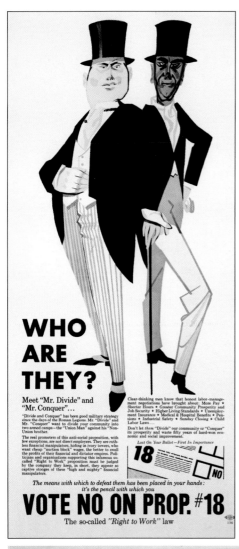

WHO ARE THEY?

Meet "Mr. Divide" and "Mr. Conquer"...

"Divide and Conquer" has been good military strategy since the days of the Roman Legions. Mr. "Divide" and Mr. "Conquer" want to divide your community into two armed camps—the "Union Man" against his "Non-Union brother.

The real promoters of this anti-social proposition, with few exceptions, are not direct employers. They are ruthless financial manipulators, hiding in ivory towers, who want cheap "auction block" wages, the better to swell the profits of their financial and dictator empires. Politicians and organizations supporting this infamous so-called "Right to Work" proposition must be judged by the company they keep, in short, they appear as captive stooges of these "high and mighty" financial manipulators.

Clear-thinking men know that honest labor-management negotiations have brought about: More Pay * Shorter Hours * Greater Community Prosperity and Job Security * Higher Living Standards * Unemployment Insurance * Medical & Hospital Benefits * Pensions * Industrial Safety * Sunday Closing * Child Labor Laws....

Don't let *them* "Divide" our community or "Conquer" its prosperity and waste fifty years of hard-won economic and social improvement.

Last On Your Ballot—First In Importance

18

The means with which to defeat them has been placed in your hands: it's the pencil with which you

VOTE NO ON PROP. #18
The so-called "Right to Work" law

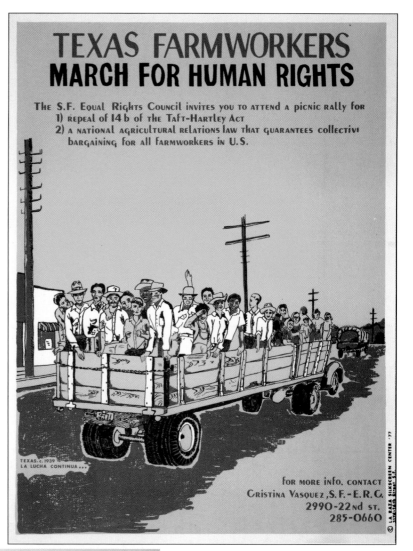

TEXAS FARMWORKERS
MARCH FOR HUMAN RIGHTS

The S.F. Equal Rights Council invites you to attend a picnic rally for
1) repeal of 14 b of the Taft-Hartley Act
2) a national agricultural relations law that guarantees collective bargaining for all farmworkers in U.S.

TEXAS, c. 1939
LA LUCHA CONTINUA...

For more info, contact
Cristina Vasquez, S.F.-E.R.C.
2990-22nd St.
285-0660

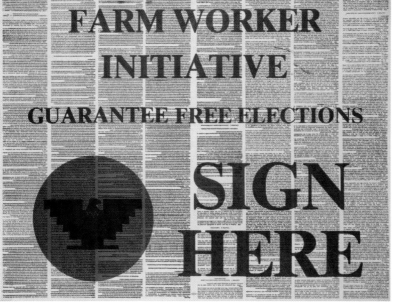

FARM WORKER INITIATIVE

GUARANTEE FREE ELECTIONS

SIGN HERE

9.19 "Who are they?" (California Proposition 18). Artist unknown, client unknown, 1958, Offset, 63.5 x 28.5 cm.

9.20 "Texas farmworkers: March for human rights." La Raza Graphics, San Francisco Equal Rights Council, 1977. Screenprint, 58.5 x 44.5 cm.

9.21 "Farm worker initiative . . . sign here" (front side). Artist unknown, UFWA, 1976. Offset, 57 x 72 cm.

10

HISTORY, HEROES, AND MARTYRS

Historical labor posters commemorate unions, events (important strikes or massacres), heroes, and martyrs. Labor posters, like all social justice movement media, like to recognize the proud stories of their leaders. The posters in this chapter honor the broad range of figures and events that make up this rich history.

Unions and groups of workers have always taken great pride in their trade, as in an 1895 example from the Brotherhood of Locomotive Firemen (10.01). Many unions have issued such posters, often designed in the shape of a building, with strong, stable foundations upon which the history of the union is built.[1] The Jewish Labor Committee of Chicago produced "Fabric of our lives," reproducing a 1980 mosaic mural (10.02). The mural and the poster celebrate the proud tradition of primarily Jewish women working in the textile industry—from immigration and the sweatshop to Chicago's famed Maxwell Street open markets and union meetings demanding a living wage for all. The border is lined with symbols of Judaism as the poster combines religious and cultural history with labor history. A passage of poetry provides a summary of the experience: "From deep within my soul's despair, a rose is striving, reaching high." In 1962 the UAW produced a folio of twenty-eight posters of paintings by John Gelsavage tracing the history of labor in the United States. This monumental project covered wide-ranging subjects from slavery and colonial days through the 1935 Wagner Act and the 1955 AFL-CIO merger. Figure 10.03 is the "Birth of the AFL." This dated series appears to be the only attempt to produce a large-format visual tableau of U.S. labor history.

Many labor history posters are produced by artists or community groups who are not in a union but feel that the people or events are important enough to memorialize in visual form. The McCormick strike poster showing police firing on nineteenth-century strikers comes from France, and exemplifies Europeans' interest in U.S. labor history (10.04). Its design places the police up high, firing down at the strikers, some of whom are dead or dying. The upper left is reserved for signs identifying the event and location, enriching the visual presentation. Just as people here create posters about issues in foreign countries, others, often from Europe, make posters about the United States. The pageant of labor history is international. The McCormick strike painting has also been used in other posters in the United States. A 1992 poster by Just-Seeds commemorates the 1892 Battle of Homestead (10.05). The illustration of the local Carnegie Steel Mill includes an explanation of what happened on July 6, 1892: "That was a war between laboring men because these Pinkertons were there under pay & the person who employed that force was safely placed away by the money that he has wrung from the sweat of the men employed in that mill, employing in their stead workmen to kill the men who made his money."

Facing page 10.01 "Blessed are the horny hands of toil." Artist unknown, Brotherhood of Locomotive Firemen, 1895. Lithograph, 71 x 56 cm.

Facing page 10.02 "Fabric of our lives." CYNTHIA WEISS; Miriam Socoloff (Chicago Public Art Group), Jewish Labor Committee; Northland Poster Collective, 1997 (mural 1982). Offset, 56 x 41 cm.

Perhaps one of the best-known American labor artists of the late twentieth century is Ralph Fasanella, whose work is featured on numerous popular posters including one about the 1912 Lawrence, Massachusetts, textile workers strike (10.06). Fasanella was a self-taught "primitive" or "outsider" style painter and UE member who devoted his considerable talents to documenting the lives and labor of the working class. One of the reasons Fasanella's art is so beloved because it is accessible and unpretentious. His paintings show, sometimes in painstaking detail, the places, events, and experiences his working class audience understands. This poster shows a massive demonstration backed by buildings that don't adhere rigidly to the laws of perspective or scale, but cumulatively contribute to an aesthetically pleasing whole. A 1975 James Dombrowski poster memorializes in text and painting the 1937 Republic Steel Strike in Chicago, where police killed at least ten people, some in shockingly brutal ways (10.07). The artwork emphasizes policemen, clubs raised, viewed from behind, allowing them to remain anonymous and thus be more terrifying. As with his poster about Southern bugwood cutters (8.10), Dombrowski's sophisticated meshing of text and image creates a powerful whole.

The greatest number of historical posters concerns labor martyrs and heroes. Unfortunately, many labor heroes are also martyrs. Labor history has many examples of "them" killing "us." The bilingual Hudson-Mohawk, May Day 2007 poster shows a tailor at a sewing machine labeled "Sacco & Vanzetti," making the very banner we are reading (10.08). There never was such a sewing machine company, but informed activists know about these two Italian-born American anarchist laborers who were

executed. All workers toil in the martyrs' shop. Their sacrifices are memorialized in posters.

The great IWW artist Carlos Cortez issued a number of such posters, often about people few have heard of, including one about Frank Little, "Half Indio, half Waičitu, all IWW" (10.09). Little was a copper mine organizer who was abducted and tortured to death in Butte, Montana. Cortez also created a portrait of Lucía González de Parsons, more commonly known as Lucy Parsons, who helped found the IWW in 1905 and was married to a martyr of the 1866 Haymarket riot (10.10). Cortez here celebrates both Parsons's labor activism and her ethnicity by printing her name and a quotation in Spanish, "Don't go out on strike. Stay at the plant and take over the equipment. If someone must endure hunger, let it be the bosses!" Perhaps Cortez's most famous poster is of Joe Hill, which exists in several different versions (10.11). He lives on in his songs and in the spirit of the labor movement, not to mention in this linoleum-cut poster showing Hill with his accordion and holding a piece of paper with a statement about the ability of the working class to stop every wheel of production if it so desires (compare to 4.08).

UFW posters in this category focus on the organization's founder, Cesar Chavez, but other leaders get their credit as well. One lesser-known such organizer was Emma Tenayuca, known as "La Pasionaria," who was born in San Antonio, Texas, in 1916 and became a labor leader at the Southern Pecan Shelling Company (10.12). She was one of the first Mexican Americans to earn a college degree (at San Francisco State University), and later became a role model for activists such as Cesar Chavez and Dolores Huerta. Juan Fuentes created a portrait of Chavez upon his death in 1993 (10.13). Fuentes' poster shows a pensive

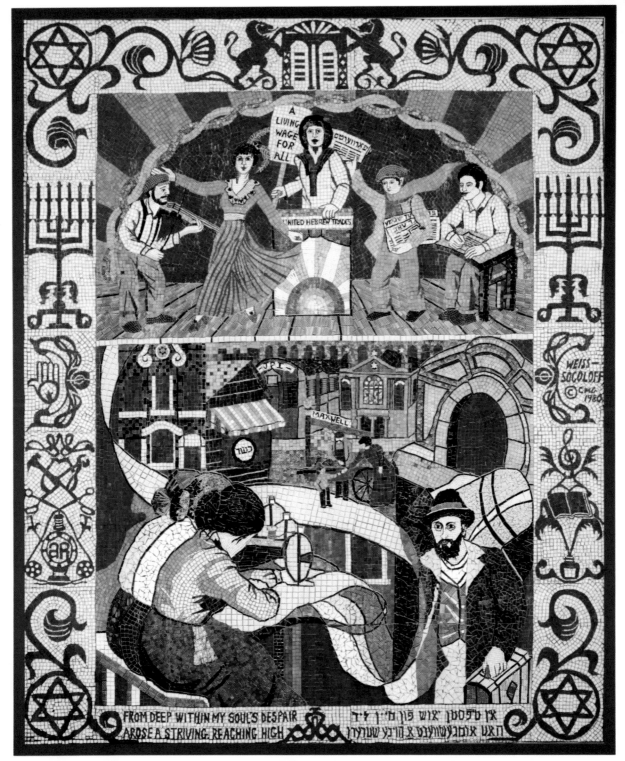

Fabric of Our Lives

Artists: Cynthia Weiss and Miriam Socoloff, Chicago Public Art Group (312) 427-2724. Mosaic mural at the Bernard Horwich Community Center 3003 West Touhy, Chicago, IL. Mural funded in part by the Illinois Arts Council. Photograph by Roberta Dupuis-Devlin, Photo Service, University of Illinois at Chicago. Art direction by Northland Poster Collective, Minneapolis, MN.

Poster produced by the Jewish Labor Committee, 25 East 21st Street, New York, NY 10010 • (212) 477-0707

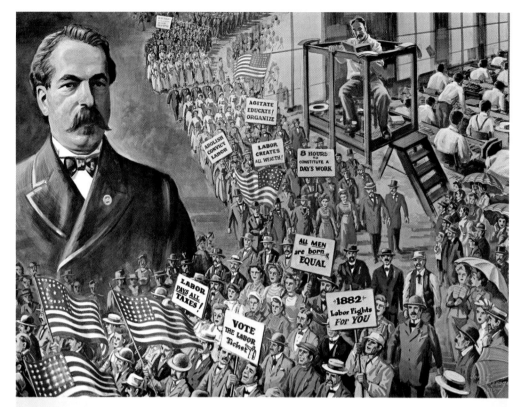

BIRTH OF THE AFL

The American Federation of Labor, organized by the leaders of the craft unions, had its origin in 1881. Samuel Gompers, shown here when he was a 'reader' for the cigar makers, became its first president and served until his death in 1925.

P. J. McGuire of the Carpenters, one of the early AFL leaders, organized the first Labor Day celebration in New York City in 1882.

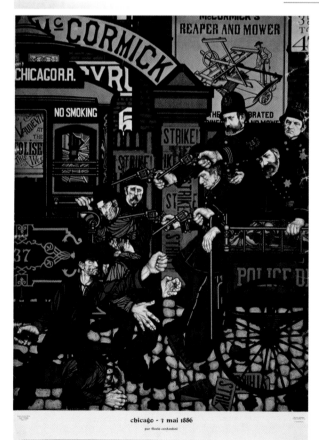

10.03 "Birth of the AFL."
JOHN ZYGMUND GELSAVAGE, UAW, 1962. Offset, 47.5 x 56 cm.

10.04 "Chicago—3 mai 1886."
FLAVIO COSTANTINI, Librairie des Deux Mondes (Paris, France), 1974. Offset, 88 x 63 cm.

elder Chavez with UFW eagle symbols creating a textile-like border similar to ancient Aztec designs. Chavez's nearly ubiquitous portrait is so distinctive, and his legacy so admired, that Apple Computer selected it for its controversial "Think different" advertising campaign.[2]

Dolores Huerta is a labor leader who is often overlooked for her contributions to organizing the UFW. One poster honors her by announcing an evening in solidarity, "Time for justice, viva Dolores Huerta" in San Francisco in 1990 (10.14). It shows a photograph of her printed in green and red, and when combined with her white sweatshirt with the UFW eagle it is almost the colors of the Mexican flag. She is holding up a sign that says, *"Si, se puede"* (Yes, we can).

Another labor figure who rose through the ranks was Hawaiian leader Harry Lehua Kamoku, a labor organizer for the ILWU in Hilo, an obscure figure but now memorialized in a single poster (10.15). Well-known leader Mary Harris "Mother" Jones has been in several posters, including a 1989 offset by Rupert Garcia that praises her as "the most dangerous woman in America," and has a spectacular portrait of her (10.16).

A few labor martyrs achieve such prominence that they become representative of something beyond their own achievements. Tom Mooney, falsely convicted of a bombing in 1916, languished in California's San Quentin prison for twenty-two years until released in 1939 shortly before his death, despite abundant evidence proving his innocence. But Mooney had been a vocal socialist labor agitator in San Francisco and had made powerful enemies among those who later saw to it that he went to jail. His commemoration represents illegal tactics brought to bear on labor leaders; indeed, he is literally the poster boy for

official government excess toward labor. In the several prison photographs of him, always showing prison cell bars and his ID number, Mooney looks out unbowed, as in the 1935 International Molders Union poster which hails him as the victim of class war and a "Monstrous capitalist class frameup" (10.17). Around the same time, another San Francisco labor organizer, Australian-born Harry Bridges, was repeatedly tried on various charges. He had been the leader of what later became the ILWU, and of the 1934 dockworkers' strike which closed down every port from Seattle to San Diego. Among posters calling to defend Bridges and his co-defendants was the startling "Save this right hand" poster by Rockwell Kent (10.18). Instead of picturing Bridges or the 1934 strike, Kent shows a hand sticking up in the middle of the frame, held by other hands while large scissors cut into the wrist.

Along similar lines of expanding a labor leader's significance beyond his or her union, is "One union for farm workers," illustrated with photo portraits of Emiliano Zapata, Martin Luther King, Jr., and John F. Kennedy, each accompanied by a quotation extolling the importance of freedom for all people (10.19).

This group of labor posters visually embodies many of the most important events and members of the labor movement. Some, in the final chapter, embody specifically cultural events. Historical labor posters help to preserve the memory of important events and people in the struggle for justice and rights. They serve as an inspiration now and in the future.

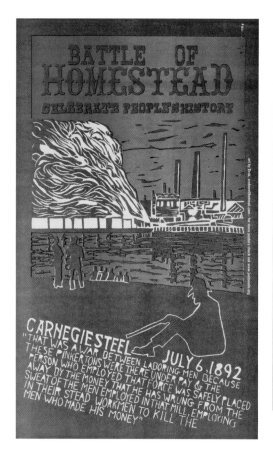

10.08 "Hudson-Mohawk May Day 2007." Josh MacPhee, Hudson Mohawk May Day Organizing Committee, 2007. Screenprint, 56.5 x 44.5 cm.

Facing page 10.07 "Let the dead walk before you." James A. Dombrowski, National Steelworkers Rank and File Committee, 1977 (art 1975). Offset, 80.5 x 60 cm.

10.05 "Battle of Homestead." Erok Boerer, Justseeds, 2002. Offset, 41.5 x 25 cm.

10.06 "Lawrence 1912: The Bread and Roses Strike." Ralph Fasanella, client unknown, 1980. Offset, 42 x 88 cm.

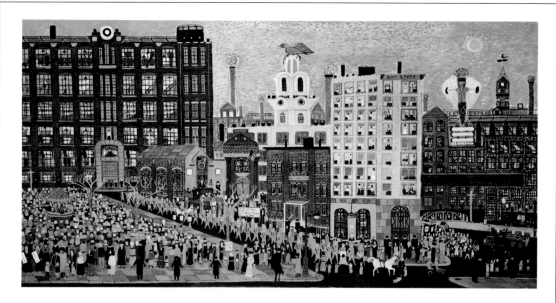

Lawrence 1912: The Bread and Roses Strike

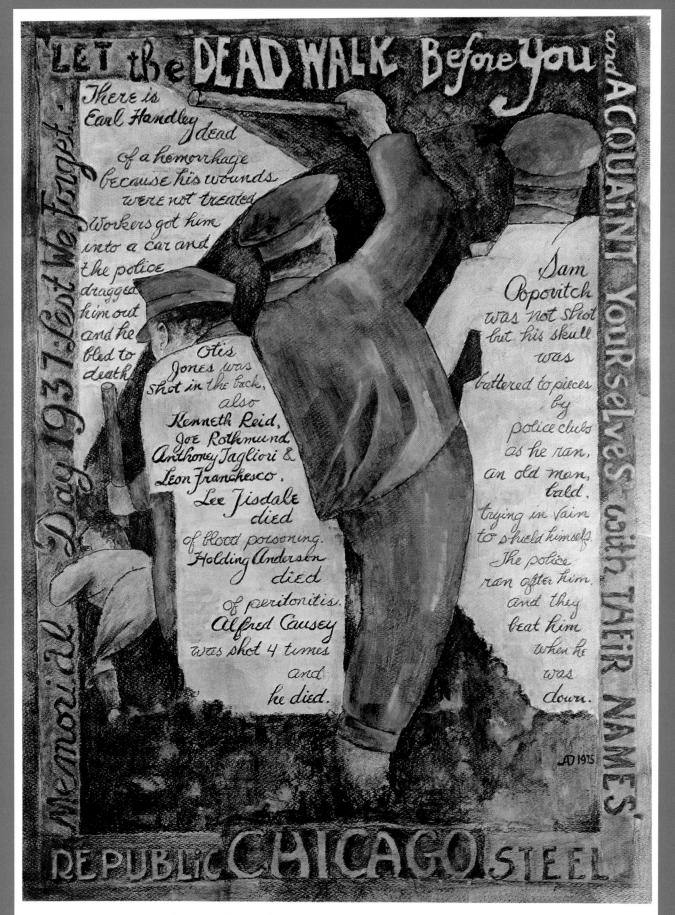

The Struggles of the Past Inspire Our Struggles of Today.

Issued by the National Steelworkers Rank and File Committee.
Box 1952, Lorain, Ohio 44055 May 30, 1977

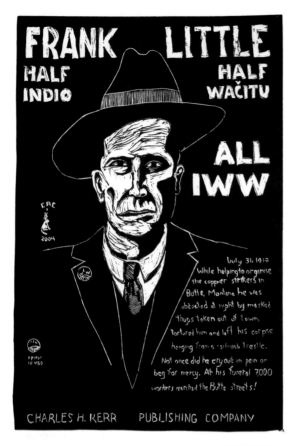

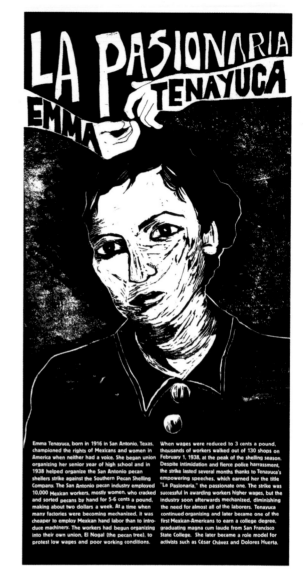

Emma Tenayuca, born in 1916 in San Antonio, Texas, championed the rights of Mexicans and women in America when neither had a voice. She began union organizing her senior year of high school and in 1938 helped organize the San Antonio pecan shellers strike against the Southern Pecan Shelling Company. The San Antonio pecan industry employed 10,000 Mexican workers, mostly women, who cracked and sorted pecans by hand for 5-6 cents a pound, making about two dollars a week. At a time when many factories were becoming mechanized, it was cheaper to employ Mexican hand labor than to introduce machinery. The workers had begun organizing into their own union, El Nogal (the pecan tree), to protest low wages and poor working conditions.

When wages were reduced to 3 cents a pound, thousands of workers walked out of 130 shops on February 1, 1938, at the peak of the shelling season. Despite intimidation and fierce police harrassment, the strike lasted several months thanks to Tenayuca's empowering speeches, which earned her the title "La Pasionaria," the passionate one. The strike was successful in awarding workers higher wages, but the industry soon afterwards mechanized, diminishing the need for almost all of the laborers. Tenayuca continued organizing and later became one of the first Mexican-Americans to earn a college degree, graduating magna cum laude from San Francisco State College. She later became a role model for activists such as César Chávez and Dolores Huerta.

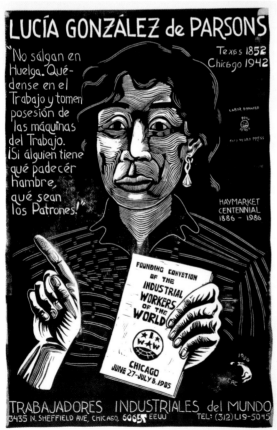

10.09 "Frank Little—half indio, half Wačitu, all IWW." CARLOS CORTEZ, IWW, 2004. Linocut, 101 x 66 cm.

10.10 "Lucía González de Parsons" (Lucy Parsons). CARLOS CORTEZ, IWW, 1986. Linocut, 89 x 59 cm.

10.12 "La Pasionara: Emma Tenayuca." LYDIA CRUMBLEY, self-published, 2004. Offset, 59 x 31 cm.

Facing page 10.11 "Joe Hill." CARLOS CORTEZ, IWW, 1973. Screenprint, 87 x 56 cm.

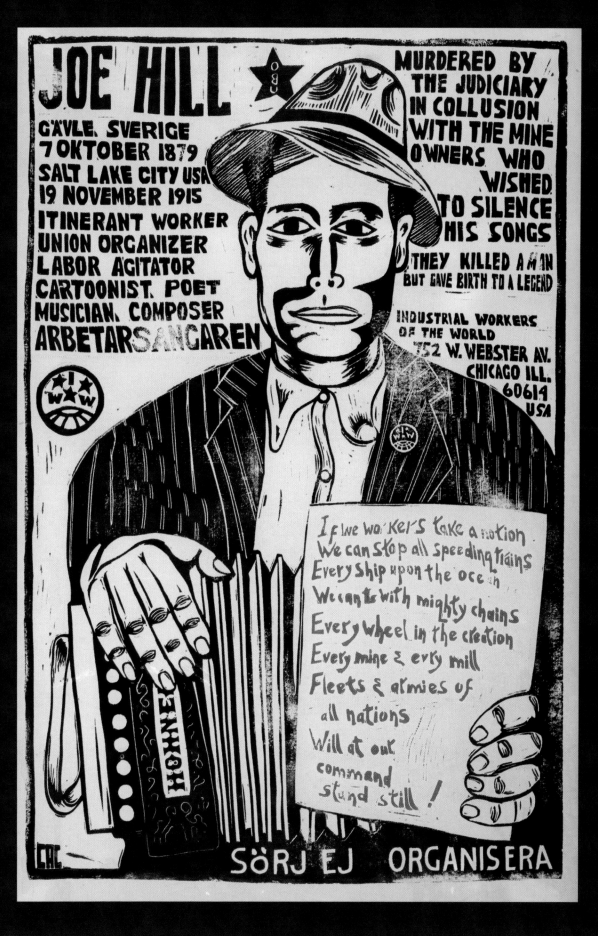

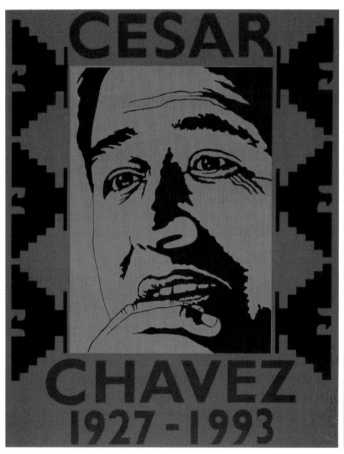

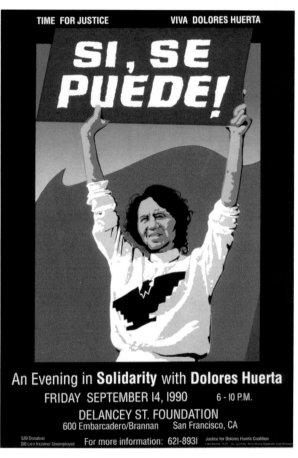

10.13 "Cesar Chavez." Juan Fuentes, self-published, 1993. Screenprint, 57 x 44.5 cm.

10.14 *"Si, se puede!* An evening in solidarity with Dolores Huerta." Jos Sances, Justice for Dolores Huerta Coalition, 1990. Offset, 64 x 45 cm.

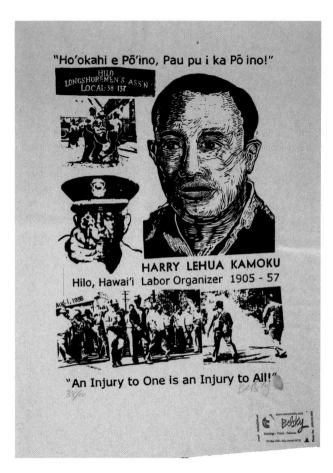

10.15 "Harry Lehua Kamoku." TOMAS BELSKY, self-published, 2001. Screenprint, 53 x 41.5 cm.

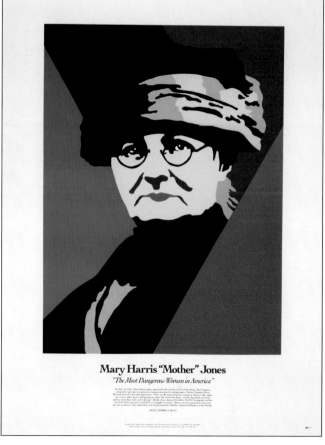

10.16 "Mary Harris "Mother" Jones." RUPERT GARCIA, *Mother Jones* magazine, 1989. Screenprint, 60 x 46 cm. Courtesy Rupert Garcia and the Rena Bransten Gallery, San Francisco.

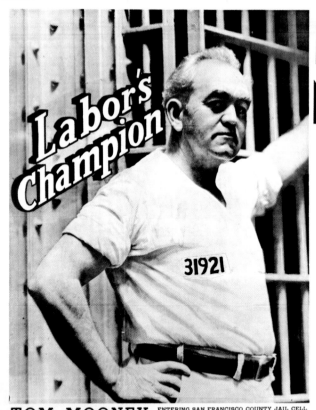

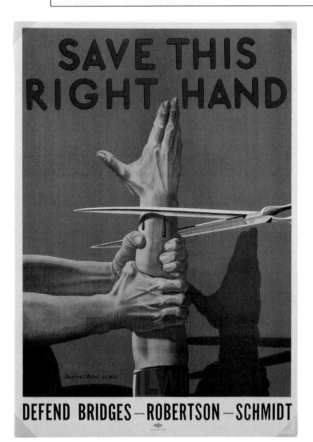

10.17 "Free Mooney." Artist unknown, Tom Mooney Molders Defense Committee, circa 1937. Offset, 71 x 84 cm.

10.18 "Save this right hand: Defend Bridges—Robertson—Schmidt." ROCKWELL KENT, ILWU, 1949. Lithograph, 39.5 x 28 cm.

Facing page 10.19 "One union for farm workers (Zapata—King—Kennedy)." Artist unknown, UFWA, 1971. Offset, 61 x 47 cm.

ONE UNION
FOR FARM WORKERS

La tierra es de todos como el aire, el agua y la luz y el calor del sol y tienen derecho a ella los que la trabajan con sus propias manos. Tierra y libertad!

EMILIANO ZAPATA

But I want it said, even if I die in the struggle, "he died to set me free"

MARTIN LUTHER KING, Jr.

The most powerful force in the world today is man's eternal desire to be free and independent.

JOHN F. KENNEDY

FARM WORKERS UNION
AFL-CIO

THE CRADLE WILL ROCK

by Marc Blitzstein

New Line Theatre

Directed by Scott Miller

The Only Musical Ever Shut Down by the U.S. Government
Book, Music and Lyrics by Marc Blitzstein
Art Loft Theatre, 1529 Washington, 2 miles east of the Fox
Tickets $15 adults, $12 students and senior adults, www.newlinetheatre.com

MAC
Missouri Arts Council

Arts & Education Council

MetroTix
314-534-1111

Oct. 4 preview 8pm 5 8pm 6 9pm 11 8pm 12 8pm 13 5pm 18 8pm 20 9pm 25 8pm 26 8pm 27 5pm

11 CULTURE

Labor posters are about more than just protest and activism. They educate viewers about a wide variety of cultural events too, featuring music, artwork, poetry, and movies of interest to their working class audience. They reproduce the work of talented artists, and they form the core of exhibits that explore and preserve labor history.

This chapter's illustrations disprove notions of benighted workers without culture. It is as if some typical worker were to say, "Whadaya mean workers don't like culture? Just last week we made up a beautiful poster to collect funds to support the strike . . ." or boycott, or campaign to fight racism or sexism, or encourage greater consciousness of health and safety issues, or promote solidarity with the strikers in another city or state or country.

Labor posters *are* cultural artifacts in themselves, and embody the same qualities as any artwork. Working people understand the need for cultural involvement, to appreciate when others create and to participate in it themselves. If there is a difference, it is that the posters also foreground an educational or agitational component, something often disparaged in the fine art world since the notion of art for art's sake came to dominance. Posters deliberately embrace their utilitarian component, and can gain strength from that association.

Cultural events for workers are usually fundraisers. But sometimes, posters announce a dance just because folks want to have a dance. Labor posters in the United States cover the whole spectrum of possible reasons for a cultural event, and, of course, the posters themselves are cultural expressions, no matter what their topic. Annual labor-related festivals are held throughout the country such as LaborFest, the Western Workers Labor Heritage Festival (both held in the San Francisco Bay Area), and the Great Labor Arts Exchange in Silver Spring, Maryland.

The posters in this chapter announce theater shows, poetry readings, films, art exhibits, books, and even the occasional car show. The events and their advertising posters are important because they help build a community of working people and give that community public recognition.

Posters announce theater pieces about labor issues, such as Marc Blitzstein's famous 1937 radical musical *The Cradle Will Rock,* a revival of which was noted in a poster of a large hand holding a sledgehammer in front of a sunburst (11.01). The jazz-blues opera *Forgotten: The Murder at the Ford Rouge Plant,* composed by Steve Jones, was first performed in 2003, and then later in 2005, sponsored by the Michigan Labor History Society. Its poster shows a young man whose face is lighted from below, in front of "the Rouge," one of the largest factories ever constructed, with flame and smoke pouring out of a smokestack at night (11.02). The paint-

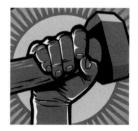

Facing page 11.01
The Cradle will Rock
(musical). KRIS WRIGHT,
New Line Theater, St.
Louis, MO, 2001. Offset,
46 x 30 cm.

167

ing featured in the artwork is ascribed to Wes DeLappe, father of noted political artist Pele DeLappe. The image is laden with the dramatic composition and lighting of popular fiction murder mysteries.

Labor music, mostly in the form of sing-alongs or performances by Utah Phillips, Fred Holstein, Marion Wade, Pete Seeger, and Woody Guthrie, among dozens if not hundreds of others, is also the subject of many posters. Carlos Cortez's poster announcing a songfest says the songs of the IWW will be presented "To fan the flames!" which is the purpose of most labor songfests, concerts, or casual get-togethers (11.03). One poster shows a drawing of Woody Guthrie reading the Communist Party USA's *People's World* newspaper and leading a demonstration for food, jobs, and housing (11.04). Guthrie's guitar, of course, was famously inscribed "this machine kills fascists," and the headline of the poster is a quotation of his: "I am out to sing songs that make you take pride in yourself and your work. I could hire out to the other side. The big money side. I decided a long time ago that I would starve to death before that." This statement makes it clear why Guthrie and his songs are so beloved by working people.

Posters also advertise poetry benefits, such as one featuring Allen Ginsberg, Lawrence Ferlinghetti, Robert Creeley, Robert Duncan, and Philip Whalen in a San Francisco benefit for striking farm workers (11.05). Ferlinghetti and Robert Bly appeared at another benefit whose poster features a photograph taken during the 1917 Russian revolution, but the banners carried by the truck through the snow-filled streets of Moscow have been relabeled with the UFW eagle and the word "poetry" (11.06). A 1980 poster features a stunning photograph of a smoke-belching steel factory by Steve Cagan, and a quotation from Carl Sandberg's poem "Smoke and Steel": "Pittsburgh,

11.02 *Forgotten: The Murder at the Ford Rouge Plant* (play), WESLEY DELAPPE (attributed), Michigan Labor History Society, 2005. Offset, 43.5 x 28.3 cm.

Facing page 11.03 "To fan the flames!" CARLOS CORTEZ, Holstein's (Chicago), 1984. Linocut, 63.5 x 48 cm.

11.04 "I am out to sing songs that make you take pride in yourself and your work" (Woody Guthrie). DON DOLAN, self-published, circa 1986. Offset, 28 x 43 cm.

11.05 "Allen Ginsberg [et al]: Poetry benefit for the farmworkers." Artist unknown, unspecified UFW support group, 1972 [?]. Offset, 35.5 x 51 cm.

A POETRY BENEFIT
FOR CESAR CHAVEZ'
UNITED FARM WORKERS

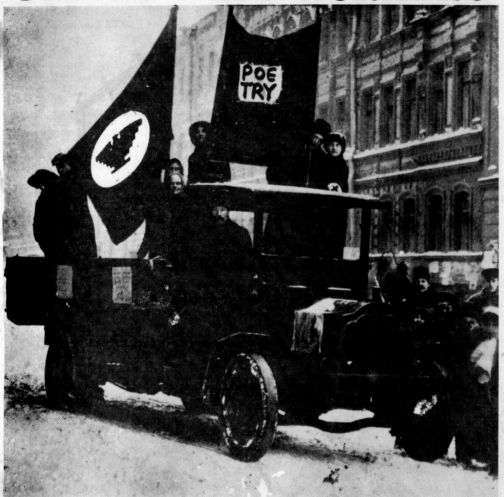

ROBERT BLY
LAWRENCE FERLINGHETTI

FRIDAY FEBRUARY 26 8:30 PM GLIDE MEMORIAL 330 ELLIS SAN FRANCISCO
Ticket Info: 864-5613; 658-4974; 362-3112 Donation $2. / Students $1.50

LABOR DONATED

Previous page 11.06 "A poetry benefit for Cesar Chavez' United Farm Workers: Robert Bly, Lawrence Ferlinghetti." Artist unknown, Glide Memorial Church, San Francisco, 1971 [?]. Offset, 43 x 28 cm.

Youngstown, Gary—Smoke and blood is the mix of steel" (11.07). The association between poetry and labor is long-standing and powerful.

Sometimes artists will create works that are then re-produced as silk screened or offset prints and sold to raise funds. As art these limited-edition prints have more aesthetic and commercial value than other posters. One example is figure 11.08, from the 1985 Watsonville cannery strike, where the delicate lines and soft colors of the chalk drawing contrast with the hardships endured by the family of a striker. The juxtaposition, as well as the content and drawing, give the work its impact.

Occasionally, movies have had pro-labor themes (this is different from simply making businessmen the bad guys, of which there are many examples). One is *Norma Rae,* starring Sally Field and represented in figure 7.09. Another is John Sayles' film *Matewan.* The poster advertising this movie captures the danger of organizing in the coal mines in its photograph of armed men advancing down a railroad track toward the camera (and the viewer) (11.09). They emerge from a shroud of smoke that covers everything behind them, making them all the more menacing.

In an unusual example, an unknown UFW group created a poster for a "Cosmic car show" (11.10). This poster, designed by the famous rock artist Stanley Mouse, is replete with psychedelic lettering that requires serious visual attention to read, at least without pharmaceutical enhancements.

Major museums and galleries occasionally mount exhibits about labor images. The artwork of the IWW was part of a 1989 show developed by the National Museum of American History and the Smithsonian Institution about symbols and images of American labor. Figure 11.11, "Badges of Pride," advertised this show. Although

the exhibit was sponsored by major institutions and involved the participation of labor scholars, a catalog was never produced—one example of the marginalization faced in promoting working peoples' culture. In 1982, the San Jose Museum of Art mounted a show sponsored by the Building Trades and the Construction Industry titled "With These Hands." The show's poster has at its center a photograph of an ironworker atop a lattice of girders, reaching for a rivet bucket (11.12). The girders mimic the worker's arms and placing him at the center of the poster and photo also makes him, the worker, the center of attention because "these hands" not only construct buildings, but also artworks.

Perhaps the most influential book about the history, art, and culture of the American labor movement is *The Other America,* also the title of a 1983 German exhibit and accompanying book. This monumental show was curated by noted American labor historian Philip Foner and German cultural organizer Reinhard Schulz. The poster title is printed in patriotic colors over a colorized collage of two photographs by Lewis Hine, creator of such iconic labor images as "Power house mechanic working on steam pump" and "Worker turning valve wheel" (fig. 11.13). *The Other America* poster photos were taken during high steel construction in New York City in 1935; the dominant image is an extraordinary balletic shot of a U.S. worker, "Icarus atop Empire State Building," to which a view of the new city skyline has been added.

Over the past few decades SEIU Local 1199, United Healthcare Workers East, has been one of the most visible union sponsors of labor culture. Local 1199 first made its cultural splash with the 1973 exhibit "Against the Wall: Protest Posters of Three Centuries," and a poster featuring a reproduction of German American artist Robert Kohler's

Pittsburgh, Youngstown, Gary —
Smoke and blood is the mix of steel.

- Carl Sandburg, <u>Smoke and Steel</u>, 1920

11.07 "Pittsburgh, Youngstown, Gary…" (Carl Sandburg poem). Photograph by STEVE CAGAN, 1980. Offset, 49 x 38 cm.

11.08 "For the welfare and future of my children, I fight for justice." ANDREA KANTROWITZ; printing assistance from Jos Sances, Rene Castro; Local 912 Strikers' Committee (General Teamsters Union), 1987. Screenprint, 46 x 54 cm.

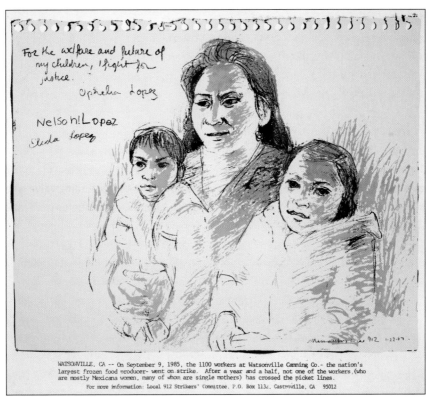

WATSONVILLE, CA -- On September 9, 1985, the 1100 workers at Watsonville Canning Co.- the nation's largest frozen food producer- went on strike. After a year and a half, not one of the workers (who are mostly Mexicana women, many of whom are single mothers) has crossed the picket lines.
For more information: Local 912 Strikers' Committee, P.O. Box 1132, Castroville, CA 95012

11.09 *Matewan* (film). Designed by Ross Culbert Holland and Lavery (NY), photographer unknown; Cinecom Entertainment Group, 1987. Offset, 104 x 68.5 cm.

1886 oil painting *The Strike* (11.14). This groundbreaking exhibit, which included over forty international artists and covered a time span from 1791 to 1973, sought to establish legitimacy for the poster medium, for progressive movements in general, and for the labor movement in particular. Kohler's painting is considered to be the first one of industrial class struggle produced by a fine artist.

In 1979, SEIU 1199 executive secretary and labor historian Moe Foner started the Bread and Roses cultural project. Paul Davis's 1978 painting of a union member shares the name of this flagship cultural project (11.15). An early exhibit from 1979 displayed the photography of Earl Dotter in "Rise Gonna Rise: Portraits of Southern Textile Workers" (11.16). This poster features one of Dotter's moving photographs, this one of three textile workers, whose expressions memorably display the hardships of their lives, and uncompromisingly indict the viewer by looking a bit down at us as they stand with their backs to a brick wall.

The Bread and Roses project later mounted a major exhibit "Images of Labor" that showed at the Smithsonian after opening in 1199's New York gallery. Posters released in honor of the exhibit included art by Jacob Lawrence, Sue Coe, Paul Davis, Edward Sorel, Milton Glaser, and many others. The exhibit catalog cover illustration by Philip Hays consists of three hard hats, an iconographic representation of labor (11.17). Subsequent exhibits and a poster series intended for mass distribution have continued this effort, producing sixty-four posters of "Women of Hope," twenty-five posters honoring African American leaders, and scores of others (11.18–11.25). Local 1199 also engaged in cultural media besides visual arts, as evidenced by a poster for the musical revue "Take Care, Take Care" (11.26) Under the creative guidance of Executive

Director Esther Cohen, Bread and Roses has continued to break new ground in cultural projects that honor workers' lives. In 2000 they launched "unseenamerica," an experiment in cultural democracy where hundreds of "ordinary" people was given cameras to photograph their own lives. Combined with their words, this became a moving exhibit and HarperCollins book by the same name.

Labor posters do more than just tackle the immediate material concerns of workers—"the bread"—they also address "the roses," the wide variety of cultural events featuring the music, poetry, and movies of labor activists. They reproduce the work of both amateur and professional artists. And they form the core of exhibits that explore and preserve labor history.

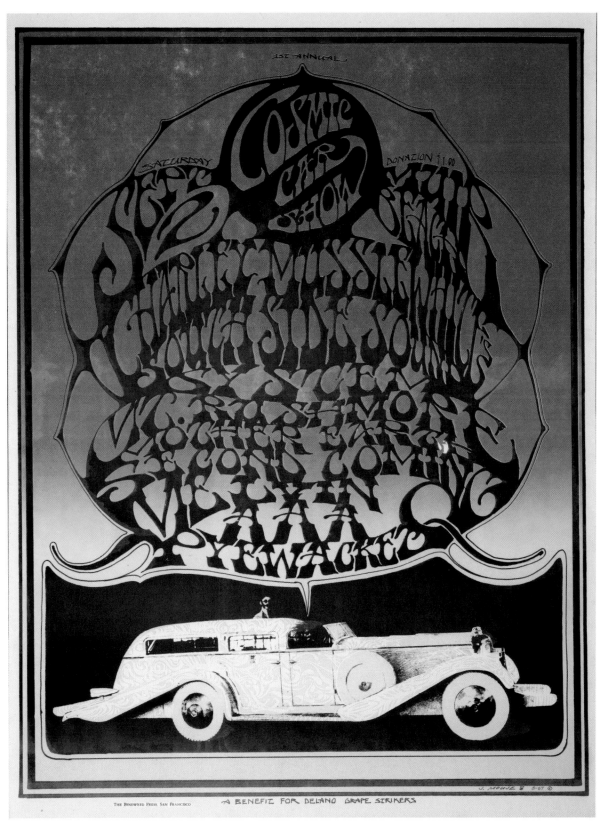

11.10 "First annual cosmic car show . . . a benefit for Delano grape strikers." Stanley Mouse, unspecified UFW support group, 1967. Screenprint, 58.5 x 43.5 cm.

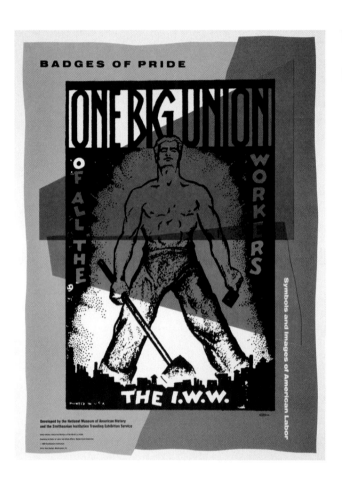

11.11 "Badges of Pride: Symbols and Images of American Labor" (exhibit). Designed by CHRIS NOEL, National Museum of Labor History, Smithsonian Institution, 1989. Offset, 61 x 46 cm.

11.12 "With These Hands" (exhibit). Photograph by DANIEL N. PEAVEY, San Jose Museum of Art, 1982. Offset, 54 x 40.5 cm.

Facing page 11.13 "The Other America" (exhibit). Photograph by LEWIS HINE, Neue Gesellschaft fur Bildende Kunst, Germany, 1985. Offset, 83.5 x 59 cm.

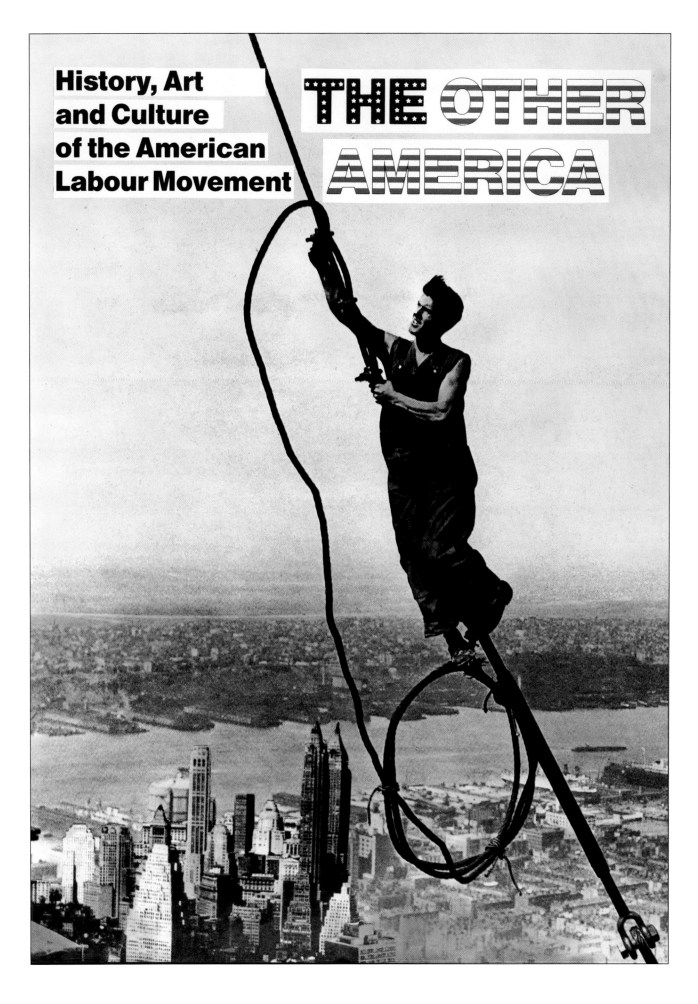

**History, Art
and Culture
of the American
Labour Movement**

THE OTHER
AMERICA

Against the Wall

PROTEST POSTERS OF THREE CENTURIES

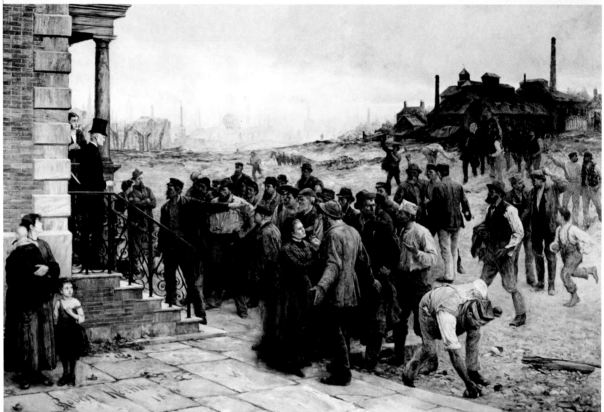

THE STRIKE by Robert Koehler, 1886

" The strongest bond of human sympathy,
outside of the family relation,
should be one uniting all working people,
of all nations, and tongues, and kindreds. "

Abraham Lincoln.

1199
NATIONAL UNION OF HOSPITAL AND HEALTH CARE EMPLOYEES/RWDSU/AFL-CIO

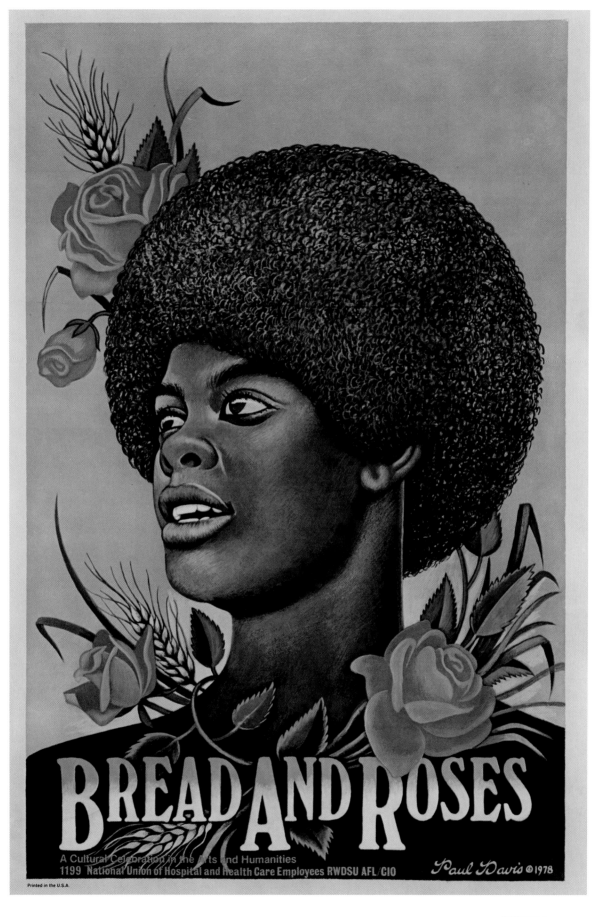

Previous pages 11.14 "Against the Wall: Protest Posters of Three Centuries." Artwork by Robert Koehler, poster designed by Phil Wolfe; SEIU Local 1199, circa 1973. Offset, 73 x 51.5 cm.

11.15 "Bread and Roses." Paul Davis, National Union of Hospital and Health Care Employees (NUHHCE), 1978. Offset, 71 x 58.5 cm.

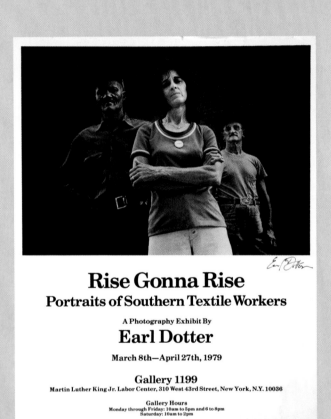

11.16 "Rise Gonna Rise" (exhibit). Photograph by Earl Dotter (www.earldotter.com), SEIU Local 1199, 1979. Offset, 55.5 x 40 cm.

11.17 "Images of Labor" (exhibition series). Philip Hays, NUHHCE, 1981. Offset, 94 x 61 cm.

11.18 "Images of Labor" (exhibition series). Milton Glaser, NUHHCE, 1981. Offset, 94 x 61 cm.

11.19 "Images of Labor" (exhibition series). Jacob Lawrence, NUHHCE, 1981. Offset, 94 x 61 cm.

11.20 "Images of Labor" (exhibition series). Sue Coe, NUHHCE, 1981. Offset, 94 x 61 cm.

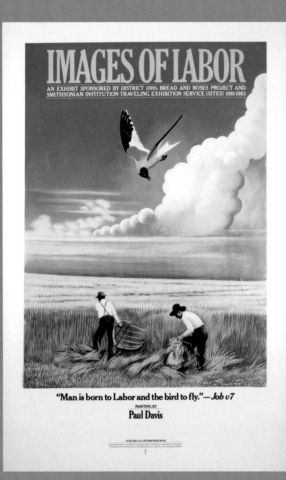

11.21 "Images of Labor" (exhibition series). PAUL DAVIS, NUHHCE, 1981. Offset, 94 x 61 cm.

11.22 "Images of Labor" (exhibition series). MIRIAM WOSK, Knowledge Unlimited, 1994. Offset, 61 x 46 cm.

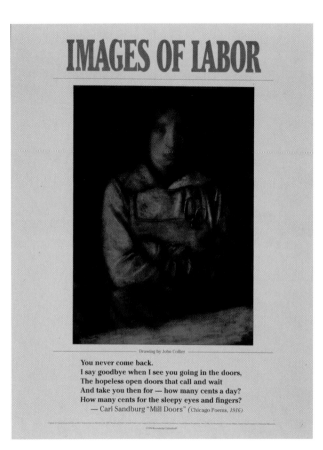

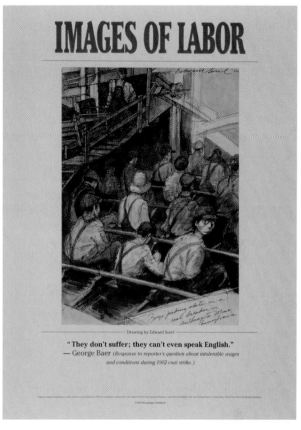

11.23 "Images of Labor" (exhibition series). JOHN COLLIER, Knowledge Unlimited, 1994. Offset, 61 x 46 cm.

11.24 "Images of Labor" (exhibition series). EDWARD SOREL, Knowledge Unlimited, 1994. Offset, 61 x 46 cm.

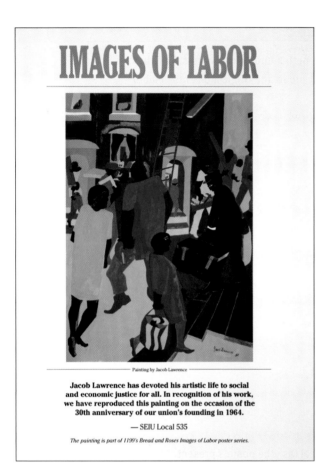

11.25 "Images of Labor" (exhibition series). JACOB
LAWRENCE, SEIU Local 535, 1994. Offset, 61 x 46 cm.

11.26 "Take Care, Take Care" (musical revue). Artist
unknown, SEIU Local 1199 Bread and Roses Project,
circa 1983. Offset, 47.5 x 33 cm.

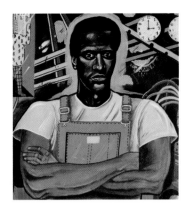

CONCLUSION

Throughout this book labor posters have agitated for a better future for workers, but they have also looked back at the people and events that mark proud and tragic moments in labor history.

The posters in this book play multiple roles. One is as the vision of activists concerned with the lives, at work and at home, of the working class. They are union organizers, supporters, rank and file members of all skill levels, political activists, and artists. The vast majority of these posters are collective efforts—by a designer (perhaps a committee of them), a printer, and often a "producer/commissioner." These posters are the results of many people's efforts, as are the products of American labor.

The posters as collected in this book also represent the work of historically minded labor activists, and librarians, and documenters, and archivists to protect these ephemeral products of the ongoing labor experience. Usually without adequate funds, and sometimes without any funding at all, these people have gathered and preserved the history of labor posters. Certainly the posters were designed to speak to an immediate audience, but this collection demonstrates that their messages remain pertinent to people's lives today, in some cases over a century after the original poster was created.

The posters can be viewed as part of labor history, documenting workers' issues as they faced them. But the posters are also part of art history and represent styles and outlooks and analytical methods appropriate to their times, the sorts of characteristics of concern to art historians. An issue may get viewers' attention, but that issue depicted with striking graphic style helps make it memorable. This study has sought to bring these two strains together, just as the posters do. One aspect alone is inadequate to the analytical task the posters present.

Historically, the posters in this book and many others like them have inspired working people during difficult times, and informed them about issues, moments, events, and people important to their lives. Most contain a call to action based on a belief in our ability to join together for a common good. If these posters inspire artists to continue creating, agitating, and educating, then it falls upon us to make the effort to collect these posters in archives for posterity. This is our cultural record, and we must preserve it.

ACKNOWLEDGMENTS

Many people and organizations have helped to put this book together. We are grateful to them all.

A special thanks to our partners, Nina Robinson and Jo Drescher, for their unstinting patience and support, and to Sarah Drescher for editorial assistance. The authors also wish to recognize Michael Rossman, poster collector and movement scholar extraordinaire, who passed away during the final stages of preparation of this book and whose collection contributed mightily to the breadth of images available. His selfless commitment to collecting, disseminating, and archiving posters has been a model for all of us.

The generous critical manuscript readings by Paul Buhle, Fred Glass, Marilyn Power, and Leah Shelledah are very much appreciated. Each offered insightful suggestions which have made this a stronger, more accurate text.

Thanks to editor Fran Benson and the Cornell University Press staff who believed in this book and guided it along.

Thanks to the following people and organizations for the use of their poster archives: Shannon Sheppard, Holt Labor Library, San Francisco; Michael Rossman, AOUON Archive, Berkeley; Gene Vrana, ILWU Archive, San Francisco; Carol Wells, Center for the Study of Political Graphics, Los Angeles; Barbara Morley, Kheel Center collection, Cornell School of Industrial & Labor Relations, Ithaca; Julie Herrada, Labadie Collection, University of Michigan; William Lefevre and Elizabeth Clemens, Walter P. Reuther Library, Wayne State University, Detroit; Catherine Powell, Jeff Rosen, and Susan Sherwood, Labor Archives and Research Center, San Francisco State University; Thomas Whitehead, Special Collections, Paley Library, Temple University; Teresa Eckmann, Special Collections, University of New Mexico; Lisa Marine and Dee Grimsrud, Wisconsin Historical Society; Lynda DeLoach, George Meany Memorial Archives, Silver Spring, MD; Erika Gottfried and Gail Malmgreen, Tamiment Library and Wagner Labor Archives, New York.

Thanks to the many artists, scholars, technical vendors, and others who helped with research, fact-checking, and making the book happen: Mike Alewitz; Marilyn Anderson; Robin Baker, Labor Occupational Health Program; Gail Bateson; Estelle Carol and Bob Simpson; Maria Catalfio; Kristin Chinery; Esther Cohen and Terry Sullivan, Bread and Roses; Steve Fesenmaier; Terry Huwe, IRLE-UC Berkeley; Gary Huck; Jane Hundertmark, California Federation of Teachers; Tony Jiga; Andrea Kantrowitz; Simon Kenrick; Mike Konopacki; Tenaya Laflore; Arieh Lebowitz, Jewish Labor Committee; Les Leopold; Ricardo Levins-Morales; Warren Mar; Molly Martin; Josh McPhee; Malaquias Montoya; Cathy Murphy; Zoeann Murphy; Peter Olney and Craig Merrilees, ILWU; Steve Ongerth; Ken Paff; Franklin and Penelope Rosemont; Julie Rubin; Martha Sanchez; Howard Saunders; ScanArt of Emeryville, CA; Nicole Schulman; Rae Shiraki, ILWU-Hawai'i; Jenny Silverman; Holly Skarros; Don Stillman; Ellen Widess; Kris Wright.

We are grateful for the subvention funding assistance that helped to make publication of this book possible:

Archie Green, Fund for Labor Culture and History; Art Pulaski and Anastasia Ordonez, California Labor Federation; Shelley Kessler, San Mateo Central Labor Council; Goetz Wolff; Vanessa Tait; Sandy Cait; Peter Jones, Labor Heritage Foundation; Stuart Basefsky, Cornell University.

Thanks to the subvention donors: UPTE-CWA 9119, Berkeley chapter; LEF Foundation; Paul E. Gottlieb; Pajaro Valley Federation of Teachers Local 1936; Amalgamated Transit Union Local 1575; Screen Actors Guild; Robert & Bonnie Castrey, arbitrators; Teamsters Local 601; Cement Masons Local 600; Five Counties [CA] CLC; Bakers Union Local 315; California Fire Foundation; San Mateo County [CA] CLC; Plumbers, Steamfitters & Refrigeration Fitters UA Local 393; OPEIU Local 3; Glaziers Architectural Metal & Glass Workers Union Local 718; Professional & Technical Engineers Local 21; Sacramento CLC; Operating Engineers Local 3; Plasterers' and Cement Masons' Local 300; Peninsula Auto Machinists Lodge 1414; IATSE Local 600 National Office; United Educators of San Francisco, AFT; Sheet Metal Workers International Association, Local 105; California School Employees Association; IAM&AW Aeronautical Machinists Lodge 1125; Southern California Pipe Trades District Council #16; Bakers Union Local 125; The Shelley & Donald Rubin Foundation; ILWU General Fund.

CREDITS

Although we have done our best to be sure that attributions are complete and accurate, it is the nature of this research that some omissions or errors have been made. We apologize in advance, and readers with corrections or additions to our catalog data are encouraged to contact the authors.

The following posters were reprinted with the permission of the United Farm Workers of America and are the exclusive property and art work of the United Farm Workers of America: 2.13, 2.23, 7.25, 7.26, 8.16, 8.19, 8.20, 8.21, 8.22, 8.24, 9.21, 10.19

The following posters are credited to the Works Progress Administration (WPA): 2.01. POS-WPA-NY.01.W76, no. 1 (C size) [P&P]; 3.02. POS-WPA-PA.M83, no. 7 (C size) [P&P]; 3.03. POS-WPA-ILL.01.T63, no. 1 (C size) [P&P]; 4.05. POS-WPA-ILL.01.G57, no. 1; and 9.03. POS-WPA-NY.B635, no. 12 (C size) [P&P].

PHOTODOCUMENTATION

All posters were photographed by Lincoln Cushing, with the following exceptions:

American Labor Museum, N.J.: 1.14

Center for the Study of Political Graphics: 3.09, 3.14, 7.26, 8.05, 8.06, 8.22, 10.14, 10.18, 10.19

Doug Minkler: 6.27

Teresa Eckmann, University of New Mexico: 9.07, 9.08, 9.09

Favianna Rodriguez: 5.20

Kheel Center, Cornell University: 6.02

Kris Wright: 11.01

Library of Congress (American Memory Project): 1.19, 2.01, 3.02, 3.03, 4.05, 5.01, 5.03, 9.03

Northland Poster Collective: 1.04, 2.20, 2.27, 3.22, 5.21, 7.01

Plattsburgh State Art Museum: 1.21

Temple University Libraries: 9.06

Wisconsin Historical Society: 2.18

Technical Note on the Production of this Book

All posters in this book were shot in RAW format with a Kodak DCS Pro SLR-n 13-megapixel camera using a Micro-Nikkor 60 mm flat-field lens. Image data went directly to a Macintosh laptop, allowing for color balance control and designated sequential file numbering. When shot in the author's studio, the posters were held in place on a wall-mounted 3' x 4' custom-built vacuum copy board, assuring orthogonal flatness without damaging the posters. Shooting on-site at remote archives was less precise, usually involving plastic clips and Post-it notes for delicate adhesion. Lighting was provided by a pair of Lumedyne 200 watt-second electronic strobe units placed at 45° to the copy board. A strobe meter was used to assure even light balance over the image area, with a standard color target and grayscale accompanying each shot. The original RAW format files were saved on DVD and hard drive, then cropped and converted to TIFF format for publication. The resultant files are equal to or larger than 3000 pixels along the longest edge (MOA II guidelines). Extensis Portfolio, a commercial stock photography application, was used to keep track of images and their relevant data. The search, display, and export functions of the application greatly facilitated the review, selection, and sharing of images.

ABBREVIATIONS AND NOTES

ABBREVIATIONS

ACTWU	Amalgamated Clothing and Textile Workers Union
AFL	American Federation of Labor
AFSCME	American Federation of State, County, and Municipal Employees
AFT	American Federation of Teachers
APHA	American Public Health Association
BWC	Black Workers' Congress
CFT	California Federation of Teachers
CTA	California Teachers Association
CACOSH	Chicago Area Committee on Occupational Safety and Health
CIW	Coalition of Immokalee Workers
CLUW	Coalition of Labor Union Women
COSH	Committee on Occupational Safety and Health
CWA	Communications Workers of America
CIO	Congress of Industrial Organizations
FEPC	Fair Employment Practices Commission
FLOC	Farm Labor Organizing Committee
IWW	Industrial Workers of the World
IAM	International Association of Machinists
ICEM	International Federation of Chemical, Energy, Mine and General Workers Unions
ILD	International Labor Defense
ILGWU	International Ladies' Garment Workers Union
ILWU	International Longshore and Warehouse Workers' Union
J4J	Justice for Janitors
LIUNA	Laborers' International Union of North America
MFLU	Mississippi Freedom Labor Union
NUHHCE	National Union of Hospital and Health Care Employees
NAFTA	North American Free Trade Agreement
OSHA	Occupational Safety and Health Administration

OCAW	Oil, Chemical, and Atomic Workers union
PATCO	Professional Air Traffic Controllers Organization
RCAF	Royal Chicano Air Force
SAG-AFTRA	Screen Actor's Guild/American Federation of Television and Radio Artists
SEIU	Service Employees International Union
SEMCOSH	Southeast Michigan Coalition for Occupational Safety & Health
SDS	Students for a Democratic Society
SMC	Student Mobilization Committee
TDU	Teamsters for a Democratic Union
TFWU	Texas Farm Workers Union
TUSES	Trade Unionists in Solidarity with El Salvador
UNITE	Union of Needletrades, Industrial and Textile Employees
UAW	United Auto Workers
UE	United Electrical, Radio, and Machine Workers of America
UFW	United Farm Workers (became UFWA in 1973)
UFWA	United Farm Workers of America
UFWOC	United Farm Worker Organizing Committee (became UFW in 1972)
UPIU	United Paperworkers International Union
UPTE	University Professional and Technical Employees, Communications Workers of America
USWA	United Steelworkers of America
WPA	Works Progress Administration

NOTES

1 For an excellent analysis of the impact the new media had on labor-management struggles, see Larry Peterson, "Pullman Strike Pictures: Molding Public Perceptions in the 1890s by New Visual Communication," *Labor's Heritage* (Spring 1997).

2 Here is the background according to Ed Reis, volunteer historian for Westinghouse, as interviewed by CFT Publications Director Jane Hundertmark on February 5, 2003: "For the past 60 years, the popular image of the World War II–era female worker in the 'We Can Do It!' poster has evoked strength and empowerment. The American public identified the image as 'Rosie the Riveter,' named for the women who were popping rivets on the West Coast, making bombers and fighters for aeronautical companies like Boeing. But history tells a different story. In 1942, the Westinghouse Corp., in conjunction with the War Production Coordinating Committee, commissioned the poster. It was to be displayed for only two weeks in Westinghouse factories in the Midwest where women were making helmet liners. They made 13 million plastic helmet liners out of a material called Mycarta, the predecessor to Formica (which means 'formerly Mycarta'). So, more aptly named, this woman is Molly the Mycarta Molder, or Helen the Helmet Liner Maker."

3 For more on this symbol, see the "A brief history of the 'clenched fist' image," essay for the "Battle Emblems" exhibit at San Francisco's Intersection for the Arts, 2/1/2006-3/25/2006; www.docspopuli.org/articles/Fist.html.

4 This poster is cataloged in the Library of Congress with the date range "1936–1943," an example of the lack of resources available within institutions for researching precise poster data.

5 In 1934, in solidarity with the United Textile Workers union, over 400,000 employees struck from Maine to Alabama. Strikebreakers, violence, state police, and evictions from company housing finally broke the strike. Since then, the company has been found guilty of illegal activities numerous times.

6 Eric Gordon, "Mike Alewitz Strikes Again and Again," *Heritage* (Spring 1994), 4.

7 Rose Schneiderman (1882–1972) was a feminist, socialist, suffragist, and labor organizer active in the garment workers' unions.

8 The essential distinction here is that craft unions, which excluded women, were organized by specific tasks, such as being a coach maker or engine mechanic. Industrial unions combine all the crafts participating in a single trade, such as automobile manufacturing. Obviously, the greater the range of jobs and the larger the membership, the greater the leverage a union has. With more and separate craft unions, the easier it is for management to isolate them and thus weaken the overall strength of workers.

9 Even if actual workers remain in their home countries, their lower wages depress U.S. work-ers' wages. This is an example of a division within the U.S. labor movement, in this case, interna-tional solidarity versus immediate effects at home. Such issues are rarely simple and never easily soluble.

10 One exception was the IWW, which has historically been opposed to war, considering it an extension of the struggle for dominance between capitalists. Many IWW members ("Wobblies") went to prison rather than submit to military conscription that would force them to kill other work-ers, a position taken in Carlos Cortez's 1970's IWW poster "Workers of the world, unite! You have nothing to lose but your generals (not shown)."

11 Philip S. Foner. *U.S. Labor and the Vietnam War* (New York: International Publishers, 1989).

12 This poster is an early example of labor groups embracing the Internet for outreach; note the prominent listing of the website address.

13 The 1892 Homestead Steel strike was a horrific example of worker and company militancy at the end of the nineteenth century. At Homestead, workers fought off an armed assault by Pinkertons (a private security company, and eventually a term meaning all hired guns) in which nine workers were killed. The strike was ultimately defeated after intervention by the Pennsylvania militia.

14 Giacomo Patri, 1898–1978, was the creator of the classic 1938 graphic novel *White Collar*, featuring 120 illustrations about class struggle, unions, and abortion.

15 "Boycott" got its name from an English land agent, Captain Charles Boycott, who led a ruth-less eviction campaign against tenants in Ireland in 1880. His employees began to refuse to assist Boycott or his family in any manner (see http://www.pbs.org/now/society/boycott.html). In this case, the boycott was of British goods as a means of protesting the unfair taxes imposed by the British in colonial America.

16 The term "labor temple" for union halls and labor council headquarters was common at the turn of the twentieth century.

17 See "A Rotten Apple for Jobs," by Mary Bergan, president of the California Federation of Teachers, February 2007, www.cft.org/about/news/arottenapple.pdf. In her critique of the Apple ad campaign, Ms. Bergan points out the irony that "Apple CEO Steven Jobs told an educational reform conference, 'I believe that what is wrong with our schools in this nation is that they have become unionized in the worst possible way. This unionization and lifetime employment of K-12 teachers is off-the-charts-crazy.' . . . Yet the campaign was happy to commercially exploit the images of Chicano civil rights icon Cesar Chavez and AFL member Albert Einstein."

ARCHIVES AND BIBLIOGRAPHY

SOURCES FOR IMAGES

Images not indicated below were supplied directly by the artist.

Archives Consulted but Not Used

George Meany Memorial Archives
10000 New Hampshire Avenue, Silver Spring MD 20903

Tamiment Library & Robert F. Wagner Labor Archives
70 Washington Square South, 10th Floor, New York, NY 10012

Institutional Archives

American Labor Museum
Botto House National Landmark, 83 Norwood St., Haledon, NJ 07508
1.04

Anne Rand Memorial Library
I.L.W.U., 1188 Franklin St., 4th Floor, San Francisco, CA 94109-6800
7.17

Center for the Study of Political Graphics
8124 West Third Street, Suite 211
Los Angeles, CA 90048-4309
1.02, 1.17, 2.03, 2.05, 2.11, 2.13, 2.15, 2.24, 2.28, 3.09, 3.11, 3.14, 3.19, 4.10, 4.16, 4.17, 5.13, 5.14, 5.18, 6.14, 6.22, 7.02, 7.03, 7.07, 7.09, 7.1, 7.11, 7.26, 8.05, 8.06, 8.11, 8.18, 8.22, 9.11, 10.02, 10.04, 10.14, 10.18, 10.19, 11.22.

The Tyler War Posters Collection
Special Collections, Temple University Libraries
1801 N. Broad Street, Philadelphia, PA 19122
9.06

Holt Labor Library
4444 Geary Blvd. #207, San Francisco, CA 94118
6.12, 6.24

Kheel Center for Labor-Management Documentation & Archives
227 Ives Hall, ILR School
Cornell University, Ithaca, New York 14853-3901
2.12, 2.21, 3.04, 3.05, 4.03, 4.06, 5.07, 5.09, 6.02, 7.15, 7.22, 9.04, 9.17, 10.01, 11.15, 11.17, 11.18, 11.19, 11.2, 11.21

Labadie Collection
University of Michigan, Ann Arbor, Hatcher Graduate Library, Ann Arbor, MI 48109–1205
2.19, 2.25, 4.07, 5.16, 6.01, 8.01, 9.01, 10.07, 10.09, 11.02

Labor Archives and Research Center
San Francisco State University, 480 Winston Dr., SF, CA 94132
2.06, 2.07, 2.08, 4.01, 4.13, 4.14, 5.04, 5.15, 5.17, 5.19, 6.20, 6.23, 7.04, 7.08, 7.29, 7.30, 8.04, 8.07, 8.08, 9.02, 9.10, 9.12, 9.13, 9.14, 9.15, 9.19, 10.17, 11.03, 11.05, 11.26

Library of Congress
American Memory Project
By the People, For the People: Posters from the WPA, 1936–1943; Web collection
1.19, 2.01, 3.02, 3.03, 4.05, 5.01, 5.03, 9.03

Plattsburgh State Art Museum
101 Broad Street, Plattsburg, NY, 12901
1.21

University of New Mexico Libraries
Center for Southwest Research, Albuquerque, NM 87131
(Holland Collection, PIC 999-001)
9.07, 9.08, 9.09

Walter P. Reuther Library
Wayne State University, 5401 Cass Avenue, Detroit, MI
48202
2.16, 2.17, 2.22, 2.23, 3.13, 3.15, 4.02, 5.02. 5.06, 5.08,
5.11, 7.20, 7.21, 8.02, 8.19, 8.20, 8.21, 8.24, 9.05, 9.21,
11.09

Wisconsin Historical Society
816 State Street, Madison, WI 53706-1417
2.18

Points of Production

Inkworks Press Archive
2827 7th St., Berkeley, CA 94707
2.10, 6.13, 6.15, 6.21, 7.24, 7.27, 8.13, 10.16

Northland Poster Collective
P.O. Box 7096, Minneapolis, MN 55407
1.04, 2.20, 2.27, 3.22, 5.21, 7.01

Private Collections

All Of Us Or None Archive
Berkeley, CA
(Currently housed at the Lincoln Cushing Archive)
2.04, 3.06, 4.04, 4.18, 4.19, 5.10, 6.05, 6.17, 7.14, 7.16,
7.18, 7.19, 7.23, 7.25, 8.1, 8.14, 8.16, 8.17, 8.23, 9.16,
9.18, 9.20, 10.05, 10.10, 10.12, 10.15, 11.06, 11.07, 11.10,
11.11, 11.12.

Lincoln Cushing Archive
822 Santa Barbara Road, Berkeley, CA 94707
Frontispiece, 1.03, 1.18, 2.02, 2.09, 2.14, 2.26, 3.07,
3.08, 3.10, 3.12, 3.16, 3.17, 3.18, 3.21, 4.11, 4.12, 4.15,
5.05, 6.04, 6.06, 6.07, 6.08, 6.09, 6.10, 6.16, 6.18, 6.19,
6.25, 6.26, 6.28, 7.05, 7.06, 7.12, 7.28, 8.03, 8.09, 8.12,
8.15, 10.03, 10.06, 10.08, 10.11, 10.13, 11.08, 11.13, 11.14,
11.16, 11.25

Tim Drescher: 3.2, 205
Shelley Kessler: 1.04, 11.23, 11.24
tenaya laflore: 7.13

Labor History

Brecher, Jeremy. *Strike!* Boston: South End Press, 1972.

Buhle, Paul, and Nicole Schulman, eds. *Wobblies! A Graphic History of the Industrial Workers of the World.* London: Verso, 2005.

Litwack, Leon. *The American Labor Movement.* Englewood Cliffs, NJ: Prentice-Hall, 1962.

Morris, Richard B. ed., *The U.S. Department of Labor History of the American Worker.* Washington, DC: U.S. Government Printing Office, 1977.

Schnapper, M. B. *American Labor, A Pictorial Social History.* Washington, DC: Public Affairs Press, 1975.

Smith, Sharon. *Subterranean Fire: A History of Working-Class Radicalism in the United States.* Chicago: Haymarket Press, 2005.

Art and Labor

Alewitz, Mike, and Paul Buhle. *Insurgent Images: The Agitprop Murals of Mike Alewitz.* New York: Monthly Review Press, 2003.

The Art of Rini Templeton. Seattle: Real Comet Press, 1987.

Buhle, Paul. *From the Knights of Labor to the New World Order—Essays on Labor and Culture.* New York: Garland Publishers. 1997.

Cushing, Lincoln, ed. *Images of Peace and Justice: Over 30 Years of Political Posters from the Archives of Inkworks Press.* Berkeley: Inkworks Press, 2007.

Foner, Philip S., and Reinhard Schulz. *The Other America—Art and the Labour Movement in the United States.* London: Journeyman Press, 1985 (abridged version of the original German edition, Foner, Philip S., and Reinhard Schulz. *Das Andere Amerika.* Berlin: Elefanten Press, 1983).

Gordon, Eric. "Mike Alewitz Strikes Again and Again." *Heritage* (Spring 1994): 4.

Johnson, Mark Dean, ed. *At Work: The Art of California Labor.* San Francisco: California Historical Society Press and Haymarket Press, 2003.

Langa, Helen. *Radical Art: Printmaking and the Left in 1930s New York.* Berkeley: University of California Press, 2004.

Lonidier, Fred. *Blueprint for a Strike.* Catalog for the exhibition "For Labor, About Labor, By Labor: Our Struggles in the U.S. from the 70's to the 90's," shown June 4–July 3, 1992 at the Walter/McBean Gallery of the San Francisco Art Museum.

Mace, Rodney. *British Trade Union Posters: An Illustrated History.* Gloucestershire, UK: Sutton Publishing, 1999.

Morris, Richard B., ed. *The American Worker.* Washington, DC: U.S. Department of Labor, 1976.

Miner, Dylan A. T. "Yours for the One Big Union: Radical Wobbly Traditions in the Art of Carlos Cortéz Koyokuikatl and Dylan A. T. Miner." Unpublished manuscript, 2005.

Noriega, Chon, ed. *Just Another Poster?* Chicano Graphic Arts in California. Settle: University of Washington Press, 2001.

O'Connor, Francis V., ed. *WPA: Art for the Millions, Essays from the 1930's by Artists and Administrators of the WPA Federal Art Project.* Boston: New York Graphic Society, 1973.

Peterson, Larry. "Pullman Strike Pictures." *Labor's Heritage* (Spring 1997): 14–33.

Prescott, Kenneth W. *Prints and Posters of Ben Shahn.*
New York: Dover Publications, 1982.

Rosemont, Franklin. *Joe Hill: The IWW & The Making of a
Revolutionary Workingclass Counterculture.* Chicago:
Charles H. Kerr Publishing Co., 2003.

Rubenstein, Harry R. "Symbols & Images of American
Labor: Dinner Pails and Hard Hats." *Labor's Heritage*
(July 1989): 34–49.

Scheper, Jeanne. "Visualize Academic Labor in the
1990s: Inventing an Activist Archive in Santa
Barbara." *Feminist Studies* 31 (Fall 2005): 557–69.

*Social Concern and Urban Realism: American Painting
of the 1930s.* 1983 catalog for an exhibit by the same
name organized by the Bread and Roses Cultural
Project at the Boston University Art Gallery.

Wobbly: 80 Years of Rebel Art. 1987 catalog produced
by the Labor Archives and Research Center at San
Francisco State for a graphics exhibit.

"Work—Fight—Give: Smithsonian World War II Posters of
Labor, Government, and Industry," *Labor's Heritage*
(Winter/Spring 2002): 36–49.

Wright, Fred. *So Long, Partner!* A compendium of over
forty years of labor cartoons created by Fred Wright
for the UE News Service. New York: United Electrical,
Radio and Machine Workers of America (UE), 1975.

INDEX

*Poster titles are in bold and illustration page numbers
are in italics.*

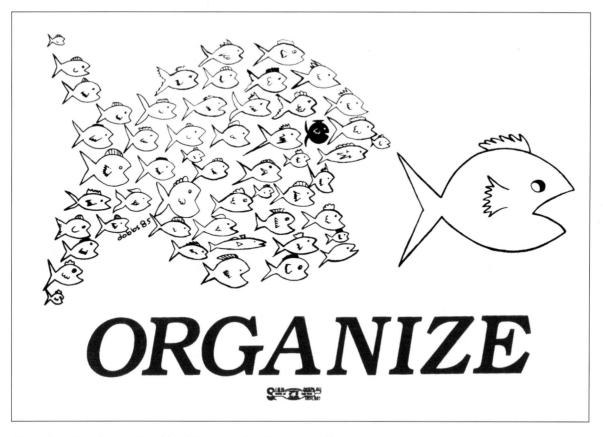

"Organize." Bill Dobbs, Northland Poster Collective, 1985. Offset, 43.5 x 56 cm.